The Cool and the Crazy

Also by Peter Stanfield

Maximum Movies—Pulp Fictions: Film Culture and the Worlds of
Samuel Fuller, Mickey Spillane, and Jim Thompson
Body and Soul: Jazz and Blues in American Film
Horse Opera: The Strange History of the Singing Cowboy
Hollywood, Westerns and the 1930s: The Lost Trail

Edited Collections

Mob Culture: Hidden Histories of the American Gangster Film
"Un-American" Hollywood: Politics and Film in the Blacklist Era

The Cool and the Crazy

• •

Pop Fifties Cinema

PETER STANFIELD

Rutgers University Press

New Brunswick, New Jersey, and London

Library of Congress Cataloging-in-Publication Data
Stanfield, Peter, 1958–
 The cool and the crazy: pop fifties cinema / Peter Stanfield.
 pages cm
 Includes bibliographical references and index.
 ISBN 978-0-8135-7299-4 (hardcover: alk. paper) — ISBN 978-0-8135-7298-7 (pbk.:
alk. paper) — ISBN 978-0-8135-7301-4 (e-book (web pdf)) — ISBN 978-0-8135-7300-7
(e-book (epub))
 1. Motion pictures—United States—History—20th century. I. Title.
 PN1993.5.U6S655 2015
 791.430973—dc23

 2014021732

A British Cataloging-in-Publication record for this book is available from the British Library.

Visit our website: http://rutgerspress.rutgers.edu

Manufactured in the United States of America

For Dad

Contents

Acknowledgments

> "Well, I'll drift."
> —Robert Mitchum in *Blood on the*
> *Moon* (1948)

I am indebted to the generosity of my colleagues and friends, none more so than Frank Krutnik. Richard Maltby also lent a hand, as he has done consistently since supervising my PhD back in the mid-1990s. Will Straw again played a role in things, and so most certainly did David Lusted, Cecilia Sayad, and Antonio Lázaro-Reboll—and I daresay Lee Grieveson made a contribution somewhere down the line. I thank you all. For giving me the book's title, a tip of the cinephile's chapeau to Wheeler Winston Dixon. I am obliged. And I am once again beholden to Leslie Mitchner; it's been a pleasure as always.

This book has been in the making for a number of years, parts having been previously published in peer-reviewed journals and collections of essays. I would like to thank those editors, notably Greg Waller, Warren Buckland, Kingsley Bolton, Jan Olsson, Roy Grundmann, Cynthia Lucia, and Art Simon. Unless otherwise noted, all illustrations are from the collection of the author and are in the public domain or available for reproduction under fair use.

The Cool and the Crazy

Introduction

• • • • • • • • • • • • • • • • • • • •

> At the movies it is the recognition of the
> topical material with traditional forms,
> the capacity of the norm to absorb new
> elements, that is a particular pleasure.
> —Lawrence Alloway, *Violent America:*
> *The Movies 1946–1964*

The book's main title, *The Cool and the Crazy*, is taken from a 1957 movie;
the second of three films made by the independent company Imperial Pro-
ductions on the topic of juvenile delinquency, it was distributed in 1958
by American International Pictures in a double bill with *Dragstrip Riot*.
Its title's slangy hip connotations suggest both the movie's topicality—its
"nowness"—and its sensational subject matter of teenage narcotic addic-
tion. *The Cool and the Crazy* was not a particularly original title, having
already been used six years earlier by the jazzman Shorty Rogers for one
of his albums. Its story was hardly unique either: drug dependency was
previously a feature of the 1956 movie *The Man with the Golden Arm*, and
the novelty of narcotic abuse by untamed youths was similarly exploited
in two other 1958 movies, *High School Confidential!* and *Stakeout on Dope
Street*. This book is about that play between novelty and repetition as it
interacts with an exploitation of the topical. It is about movies made with

1

the marketplace uppermost in mind. It is not about film as art, or if it is, it is about movies as an industrial art.

The "pop" in the book's subtitle references pop art, not to draw comparisons and links between Hollywood and Warhol, but to bring attention to the influence on my work of British pop artists and critics—Lawrence Alloway and Richard Hamilton, among others. More importantly "pop" is used to underscore the idea that this is a study of the popular, with its diminutive signifying a material culture that is intended to be effortlessly consumed. The movies I study, for the most part, are ephemeral; they were designed with built-in obsolescence, made for a market with a voracious appetite that demanded new products on a regular, preplanned basis. The films are evanescent, only fleetingly held up before the public eye, with little expectancy on the part of their producers that they will remain in circulation much beyond their original theatrical run. These movies offered both the new and the familiar, and to a large extent they are interchangeable—a standardized product and a repeatable experience. The films studied here were not made to be contemplated as art objects; few are worthy of extended analysis, but when we consider them in their commonality, that is, when we organize and understand them in terms of cycles and trends, we can learn much about the work they do, the pleasure they provide, and the world they and we exist in.

As a film unspools and is projected onto a screen, its audience is confronted with a fantastical representation of itself: the spectral images and amplified sounds confirm the filmgoer's membership in a commonwealth of viewers. The screen's mirroring of this public sphere is an unfaithful reproduction; its reflective powers are illusory. Rather than the real that corresponds to an audience's own social circumstances, film offers instead a false but believable account. The Surrealist René Crevel's 1927 critique of this bad contract between cinema and its patrons, between the sidewalk and the screen, is pertinent: "In spite of all the gazes met with, the street had already proved a disappointment. In the absence of all those glances that might have done something for us, our indolence has expected a lot of those black-and-white creatures with whom most adult males would like to fall in love. . . . At pavement level you used to tell yourself the marvelous bliss could never end, since the marquee announces 'nonstop entertainment.' "[1] Film never fulfills its part of the contract. Desire is never satisfied; the entertainment ends and the jouissance of "marvelous bliss" is deferred, held over for the next screening. Entering into the shadow world of the

cinema does not deliver a seamless continuity between social realities and the pictureplays on the screen; instead the theater provides a weak echo of the street's cacophonous sounds and a trompe l'oeil in place of strangers' ill-met glances.

Those who promise to meet the audience's gaze, the strangers on the cinema screen, are predetermined, and the aleatory flow of chance encounters on real city streets is rarely matched. This lack of authenticity, the refusal of film to be just a recorder of reality, is compensated by the use of familiar structures of narration, stories, and spectatorial pleasures. A film's notion of verisimilitude is linked to a social reality and to an understanding of the world predetermined by repeated representation in earlier fictions. What follows explores this compact between the everyday and film convention.

Typically, the correspondence between film and the public sphere is conceived in terms of cinema's ability to offer social commentary, to provide a record, however skewed, of current realities. I consider the ways in which overdetermined fictional structures and forms qualify this correspondence. The construction of the everyday is grounded in a recognizable world that is based on a lived experience familiar and identifiable to the majority of a film's audience, but the everyday is also made manifest and meaningful by recourse to formulaic tropes of fiction. The focus of the book thus records the uniqueness of a topical event and the quotidian correspondence between filmmaking and the social.

The combination of the social and the formulaic in film has its origin in popular stories for a mass audience—dime novels and penny dreadfuls—that were produced around the turn of the century. Michael Denning argues that these stories were a fantastic refashioning of the mundane: "A story to be a story had to be set in a contemporary time and knowable landscape, but its plot had to be out of the ordinary; 'everyday happenings,' according to this . . . aesthetic, did not make a story. The story was an interruption in the present, a magical, fairy tale transformation of familiar landscapes and characters, a death and rebirth that turned the world upside down."[2] The heroes and villains of crime films with a Cold War topic, *Pickup on South Street* (1953) or *I Married a Communist* (1949), for example, may be fantastic versions of contemporary social realities, but they are also linked to the quotidian world of their contemporary audience. Popular fictional tales such as these are not best considered as a lopsided record of the topical—a misrepresentation; rather, they should be understood as melodramatic excursions into a recognizable world.

The Cool and the Crazy explores the associations and connections between film and its social contexts. It examines the way film utilizes current and timely issues while also itself being topical. The focus is on how movies exploit substantive events like the outbreak of war, or other manifestations of the contemporary such as those dramatized in social problem pictures (with stories ripped from today's headlines), and, more specifically, on how filmmakers take advantage of fads in musical styles, the popularity of certain sports, or other material and cultural iterations of the topical. The aim is to write a credible history of film and the public sphere—a history avoiding reflectionist or symptomatic analysis that imagines unmediated or even allegorical correspondence between movies and their contexts.

In making the connections between cinema and the social, I push against the tendency toward overly determined readings of films, which consider movies as a barometer of their times. David Bordwell and Jeff Smith, among other scholars, have systematically critiqued approaches that utilize cinema as a symptom or measure of social and cultural life and have done so in good part because such studies rely on a high degree of selectivity.[3] As Richard Maltby argues, the process of selection never fully accounts for why certain films are prioritized over others.[4] Such a method claims, for example, that 1950s romantic comedies somehow reiterate the notion of social conformity generally ascribed to the years of the Eisenhower administration, or that noir films subvert and attack compliance with that same field of convention, while ignoring any film that contradicts such reductive readings.

Maltby's position revises the dominant mode of film study, relocating the focus of scholarship away from the primacy of individual films, or even specific genres, toward a better understanding of cinema's place within the public sphere. As he explains, during Hollywood's studio era, films were generally in circulation for very limited periods and would usually play for only three days at any given cinema. This rapid turnover of movies demands that we "acknowledge the deliberately engineered ephemerality of cinema, both as a property of its commercial existence and as a phenomenon of memory."[5]

The concept of the experience of film viewing as the primary concern of film scholarship is shared with the British art critic Lawrence Alloway, who in the 1960s argued that the habitual practice of watching movies must be central to any analysis.[6] He conceived of popular film as being defined by the topical; hence, as a form and an experience, it is marked by transience and obsolescence. As understood by Alloway, the key features of popular

film are redundancy rather than permanence, and repetition with minor modification rather than innovation.[7] In counterpoint to the fine arts, he claims, it is the fleeting and dispensable qualities of film that should attract the attention of scholars. As an obsolescent art form, film is expendable, inherently ephemeral, and largely forgettable (or hard to remember). Inasmuch as films provide transient and immediate pleasures, they can only be recalled in vague outline or in the retention of a moment, never in their entirety.

In her dream portrait of Hollywood films of the 1940s, Barbara Deming sought to assure her readers of the integrity of her account by insisting that she did "not rely upon memory. At each film I took lengthy notes in shorthand—a very literal moment by moment transcription."[8] For the habitual cinemagoer, however, the uniqueness of the film viewed was less important than the repeatable pleasure of "watching the movies." Regular filmgoers do not make notes of the films they are watching, nor do they need perfect recall. Having a poor recollection of films, even of ones recently viewed, is part of the experience of cinemagoing. Film's evanescence, Alloway contends, is countered by the proliferation of "continuing themes and motifs," with "the prolongation of ideas in film after film" compensating for "the obsolescence of single films."[9]

Serial viewing of this order requires a very different mode of study than the explication of individual films that is generally favored by scholars and critics. The object of study is not film as a unique textual entity but a multiplicity of films, which are categorized in terms of runs or sets. Such a study focuses on continuity (the prolongation of structural properties, themes, tropes, and motifs across a range of differentiated articulations) and ephemerality (acknowledging the fleeting nature of audience engagement). To this end, I am proposing a theory of cyclical change within which actual case studies can be grounded, a theory that recognizes that American film producers and exhibitors used cycles, however equivocally or intuitively, as a way of understanding, predicting, and managing change. My concept of cycles, therefore, is based on theories rooted in the practice of making and exhibiting films.

Intimately tied to the moments of their production, distribution, exhibition, and reception, film cycles are defined by their place within a historical continuum. Documenting the repetitions, overlaps, and fusions that coordinate the associations between individual films within a cycle—and, in turn, the liaisons and connections across cycles—renders the process

visible to cinema scholars. Such a study reveals uniqueness to be little more than the repetition of existent components, producing what the literary scholar Franco Moretti has termed "regular novelties."[10] Tracking the dialectic between repetition and innovation across runs of films makes legible changes to cinematic environments and to the public sphere within which films are produced and consumed.

Genre studies have long been the principal means by which the "relationship between films and the society they address" has been articulated.[11] In his thoughtful revisionist history of slasher movies, Richard Nowell argues that this construct between genre and society is often made at the cost of ignoring the commercial imperative that drives film production, particularly as it operates in the realm of distribution. Genre studies also tend to artificially partition one type of film from another, even while they might be open to discussion of a particular film's hybridity. In counterpoint, a film's generic instability is not marginalized in a study of cycles but is understood to be fundamental to the production and reception of formulaic commercial cinema.[12] The ideal of stability is further compounded by the tendency in genre studies to conceive of that ideal in terms that transcend the particular context of a film's production: for example, the notion that westerns are inherently defined by the antinomies of civilization and savagery set on America's frontier,[13] or that slasher films produced between 1979 and 1982, by dint of a few shared characteristics, were directly influenced by *Psycho* (1960) and *The Texas Chainsaw Massacre* (1974). My own work on 1930s western cycles and Nowell's research robustly contest such axioms.[14] As conceived by Nowell and myself, cycles are always located within their production and exhibition contexts and are defined by charting their emergence, consolidation, and diffusion over a measurable period of time.

In film studies, a theory of cycles and trends remains notably underdeveloped, but what work there is has deployed a similar set of temporal measures. In his study of film genres, Rick Altman notes that by "assaying and imitating the money-making qualities of their most lucrative films, studios seek to initiate film cycles that will provide successful, easily exploitable models." Each film in the cycle contributes to the marketing of the others, but overreliance on the repeatable experience will eventually lead the market to its saturation point. Through the various viewing positions—production, marketing, and consumption—that can be assumed in relation to the body of films that form a cycle, Altman argues, a consensus emerges over its identification as a genre, or at least as a potential generic

type. This is "a never-ceasing process, closely tied to the capitalist need for product differentiation."[15] The commercial success, then, of an individual film encourages repetition of key elements. The shared characteristics utilized across a number of films form a cycle, and at the point when the repeated elements are sufficiently stabilized, the cycle begins to transform into, and is eventually identified as, a genre.

In counterpoint to Altman, Tino Balio argues that the development of a linked run of films leads not to the formation of a genre but to what the industry recognized as a trend, an overarching production category, which is constituted by film cycles. In his study of the studio system in the 1930s, Balio lists six production trends: prestige pictures, musicals, the woman's film, comedy, social problem films, and horror films.[16] The trends are not possessive of the cycles from which they are formed, so the possibility of a group of films overspilling the mold and mutating across trends is a common occurrence; in the process, a trend dissipates and is eventually replaced by a new trend or trends. Because of the industry-led need to remake and remodel, cycles are apt to be rapidly exhausted, perhaps even within a single production season, while trends might last for several years.

The films that formed the juvenile delinquency cycles in the 1950s, for example, were part of the trend in social problem pictures—drug addiction among teenagers, for instance—and juvenile delinquents were also highly visible in western, musical, gangster, comedy, and horror film cycles. Through sheer prevalence, cycles of films about and aimed at teenagers were significant enough in production, marketing, and consumption terms, and sufficiently long lasting, to become in turn notable enough to be recognized as a trend. The shifting parameters of cycles and trends reveal the process of continual reconstituting and refashioning of existing forms.

In his study of Hollywood and genre, Steve Neale concludes with an assertion made by Maltby: "Hollywood is a generic cinema, which is not quite the same as saying that it is a cinema of genres." This position is arrived at following a survey of key genre theories that have an overwhelming tendency to privilege exemplary films and canons of excellence and, Neale argues, produce a misleading picture of film history. In recognizing the limitations of a genre analysis abstracted from the historical conditions of the production and reception of movies, an argument can be made for a history of Hollywood that is cognizant of and responsive to Neale's conviction that the industry organizes its "production schedules around cycles and sequels rather than genres as such." Neale concludes by asking

for studies of "unrecognized genres like racetrack pics, of semi-recognized genres like drama, of cross-generic cycles and production trends like over-land bus and prestige films, and of hybrids and combinations of all kinds."[17] *The Cool and the Crazy* attempts to be that sort of study.

Neale considers genres to be formed of transient groupings, historically provisional and empirically diverse, which is "manifest not just in the way texts and their constituent parts are grouped, but also in the way extra-textual norms and expectations shift and change, in the way labels and names are altered and redefined, and in the way each of these aspects of genre interact with one another over time." He makes three observations on this process: First, "the repertoire of generic conventions available at any one point in time is always in play rather than simply being re-played, even in the most repetitive of films, genres and cycles." Second, "generic reper-toire always exceeds, and thus can never be exhausted by, any single film." Third, "generic repertoires themselves can be at least partly compatible."[18]

Neale's formulation of generic convention and repertoire is comparable with the way cycles operate, with change occurring incrementally. The marking of time across a cycle's emergence, consolidation, and dissipa-tion is etched through the correspondence it has with the topical. Change in a cycle is always contingent on industry practice and policy and on an engagement with the public sphere. Trade press coverage of film produc-tion during the studio and poststudio eras, for example, regularly forged and commented on associations between films and the topical, and they did this routinely through an ongoing discussion about film cycles.

The trade press and industry insiders had an equivocal take on the bene-fits of film cycles, but they did not doubt that cycles played a crucial role in explaining and prophesying changes in the market. In the summer of 1950, the chief film buyer for the Fabian circuit based in New York credited the decline in box office receipts to film producers' dependence on film cycles. Overproduction of westerns had harmed box office during the past year, he claimed, and now a "superfluity of musicals threatened to repeat the process." The buyer discussed the difficulty of doing "justice to his houses or to the pictures when he's forced into the position of dating the same type product week after week. Everyone does a lot better when we can hit a change of pace." But, as a *Variety* reporter responded, this was a common complaint "heard almost since the start of the industry. They've never had any effect, since it has been habitual for studios to hop on a bandwagon as soon as one type of pic or another shows up with extraordinary grosses."[19]

A January 1951 edition of *Variety* ran several pages of opinion on the state of the film industry from leading figures in production, distribution, marketing, and exhibition—all of whom were cautious about the industry's future prospects but also keen to give a positive spin, despite the present situation of declining box office. The executive director of the Theatre Owners of America, Gael Sullivan, summed things up for his constituency: "The exhibitor knows there are new dynamics a-coming up that create additional movie patrons—bigger screens, all-color films, three dimensional film, third dimensional sound, and theatre television." These were innovations that he hoped would counter alternative attractions, including not only domestic television but also floodlight events such as harness racing and baseball. Local censors were also playing a part in robbing the pockets of theater owners, according to Sullivan, and so too was Hollywood's reliance on film cycles: "The poor theatre owner suffers from cinema cycles. It takes the form of an outbreak of westerns all at one time which brings in the kids but sends ma and pa back to their canasta game. Or it might be an outbreak of socially significant problem movies which ma and pa dote on but which makes the teenagers think a ride in their jalopy or a beach barbecue isn't such a bad pastime after all."[20] As much as this is a critique of cyclical film production, it is also a tacit recognition that the universal audience was a thing of the past, here pulled apart by divisions along generational lines and film cycles aimed at these niche markets.[21]

Five years after these comments on film cycles were published, the issue was again discussed in the *Motion Picture Herald*. The piece also focuses on the difficulties the small, independent theater owner faced, but here the columnist draws parallels with how film producers attempt to create or sustain a market for their movies by working in cycles, and how exhibitors follow a similar mode of practice:

We exhibitors get into cycles just as much as production does. We as a body are not bulging with an over-abundance of originality either.... Inertia is a mark of our push-button way of life. When the spark of enthusiasm does glow into a fresh slant, the exhibitor who begat it may report it to the trade papers, whereupon trade papers pass it on to other exhibs, who jump on the if-it-worked-for-him-it'll-work-for-me bandwagon and we have a cycle of double bills, free dishes, buck nights, family nights, live feature nights, drop-the-admission nights, etc., ad infinitum.

However, when things are working in the exhibitor's favor, he becomes complaisant, and then the cycle passes: "A few pictures flop and we get back to wailing about cycles in production." But if a cycle's unreliability, its lack of sustainability, is a problem for the exhibitor, it is also his salvation, as "cycles do represent an effort to do something about the 'reversals.'" It is like being on a merry-go-round, says the columnist; when "one thing peters out, we hook on to another, until it too has had its day and another cycle ends."[22]

As employed in film trade journals, the terms "fads," "cycles," and "trends" are somewhat interchangeable, used to suggest the transitory state of audience interests as well as shifts in film production. Scholars, though, might consider these terms as each defining a distinct scale and time frame. Such a concept of measuring their duration and amplitude would share similarities with that outlined by Moretti in his theory of cycles in literature.

Drawing upon the work of the historian Fernand Braudel, Moretti explores three time frames: event, cycle, and longue durée. He draws the conclusion that "the short span [event] is all flow and no structure, the longue durée all structure and no flow, and cycles are the—unstable— border country between them." In this context, temporal structures become visible to the literary historian because repetition is introduced into the equation; hence, he or she is able to "map" regularity, order, and pattern. In his refiguration of Braudel's tripartition of temporal struc- tures, Moretti renames longue durée as "genre," that is, as "morphological arrangements that last in time."[23]

Braudel understood all historical work to be involved with "breaking down time past, choosing among its chronological realities according to more or less conscious preferences and exclusions." This basic principle informed his proposed dialogue between history and the social sciences. He argued that the social sciences were beleaguered by being overly fixated on the event. This short time span is noisy and explosive, and more a mat- ter of the moment than a means of explicating historical forces. The event's "delusive smoke fills the minds of its contemporaries, but it does not last, and its flame can scarcely ever be discerned." The economist's preference for a longer time span than the event—the cycle—as an object of study provides a valuable key to the orchestration of conjunctures out of which a history can be written. The problem facing the historian is how to make use of cycles, which are often little more than sketches and hypotheses. The answer, Braudel proposes, is found in the manner in which these cycles are

structured, how they are organized into a "coherent and fairly fixed series of relationships between realities and social masses." This "structure" is what forms the longue durée:

> For us historians, a structure is of course a construct, an architecture, but over and above that it is a reality which time uses and abuses over long periods. Some structures, because of their long life, become stable elements for an infinite number of generations: they get in the way of history, hinder its flow, and in hindering shape it. Others wear themselves out more quickly. But all of them provide both support and hindrance. As hindrances they stand as limits ("envelopes" in the mathematical sense) beyond which man and his experiences cannot go.[24]

Contiguous events and activities form cycles, which in turn are limited by the structures within which they are produced, but which they also help shape. Identifying these structures (and their shifting forms) produces a history defined in terms of the longue durée. Though he never makes the connection, Braudel's theory shares a number of elements with business cycle theory as first popularized and developed by the economist W. C. Mitchell from the 1910s until his death in 1948. Mitchell's theory has a predictive function, in which abstract models are used to forecast change and regularity within an economic system.[25] It is based on a tripartite structure that is made of fluctuations, cycles, and trends. Fluctuations are localized, short-lived expressions of economic activity—an event, or a fad. The volatility of economic systems, of which fluctuations are a symptom, can be better understood—and hence, change can better be predicted—if a structure (that is, the cycle) is used to identify the general characteristics of change. The cycle, then, provides a model from which general tendencies in economic activity over time can be identified—tendencies that are not obscured by dramatic fluctuations or by fast-moving or attention-grabbing events. The variations in cycles, both in terms of duration and amplitude, are in turn held within trends. According to the economist Stanley Bober, "the trend is represented by a monotonic movement, which is the result of the longer-run underlying forces that affect the series [of cycles]." Cyclical changes are then determined by "departures from a calculated trend line." These changes have four phases: "Starting at a trough or low point, it (1) traverses through an expansion phase, (2) rises to a peak or high point, (3) declines through a contraction phase, and (4) reaches a trough."[26]

There are two core principles involved in a cyclical economic model. The first principle is that each cycle must be considered as "a unique series of events, which has its own particular explanatory forces and its own particular effect on the economy." The second principle is that, "although each cycle has its own different experience, it is an outgrowth of economic processes that were occurring during the preceding unique cyclical experience." Crucially, a universal model for business cycles is unattainable, because duration and amplitude differ from cycle to cycle, and although business conditions repeat themselves, they do so always with an element of difference. Paraphrasing Mitchell, Bober writes that even "though it may be possible to offer a valid explanation for a particular cycle, it is quite unlikely that the particular conditions that made this one explanation valid would necessarily exist again, or for that matter, did exist in the past."[27] Despite the particularities of any given situation, this theory, so it is argued, allows for an accurate prediction based on past cyclical examples of when expansion will turn to contraction, and when contraction will turn to expansion. For the economist, the value of this theory is that it allows for credible predictions based on a foundation of historical evidence. For the film scholar, film cycles allow for a verifiable account of continuities and shifts in film production and the manner in which that production is linked to the public sphere. According to Mitchell, the process of repetition and difference means that a "theory of business cycles must therefore be a descriptive analysis by which one set of business conditions transforms itself into another set."[28]

The study of film cycles allows for a particularly responsive account of small but significant shifts in how Hollywood conceived, produced, distributed, and exhibited its films. Such a study will not privilege repetition over novelty, or change over stasis, but instead will seek to examine and explain patterns of reiteration alongside modification. In this sense, conventions are never entirely fixed but are mutable: not replayed but in play, to paraphrase Neale. A generic ideal can never be realized, only imagined. The architecture critic Reyner Banham, a contemporary of Alloway, wrote that in "engineering a standardized product is essentially a norm, stabilized only for the moment, the very opposite of an ideal because it is a compromise between possible production and possible further development into a new and more desirable norm."[29] The industrial art of Hollywood is based upon the fetish of the norm, its avowal

and disavowal: change and stasis, or the familiar masquerading as inno-
vation, characterize Hollywood's film production.

The question facing the film historian is how to make use of any given
theory of cycles, whether propounded by literary theorists, historians,
business scholars, or trade press commentators. The answer is found in the
manner in which cycles are organized by the associations made between a
system predicated on the serial production of movies and the public sphere
in which it participates. Contiguous events and activities inside and out-
side the institutions of filmmaking form film cycles; therefore, identifying
them and then writing a descriptive analysis of how one cycle transforms
itself into another will produce a history of film understood through its
relationship to the topical. This strategy shares with business cycle theory
an understanding that a universal model is not applicable to this type of
historical inquiry because each cycle is unique, even as it is an outgrowth of
activities and practices that were occurring during preceding cycles.[30]

One determinant of change is the need for productions to respond to
topical issues and to maintain a correspondence with contemporary cul-
ture through the incorporation of everyday objects into a film's mise-en-
scène. Hairstyle, the cut of a coat, model of automobile, street furniture,
branded goods, and denim jackets worn by cowboys in westerns all help
to signify a film's contemporaneity. As much as Hollywood drives fashion
changes (magazine spreads on the latest styles worn by the top stars, say),
it is also at the mercy of vogues and fads. This is why movies fast become
outmoded.

In the case studies that follow I include an analysis of films that explicitly
exploited contemporary fads in music, the moral panic spurred by juvenile
delinquency (which I consider from three distinct views), the popularity
of alternative forms of entertainment, international events, and vogues in
male apparel. In each study, the causal explanation behind the formation of
a cycle and its associations with the topical is complex and sometimes indi-
rect. In a number of cases, the connection between film and the social is
filtered through synergies with other media forms, or via changes in leisure
activities; in others, it is tied to modifications in censorship and industry
self-regulation, or to shifts in audience demographics and sites of exhibi-
tion, as well as to the more direct exploitation of contemporary events such
as wars and moral panics. But each, following Braudel, can function as an
example of the "relationships between realities and the social masses."[31]

The Cool and the Crazy is composed of seven chapters, beginning with an account of the postwar cycle of boxing movies and movies that feature boxing. Though the critical and box office success of *Body and Soul* (1947) might handily act as prescient omen for the extraordinary number of films on the topic that followed in its wake, the effect of that one film on filmmakers cannot be made to account for the cycle as a whole. After baseball, boxing in this period was America's favorite sport; its representation in films is therefore hardly surprising, perhaps no more than an expedient exploitation of its popularity. As such it had a high profile in a good number of films that were not ostensibly about the fight game, as could be claimed of *Body and Soul*, but featured it as an aspect of everyday life or as a leisure activity, with characters attending an arena, or through having marginal figures involved in the sport as promoters or fighters, for example. I consider these varied representations of boxing in terms of the temporary creative alliances formed in order to facilitate independent productions, which gave a good number of these films a peculiarly nostalgic gloss and a left-leaning sensibility in their portrayal of urban, ethnic, working-class life. There is often an explicit social critique in these films, but this was not true of all the films in the cycle, which just as often used boxing for whatever popular currency filmmakers thought it had with their audience. Despite film's widespread coverage of the sport, it was a rival visual medium, television, that was most significant in its evolution. Boxing's popularity soared with its exposure on television, transforming it from a local attraction to a mass spectator sport. The films in the cycle are just as likely to comment on this state of affairs as they are to use boxing as an allegory for political corruption or social inequality. I use this competition between film and television to explore Alloway's concept of popular culture's "temporal function or span of usability."[32]

Chapter 2 shifts focus from how Hollywood reflected on and incorporated into its fictions the popularity of other forms of contemporary entertainment and turns to the ways in which the industry responded to and exploited the war in Korea. For the United States, the Korean War began on June 25, 1950, and Hollywood fully entered the fray six months later, in January 1951, when two films, both produced in the autumn of 1950, were released, *Korea Patrol* and Samuel Fuller's *The Steel Helmet*. These were low-budget films distributed by independents, Eagle-Lion and Lippert Pictures respectively. This chapter examines the manner in which American films represented the war in Korea, and how Hollywood reacted to the changing

situation on the ground and exploited the war's topicality. The films drew upon conventions established in the depiction of earlier conflicts, but by necessity these were modified to fit the needs of the still unfolding war. I trace the play between convention and modification across the years of the war and then after its close. Throughout this coverage attention is paid to the way filmmakers negotiated the lag between an event occurring—the retreat from Chosin following Chinese intervention, for example—and its representation on the screen. The focus of the chapter, however, is not on how well, or poorly, Hollywood documented and commented on the war's unfolding events; rather it is on how the cycle maintained a correspondence between representing aspects of the conflict and the everyday, which are refracted through moments of self-reflection on cinema's role in the public sphere.

The picture that focuses on and exploits social ills and anxieties has long been a staple of Hollywood's production trends. Moral panics, scandals, and social discord, whether evoked by white slavery, gangsterism, drug addiction, political chicanery, returning war veterans, or prison reform, for example, all carried a whiff of the controversial. Though all films are caught up in the imperative to keep up to date, some, such as the social problem film, are more highly marked by a link to contemporary culture. The social problem picture was never a major trend in studio-era productions, but film's "ripped from today's headlines" often created a great deal of interest, from the public and industry commentators alike.[33] Following the Paramount decrees in 1948 and the subsequent dismantling of the studio system, headline pictures took on a much higher profile within production schedules and the marketing of new releases. According to Maltby, the studios focused their energies post-1948 on distribution and financing agreements with independent producers and "quickly phased out the standardized production of the moderate-to-low-budget, formulaic movies that had sustained the industry by dependably meeting the fixed expense of studio overhead and the screen-time demands of exhibitors." The dissolution of the system of vertical integration, which ensured the studios controlled all aspects of the production, distribution, and exhibition of films, and particularly the end of the system of block booking that guaranteed screen time for all of Hollywood's films, regardless of the market, now meant the industry had to "sell each movie on its individual merits."[34] For the lower end of the production sector, that is, for films that did not have the singular attraction of a headlining star as a major component in the

film's marketing, there was a greater reliance upon a film's "got-to-see" factor, its exploitation of sensational material, and this is the type of film that chapter 3 examines.

The shift to film production that was aimed at a segmented rather than universal audience further pushed producers toward emphasizing a film's most provocative attractions, as did the film industry's repositioning of its products as distinct from television's family-oriented dramas. Maltby writes: "Once television became the primary provider of the affirmative cultural vision of America as a national community, Hollywood could engage controversial material on a more routine basis than the studios had attempted before."[35] To an extent this provides the justification for each chapter's topic and the reason why these case studies are based on cycles and trends from the immediate poststudio era, roughly from the late 1940s to the early 1960s. The period provides an intensified dialogue between film and the public sphere, with topical issues playing a more visible role in defining a film's uniqueness, while cleaving to convention became maximized in order to conform to audience expectations.

One aspect dramatized in the cycle of films within the trend in teenpix was a concern with the speed of reinvention and a movie's ability to appear to be of the moment—to draw from the topical issues of the day, particularly the fads and fashions of teenage culture. Not the least of these were the myriad musical styles and forms that were on offer, which were represented in a heightened dramatic form. While the turnaround of musical fads was fearsome, movie fads were also fleeting and could leave even the most watchful of film industry commentators at a loss in their monitoring of the latest cycles. However, with the benefit of hindsight it becomes possible to track fads as they formed into cycles, and cycles into trends. Indeed, it becomes possible to also identify "failed" cycles, that is, production fads that were not sustained long enough to register as cycles. Chapter 4 challenges the received wisdom that teenpix of the 1950s were dominated by a soundtrack of rock 'n' roll. I argue that this cycle of film production was marked by a diversity of musical genres, styles, and types. Not only rock 'n' roll but rhythm and blues, folk, rockabilly, swing, West Coast jazz, bebop, Latin music such as the mambo, the rumba, and the cha-cha-chá, and Caribbean calypsos were all heavily featured in these films. This study is carried out through a focus on the temporal arrangements that govern serial production and consumption of movies and popular music, which would appeal to diverse and capricious teenage tastes.

Chapter 5 tracks the emergence, consolidation, and dissolution of the short cycle of hot rod movies that was exhibited from 1956 to 1958. The aim is to explore this cycle's connection to topical issues and show how filmmakers used timely subjects that could be linked back to their production and exhibition contexts. Beginning with an account of the media frenzy that whirled around the subculture of hot-rodding and the sensationalist marketing strategies used to promote the films, the chapter then considers the portrayal of automobiles and youth culture and the primary exhibition outlet for these movies in drive-in theaters. What becomes readily apparent is the extraordinary mismatch between the thrills promised by the sales pitch and the pedestrian action of the films themselves. While the cycle showed intent to speed, few examples actually delivered on the promise to thrill. If the films were lacking in propulsive elements, how then do we account for their appeal to producers, exhibitors, and audiences alike? In part the answer lies in the displacement of speed as an aspect of the films' content and its emergence as a key factor in their production and exhibition. I argue that an accelerated manufacturing and consumption process compensates for the films' underpowered, pedestrian action sequences. The film itself is not as important as the event of going to see the movie. What draws all these areas of interest together is a series of inquiries about what made hot rods and hot rod culture useful to film producers and audiences.

As much as cyclical production was based on novel topical issues, such as juvenile delinquency, fast-moving fashions in popular music, or the moral panic around hot rod culture, it was also fueled by generic reinvention, or more precisely, in the context of the 1950s, rejuvenation. All of the major Hollywood genres—musical, romance, comedy, horror, and western— were reworked to appeal more forthrightly to a teenage audience. Chapter 6 examines these acts of rejuvenation with a particular emphasis on the retro-gangster cycle of the late 1950s and early 1960s. This cycle exploited the notoriety of Prohibition-era gangsters such as Baby Face Nelson, Al Capone, Bonnie Parker, Ma Barker, Mad Dog Coll, Pretty Boy Floyd, Machine Gun Kelly, John Dillinger, and Legs Diamond. Despite the historical specificity of the gangsters portrayed in these biopix, the films each display a marked interest in relating their exploits to contemporary topical concerns. Not the least of these was a desire to exploit headline-grabbing, sensational stories of delinquent youth in the 1950s and to link these to equally sensational stories of punk hoodlums from the 1920s and 1930s. The analysis of this cycle examines the crossovers and overlaps between

cycles of juvenile delinquency films and gangster biopix. At its center is the manner in which many of the films in the cycle present only a passing interest in period verisimilitude, producing a display of complex alignments between the historical and the contemporary that finds an echo in westerns of the period.

Chapter 7 considers the topical elements in the western's ostensible historical setting. The seminal texts on genre theory by John Cawelti, Thomas Schatz, and Will Wright suggest that the western is somehow timeless and yet endlessly adaptable.[36] As myth it says something universal about the American condition, and as a commercial product the western is also susceptible to the vagaries of the marketplace. This chapter takes a much more local look at how the western constructs American history and how it is in turn a product of the history it has made. I examine the tension between the historical and the contemporary, and the role of anachronism in that construct. Rather than considering the western's structural foundations or its semiotic iterations, my focus is on the elaboration of history through material culture, particularly costuming and the manner in which clothes embody contradictions woven around questions of authenticity. The history of events that occurred, or might have occurred, on the American frontier in the 1880s has a role to play in the western, but it does not principally determine how a film presents that moment in time. The history of the western itself plays an equal if not a greater role in how that time is represented. One of the key cycles of postwar westerns was sold on its ability to evoke a more authentic vision of the West than that previously provided by Hollywood, whether in B movies or A features. But as I show here, this cycle's particular construction of authenticity was heavily derived from the marketing of blue jeans, which was based on a wholly fabricated and romanticized image of cowboy costuming that often had more to do with the tourist industry and dude ranching than it had to do with the actuality of workaday cowboying.

By paying close attention to the associations governing the multiple ways that films are tied up with the topical (and are themselves emanations of the topical), the historian is provided with a compelling set of questions that can help explain the life of films within the public sphere. On this topic, Greg Waller writes: "Topicality is elusive and conjectural, but it cannot be ignored, especially when it comes to films designed for the commercial marketplace, where the topical is a significant attraction, a source of pleasure and a reminder of the ties that link the screen to the discourses

that circulate in and comprise the public sphere."[37] It is difficult to account in general terms for topicality in film, but by being attentive to a range of factors that can be evaluated and judged with due regard to the historical evidence and its varied contexts, we can better understand a timely topic's usefulness and its value for film producers, distributors, exhibitors, and audiences alike.

It is my ambition that the ideas presented here will unsettle received wisdom on the study of discrete genres as the most effective way of engaging with the history and theory of the production and reception of formulaic film narratives. My research makes no attempt to be all-inclusive in its coverage of postwar cycles and trends, but the studies I have written, both individually and collectively, are indicative. Discussing the "zeitgeist fallacy," Moretti notes how readily literary scholars move from an interpretative analysis of rhetoric to making generalizations about social history in light of their readings. The insight may be more or less illuminating, but the version of history produced is authoritarian, always producing a corresponding fit between the text and its context. However, "what becomes arbitrary when it is generalized may perfectly well not be so if it aims for a more restricted sphere of validity."[38] This more localized approach means that it is possible to test theories against the evidence presented. Similarly, my studies of cycles and trends do not claim to elucidate the spirit of the times, or to prescribe an overarching social reading of the multitude of films produced in the poststudio era, but they do aim to show how cyclical film production and events and concerns within the public sphere coincide, or not, as the case may be.

In reaching his conclusion, Moretti drew upon the work of the art historian Erwin Panofsky, who also guided Alloway's theories. Panofsky developed a concept of iconography, a "branch of the history of art which concerns itself with the subject matter or meaning of works of art, as opposed to their form." Alloway suggests that by arguing that the search for cinematic masterpieces is inappropriate, or forsaking a concentration on the supposedly unique features of the medium, we can then better consider "the crossovers among communicative forms." In doing so we are able to "chart the forms that topicality takes in the movies, often oblique but definitely present as a predisposing factor in the audience's attitudes."[39] This position is somewhat akin to that taken in *Reinventing Film Studies* by Christine Gledhill, wherein she discusses the difficulties facing the discipline in the aftermath of its engagement with "grand theory." She writes: "If . . . film

studies is not to diminish into a conservative formalism or a conceptually unrooted empirical historicism, the question of how to understand the life of films in the social is paramount." Gledhill's particular concern is with genre theory and the need to maintain an open-ended understanding of how film genres work as modalities, in which ideologies "provide material for symbolic actions and the aesthetic process hands back to the social affective experience and moral perceptions." Genres, she argues, "construct fictional worlds out of textual encounters between cultural languages, discourses, representations, images, and documents according to the conventions of a genre's given fictional world, while social and cultural conflicts supply material for renewed generic enactments."[40] Though I displace genre with cycles and trends, my study supports and builds upon Gledhill's directive, as it does upon the ideas and practice of Neale, Maltby, Moretti, and Alloway.

Alloway was principally an art critic, and Moretti is a literary historian, and their work as such is suggestive of the value to be gained from an interdisciplinary approach to the study of film. But whatever the models I draw from, the ambition is to match my findings with those of the work presently being carried out under the banner of "new cinema history," an approach exemplified by the work of Neale and Maltby. The latter argues that such a history must be written "from below" so that the social experience of filmgoing is recognized, alongside histories of production and textual readings of film. The axiom of the new cinema history is that it is based on the empirical study of the circulation and reception of cinema, and the industrial, institutional, political, legal, and cultural forces and policies that help determine that movement and consumption. The best of this work is a long way from the "conceptually unrooted empirical historicism" that Gledhill fears. Indeed, like Moretti's quantitative approach, it can determine the questions that can be asked of film that free the scholar from textual readings that only honor its uniqueness while ignoring what is shared with other films and other media.

1

Monarchs for the Masses

• •

Boxing Films

In this chapter, the cycle of postwar boxing movies is opened up on three fronts: the first examines the films in terms of an expressed desire on the part of their makers to engage in public debate on the state of the nation; the second front considers a countertendency toward a nostalgia for a lost sense of community and an authentic masculinity; and the third front looks at the cycle not as a melancholic longing for a more certain past, or as films with a social conscience, but as examples of a highly evolved dialogue between the movies and the everyday world experienced by its audience.

Champion (1949) opens and closes with a ringside radio commentator setting the scene for Midge Kelly's defense of his championship title: "Listen to the crowd. Actually, they're cheering more than a man tonight. They're cheering a story; a story that could only have been lived in the fight game: a story of a boy who rose from the depths of poverty to become champion of the world." After being brutally battered by his opponent, Kelly, played by Kirk Douglas, makes a dramatic comeback in the final round of the bout and holds on to his title. His victory comes at a high price, and he dies in his dressing room from a brain hemorrhage. The hero's rise from the gutter of ghetto life to the dizzying heights of a penthouse

overlooking the city, followed by an equally dramatic fall, was already pure formula by the time Carl Foreman had turned Ring Lardner's short story into a screenplay. RKO, however, contested the idea of common ownership of this formula when it took Stanley Kramer, *Champion*'s producer, and the production company Screen Plays II to court on the grounds that they borrowed too freely from its own production of *The Set-Up*. Attorneys for Screen Plays II and United Artists, the film's distributor, countered that the two films were sufficiently different and that the Howard Hughes–run corporation was attempting a spoiling action against box office competition. Their cry of corporate bullying went unheeded, and the judge ruled that *Champion* should be shorn of its offending scenes.[1] These scenes were relatively minor moments in a film that shared the same premise not only with *The Set-Up* but also with many other boxing movies—that mobsters control boxing, and that corruption, inside and outside the ring, is endemic to the sport. The struggle against moral depravity is as much a part of the formula as the struggle against economic deprivation.[2]

Following and paralleling the critical and box office success of *Body and Soul* (1947) and *Champion* (1949), the major studios and new independents produced a number of films that exploited the sport of boxing. These included *Killer McCoy* (1947), *Big Punch* (1948), *Whiplash* (1948), *In This Corner* (1948), *Leather Gloves* (1948), *Fighting Fools* (1949), *Duke of Chicago* (1949), *Ringside* (1949), *Right Cross* (1950), *The Golden Gloves Story* (1950), *Iron Man* (1951), *Roaring City* (1951), *Breakdown* (1952), *The Fighter* (1952), *Kid Monk Baroni* (1952), *The Ring* (1952), *Flesh and Fury* (1952), *Champ for a Day* (1953), *The Joe Louis Story* (1953), *Tennessee Champ* (1954), *The Square Jungle* (1955), *Killer's Kiss* (1955), *The Leather Saint* (1956), *Somebody Up There Likes Me* (1956), *The Harder They Fall* (1956), *World in My Corner* (1956), *The Crooked Circle* (1957), and *Monkey on My Back* (1957). The cycle continued sporadically into the latter part of the decade before ending with *Requiem for a Heavyweight* (1962). Boxing also featured prominently in a number of comedies—*The Kid from Brooklyn* (1946), *Sailor Beware* (1952), and *Off Limits* (1953), for example—and in crime films and melodramas: *The Killers* (1946), *Till the End of Time* (1946), *Nobody Lives Forever* (1946), *Brute Force* (1947), *The Street with No Name* (1948), *Tension* (1949), *The Big Night* (1951), *Glory Alley* (1952), *The Turning Point* (1952), *The Quiet Man* (1952), *From Here to Eternity* (1953), *On the Waterfront* (1954), *Kiss Me Deadly* (1955), and *The Big Combo* (1955); boxing even featured in musicals such as *It's Always Fair Weather* (1955).

Filmmakers understood that the boxing story offered a particularly viable vehicle for broad social commentary, with its proletarian protagonist, his struggles with organized crime, and an unforgiving social and economic order. *Body and Soul* is exemplary in this regard with its tale of a poor New York Jewish boxer who throws aside friends, family, and lovers in his obsessive drive to succeed. The factors that led the film's star, John Garfield, its screenwriter, Abraham Polonsky, and its producer, Bob Roberts, to choose a boxing story for the actor's first post–Warner Bros. film are complex and convoluted, but some are relatively clear. They had originally planned *Body and Soul* to be an account of the life of Barney Ross, an ex-marine and world champion across three divisions (lightweight, light welterweight, and welterweight) from 1933 to 1935. What drew them to Ross's story was the self-evident fit with Garfield's screen persona—street tough, New Yorker, and ex-soldier (Garfield was 4-F but had played military personnel in a number of wartime films, notably in the 1945 movie *The Pride of the Marines*). Ross's biography would eventually be filmed in 1957 as *Monkey on My Back*. That film showed little interest in Ross's boxing or military story, preferring instead to exploit his drug addiction in a bid to capitalize on the recent notoriety of *The Man with the Golden Arm*, released a year earlier.[3] Just as important in the decision to make a boxing movie was the knowledge that there was a viable tradition of stories told about the sport, most notably Clifford Odets's 1937 drama *Golden Boy*. Overshadowing all of this detail, however, was the cool fact that boxing was an extremely well liked form of entertainment—after baseball it was America's favorite sport—and so mass interest in the fight game would have been self-evident to these filmmakers. It was this popularity they sought to exploit.

Like other filmmakers with a social conscience and an interest in their heritage, Roberts and Garfield were attracted to the history of Jewish involvement in boxing, both inside and outside the ring. The novelist and critic Meyer Levin wrote in 1953: "Remember that Jewish boy in the Fannie Hurst era, that sensitive son of the unworldly Talmudist? He wanted to become a great violinist, a great surgeon, a great lawyer. His breed has vanished from today's fiction about the East Side. We are more 'realistic' now and our typical Jewish lads become prizefighters, hoodlums, gangsters, and what not."[4] In the late 1920s and early 1930s, Jews were the dominant ethnic group in the sport; there were twenty-seven Jewish world champions between 1910 and 1940, among them Benny Leonard, Barney Ross, and "Slapsie" Maxie Rosenbloom. The list should also include Max Baer; he

was a heavyweight champion and Hollywood actor who fought with a Star of David on his trunks but, according to some sources, was only passing as a Jew.[5] Throughout the 1920s and 1930s, fully one-third of all professional boxers were Jewish. By 1950, however, Jews had almost no presence in the ring at all, with Italian boxers superseding the Jewish champions by the end of the 1930s. Greater social and cultural integration into the mainstream of American life, economic advancement, and high postwar attendance in postsecondary education meant that boxing was no longer viewed by Jews as a lucrative road out of the ghetto.

As a social historian of boxing, Jeffrey T. Sammons, writes: "The succession had gone from Irish to Jewish and would pass on to Italians, to blacks, and to Latins, a pattern that reflected the acculturation strategies of those ethnic groups located on the lowest rungs of the socioeconomic ladder. As each group moved up, it pulled its youth out of prizefighting and pushed them into more promising and meaningful pursuits."[6] Though Jewish presence in the ring declined rapidly, Jews maintained a significant presence outside the ring through management (Al Weill for Rocky Marciano, Irving Cohen for Rocky Graziano), promotion, match-making, journalism (*New Yorker*'s A. J. Liebling), and publishing (Nat Fleisher with *Ring* magazine), training (Mannie Seamon and Charlie Goldman, respectively Joe Louis's and Marciano's trainers), and sportswear manufacture (Everlast). As Allen Bodner, a historian of Jews in boxing, notes, throughout the 1920s and 1930s neighborhood and championship boxing matches were significant "social and political events" in the life of East Coast Jewish communities.[7] The films with a social conscience in the boxing cycle draw covertly or overtly upon this heritage, building a formula that engages with the wider world of the sport in its various incarnations as live spectacle, as radio entertainment, and later as a key component in television's popularity, as well as linking with more romantically inclined ideas of the sport's role within working-class life and culture.

Numerous films featuring boxing had been made in the 1930s, but they differed significantly from their counterparts in the 1940s and 1950s in that they downplayed or avoided the issue of moral and economic struggle. There is no emphasis on a boxer's ethnicity, and the films tend to eschew a downbeat ending. Boxing movies such as *The Prizefighter and the Lady* (1933), *The Personality Kid* (1934), and *Cain and Mabel* (1936) highlight romantic intrigue, often across class boundaries, and the display of partially naked men provides ample opportunity for the expression of female sexual

desire. None of these elements are absent from the postwar cycle, but they are now contained within a narrative framework that valued social verisimilitude over romance.

Midway through Robert Aldrich's 1955 adaptation of Clifford Odets's *The Big Knife* (1949), friends of the Hollywood movie star Charlie Castle (Jack Palance) gather in the early evening to watch one of his old movies, a fight film made eight or nine years previously, when Charlie still "had a lot of steam." The end of the picture shows Charlie's character recovering from a near knockout to win the fight. Charlie asks Hank, a scriptwriter who has grown disgusted with Hollywood and has plans to return to New York and write "the great American novel," what he thinks of the picture. "I keep wondering what would happen if you lost the big fight," replies Hank. "Uncommercial," responds a cynical Charlie, adding, "Kid thinks he's still writing for Mercury and the Group. It would have turned out to what Uncle Hoff describes as 'disaster.' " Hoff (Rod Steiger) is Charlie's domineering producer. Charlie once had dreams of making socially aware movies and great art, a dream he nurtured in the politically progressive theater of the 1930s (represented by his allusion to the socially committed Mercury and Group Theatres). But now that dream has soured and he is owned by Hoff, body and soul.

Odets's play looks back to the 1930s, from the perspective of a once radical playwright who, at the height of the McCarthy witch hunts, must try to come to terms with the loss of his youthful ideals.[8] Charlie's estranged wife, Marion (Ida Lupino), challenges him to stand up to Hoff. "What do you believe in now?" she asks him. "What do you want?" he answers, and then continues: "The wide-eyed kid I was, nursing a cup of coffee in Walgreens, yelling about the sad state [waving his arms] . . . of whatever. . . . And, anyhow, what is all this arty bunk? You know this industry is capable of turning out good pictures, pictures with guts and meaning." Marion replies: "Sure, sure, we know some of the men who do it, Stevens, Mankiewicz, Kazan, Huston, Wyler, Wilder, Stanley Kramer, but never Stanley Hoff." These filmmakers were the cream of Hollywood's post-witch-hunt liberals, including the ex-Communist Elia Kazan, but unlike Kazan, Charlie does not even have a home within Hollywood's liberal community. As Eric Mottram concludes in his analysis of the play, Charlie eventually "chooses right and is defeated by his own character, becoming the typical hero of the thirties rather than the postwar years—the American failure whose defeat exposes his fundamental decency in a bad time."[9]

Unique to the film adaptation are the boxing movie Charlie starred in and an opening sequence that shows him sparring with a trainer, as the voice-over narration informs the viewer that "Charlie Castle is a man who sold out his dreams, but he can't forget them." These images of boxing link back to Odets's earlier drama *Golden Boy* (1937), a play formed in the hothouse of New Deal politics and first performed by the Group Theatre.[10] *Golden Boy* was made into a film in 1938 (released in 1939), directed by Rouben Mamoulian and starring Barbara Stanwyck and William Holden. It is the story of a young man's tentative and short-lived claim on fame and glory as a boxer. Joe Bonaparte is the son of an Italian immigrant who has grown up in the polyglot world of New York's Lower East Side. His brother is a union organizer, and his brother-in-law is a Jewish cabdriver. His father talks to his best friend, a Jewish store owner, about his dream that Joe will become a concert violinist. There is no money in being a musician, and the modern, fast-moving world is no place for the sensitive male. Joe rejects his father's dream and becomes a boxer. "You could build a city with his ambition," a character says of Joe. Joe wants the high life: "Bury me in good times and silk shirts," he says. Joe is in a hurry to get somewhere, anywhere, as long as it's out of the ghetto: "That's what speed's for, an easy way to live," he says. To achieve his ambition to become "the monarch of the masses," Joe, like Charlie in *The Big Knife*, signs a contract with a manager who provides for his every whim, and in return Joe also gives himself up body and soul.

Boxing provided Odets with an overdetermined masculine story form in which to consider the role of the artist within an exploitative capitalist society. The subject of prizefighting enabled him to couch these bourgeois concerns within a drama that he believed had the potential to reach out to the mass audience that was drawn in the hundreds and thousands to live boxing events in the 1930s. On the other hand, *The Big Knife* was a chronicle of the failure to provide and sustain a socially engaged art for the masses. The preeminent left-wing dramatist of the age, Bertolt Brecht, had also shown some interest in boxing. In 1926 he began production on what was to be an unfinished work called *The Human Fighting-Machine*, a collaboration with the then German middleweight champion Paul Samson-Koerner. Brecht's aesthetic interest in boxing was for its formal properties—the ring as a theatrical space, the "hard seats and bright lights," and an audience "smoking and observing"—rather than, as with Odets, for its thematic potential.[11]

Odets's and Garfield's paths crossed repeatedly during the 1930s and 1940s, but they only once worked together on film, an adaptation of Fannie Hurst's *Humoresque* (1946). When *The Big Knife* opened in New Haven in January 1949, its star was John Garfield. In 1952 he took the lead in the revival of *Golden Boy*; he had been the dramatist's first choice for the role when the play debuted in 1937, though Luther Adler got the part. Garfield was also Columbia's first choice for the lead in its film adaptation of *Golden Boy*, but Warner Bros., who had Garfield under exclusive contract, refused the rival studio's advances.[12] Eighteen months before *The Big Knife*'s debut, *Body and Soul* opened in New York; the film reconfirmed Garfield as a star of the first order. He had earlier portrayed a boxer in *They Made Me a Criminal* (1939), in which his character is framed for murder and goes on the lam, ending up on a ranch in Arizona with the Dead End Kids. It was one performance, among many, that helped establish Garfield's onscreen proletarian persona. The critic for the *New Yorker* took note of his acting: "There is nothing noisy, stagy, or showy about him. One can find hundreds such along Sixth Avenue, spelling out the signs in front of the employment agencies."[13]

The vast majority of the boxing films in the 1940s and 1950s follow the line laid down by *Golden Boy* and portray an urban, proletarian, ethnic culture in which the boxer's aspirations for success are deeply problematic. The films do not represent the boxer's story as a quick and glory-filled route out of the ghetto, the kind suggested by the climatic victory of Charlie Castle's character in the fight film he made for Hoff. Instead, these particular films are concerned with dramatizing defeat. As such they trail *Golden Boy*, which the drama scholar Gabriel Miller has noted "follows the classic tragic formula of an individual's rise to power and subsequent fall, precipitated by the recognition of irreparable error committed in the use of that power; for this he suffers and dies, having exhausted all the possibilities of his life. Odets moves his hero toward an action that causes great suffering, and then by exposing the consequences of the deed reveals to him the true nature of his ambition."[14] Along with John Lahr's claim that Odets "pitted American optimism, which was grounded in the myth of abundance, against the demoralized resignation that came with the fact of scarcity,"[15] Miller's description of *Golden Boy* can also stand for the best-known film in the cycle, *Body and Soul*. But it is also an apt description for a little-known King Bros. feature called *The Ring* (1952), directed by Kurt Neumann, with a script by Irving Shulman based on his

novel *The Square Trap*. Shulman had achieved public recognition following the publication of *The Amboy Dukes*, an early postwar tale of juvenile delinquency that was adapted for film as *City across the River* (1949). He later coscripted *Rebel without a Cause* (1955).

The social, racial, and ethnic dynamics of the boxing story are particularly explicit in Shulman's telling. *The Ring* replaces *Body and Soul*'s New York Jewish ghetto with Olvera Street, a little bit of Old Mexico forgotten by time and surrounded by modern Los Angeles. Residents make their living touting for tourist money and in unskilled labor. The young underemployed Latinos kill time in their clubhouse, listening to worn-out phonograph records. Bullied by the local police force, excluded due to his race from a skating rink, and indignant that his father has been laid off work by his "Anglo" bosses, Tommy socks two Anglos who insult his girlfriend (Rita Moreno). Tommy is played by Lalo Rios, who had a featured part in Joseph Losey's *The Lawless* (1950). A boxing manager, Pete Genusa (Gerald Mohr), witnesses the scuffle and tells Tommy he has potential as a prizefighter. Genusa explains that a career in the ring is "the quickest way to get

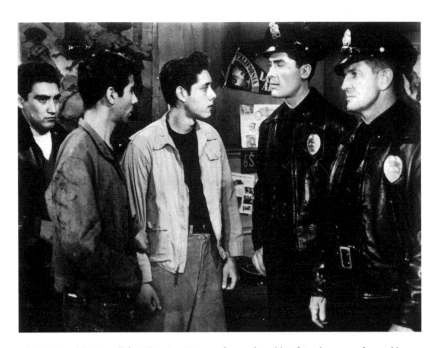

FIGURE 1 Publicity still for *The Ring*. Tommy (center) and his friends are confronted by the police in their clubhouse.

someplace, be somebody—better than any Anglo; better than any Anglo you can lick!" Tommy trains hard and wins his first few fights, becoming a hero to his younger brother and the local gang members. His father, however, is disgusted with his chosen profession, but with no other money coming into the home his position of authority is undermined. As his wife explains, boxing is "dangerous, not dishonest . . . so we will pray for him."

In the novel, Shulman describes how watching John Garfield in *Body and Soul* had fueled Tommy's dream. Tommy reasons that "stories and movies aren't made up, but come from real life; he had to become champion."[16] The novelist's ploy of bringing the conventions of the boxing story to the fore in *The Square Trap* directs the reader's attention to how ill-founded Tommy's dream is and toward a recognition of the impossibility of succeeding in such a corrupt racket. But Shulman also acknowledges the seductive power of the dream of becoming somebody like Garfield's fictional fighter or Art Aragon, a popular Latino fighter who is given a cameo in *The Ring*. Hope for a better future is hard to come by in an environment where the racial and economic indignities Tommy, his family, and friends have to suffer determine their social reality; boxing, despite all the evidence to the contrary, offers at least the possibility of making something of yourself.

Like Joe Bonaparte in *Golden Boy*, Tommy in film and novel wants it all and he wants it fast. Chasing after a bigger bankroll, Tommy forces his manager to get him fights for which he is ill prepared. He loses the bouts and his little star fizzles out. He never achieves the dream. Bruised and battered, but back with his family and friends, Tommy has learned a cruel but necessary lesson: that struggle to better oneself is important, but not if it costs self-respect. Tommy never makes it out of the lower reaches on the fight card; he never gets star billing. In defeat, the more illustrious protagonists of *Golden Boy* and *Body and Soul* are compensated by their realization that their worth can be measured by their relationship with the community in which they were first formed. On the other hand, at the end of the novel Tommy has nothing but a damaged face and a ripped spleen. He has no job, no prospects, no hope. Shulman reveals the dream to be utterly compromised, a horrible illusion:

When he starts he has hope. Later he hopes for hope. In the end he prays for hope.

But he doesn't have the things people think he has. Because he is caught in a square trap—the ring.[17]

The film version, however, ends on a relatively upbeat note, with Tommy burning his fight gear and protecting his little brother from following the same false dreams. Tommy is characterized as an exploited laborer, and his eventual recognition of his plight is perceived as the equivalent of a political awakening. He rejects the empty promise that Genusa had held out to him, that boxing would make him somebody, better than any Anglo, and symbolically realigns himself with his father. When explaining to his family why he had lost his job, Tommy's father gave the excuse that when an "Anglo becomes old he is promoted to a boss; when a Mexican becomes old he is laid off." His father's sense of injustice and recognition of Tommy's exploitation are further underscored in the novel: boxing, he says, is an "American sport . . . an Anglo sport. They love to see people beaten because they enjoy beating people."[18] The message of the film and the novel is that whatever promises boxing offers, it cannot level social, economic, and racial inequality. But this was a message that clearly failed to make an impact on the reviewer for the *Hollywood Reporter*, who panned the film, calling it "a depressing, rather pointless harangue on American discrimination against its Mexican minority group," and suggested it would only be of interest to "East Los Angeles, the Mexican-American population and those who love films depicting minorities as abused in America."[19] When Tommy gives up boxing at the end of *The Ring* it is not clear what new career path is open to him: only the vagaries of unskilled labor appear as an option. The strength of both novel and screenplay is that Shulman refuses to pretend it could be otherwise. Other films in the cycle, however, are concerned to show a world that exists outside of the ghetto, in particular a world of culture and education.

In his screenplay for *Humoresque*, Odets returned to ground previously examined in *Golden Boy*, though this time refined culture prevails over the fistic arts. Garfield plays a musically talented Lower East Side kid who, with the patronage of a wealthy woman (Joan Crawford), escapes from the New York ghetto. Early in the game of social advancement, a woman at a party held by his patron approaches the young violin virtuoso. She looks him over before asking: "Are you a prizefighter? You look just like a prizefighter." The linking of violinist with pugilist in *Humoresque* was not only a reflection upon Odets's play *Golden Boy* and a comment on Garfield's persona; it was also yet another contraction between artist and boxer.

In the 1940 film adaptation of Aben Kandel's 1936 novel *City for Conquest*, New York's Jewish ghetto is refashioned as Irish, with James Cagney

as a trucker who becomes a prizefighter to get enough money to support his brother's ambition to compose and conduct a symphony. The symphony is inspired by the city of New York in "all its proud passionate beauty and all its sordid ugliness." In *Kid Monk Baroni*, with a script by Kandel, the boxer sings and listens to choral music. In *Champion* the artist is a beautiful female sculptor who takes Midge Kelly on a tour of a museum filled with Greek statues and then poses, objectifies, and seduces the prizefighter. The clay statuette she makes of Kelly underscores his manager's description of him as a golem. (The idea of Kirk Douglas, born Issur Danielovitch, playing Midge Kelly, an Irish American, as a golem, a Jewish monster, complicates the question of ethnicity, suggesting, as with *City for Conquest*, an easy slippage across ethnicities in the boxing films of this period.[20]) In *Body and Soul*, Charley's girlfriend goes to art school, quotes William Blake, and lives with a "surrealist" sculptor who uses boxers and longshoremen as models.[21] The roommate of Charley's girl has some choice chat-up lines, which clearly evoke her sexual desire for strong proletarian men, and a way of running her fingers up, down, and around phallic sculpture. And in *Whiplash* the boxer is a painter. The contrivance that brings artist and fighter together is to the benefit of the artist. The novelist Joyce Carol Oates in her rumination on boxing noted "that the artist senses some kinship, however oblique and one-sided, with the professional boxer."[22]

The journalist A. J. Liebling takes the idea one step further: "A boxer, like a writer, must stand alone." And he finishes his book on the "sweet science" by noting how one boxing commentator had compared Rocky Kansas's style to Gertrude Stein, *Les Six*, and nonrepresentational painting, all of them novelties that irritated him, while Kansas's opponent, Benny Leonard, reminded him of the classic verities. When Leonard floored Kansas with an "entirely orthodox blow to the conventional point of the jaw," it confirmed "the old masters did know something. There is still a kick in style, and tradition carries a nasty wallop." Boxing as a forum for debates on art and modernism was a little rarified even for the most erudite of the fistic art's followers, and Liebling preferred to fall back on the American classic *Moby-Dick*, linking Ahab and the white whale to Archie Moore and Rocky Marciano in his account of their bout that begat his ruminations on the sweet science and the fine arts.[23]

In his journalism and his fiction, W. C. Heinz constantly made links between art and boxing; the idea that trainers mold their fighters the way a master sculptor shapes his clay particularly appealed to him, though he

gave too much agency to the boxer to think of him as a golem. In his classic boxing novel *The Professional* (1958), Heinz writes: "When the bell rang I watched Doc's kid walk out slowly and then start to circle, his hands low, looking out the tops of his eyes, and there was no question about it. He was Doc's fighter. It is what a painter does in his paintings so that you would know them, even without his signature, and what a writer does in his writings, if he is enough of a writer, so you know that no one in the whole world but he could have been the writer."[24] Elsewhere Heinz has written that "boxing divorced from danger is devoid of excitement and the emotion that is, of course, the quintessence of the art." This is an image that he linked to a quote from Rainer Maria Rilke, who wrote: "Works of art are indeed always products of having-been-in-danger, of having-gone-to-the-very-end in an experience, to where man can go no further."[25] In cases such as these, the imagined correspondence between the artist and the boxer is not particularly oblique.

Screenwriters and playwrights like Odets, Polonsky, and Shulman may have been responding to boxing as a particular social facet of ethnic urban life, but they were also drawing analogies between themselves as artists involved in "dangerous and adventurous" occupations and the boxer. This analogy helped shore up their sense of self-worth in terms of class, ethnic, and masculine attributes that their actual position as intellectuals otherwise militated against. In his impressionistic history of Jewish gangsters, *Tough Jews*, Rich Cohen considers how and why his father's generation, which came of age during the Second World War, made folk heroes out of thugs and killers like Meyer Lansky, Louis "Lepke" Buchalter, Buggsy Goldstein, Abe "Kid Twist" Reles, Dutch Schultz, and Bugsy Siegel: "They were always on the look-out for someone other than their father, a destiny other than the domestic one they saw at home."[26] For Odets and his cohort, Jewish boxers offered a more legitimate figure with which to counter the stereotype of the effeminate, scholarly, artistically inclined Jew.

The cycle of boxing films ran parallel with Rocky Marciano's reign as heavyweight champion and had begun at the end of Joe Louis's extraordinary dominance of the heavyweight class in the immediate pre- and postwar years. It also coincided with Sugar Ray Robinson's supremacy in the postwar welterweight and middleweight classes. Yet apart from black independent productions such as Oscar Micheaux's *The Notorious Elinor Lee* (1940), two films starring Joe Louis—*Spirit of Youth* (1938) and *The Fight Never Ends* (1948)—and the biopic *The Joe Louis Story*, black boxers

took a back seat to the travails of their white counterparts. Secondary roles such as those in *Golden Boy, Body and Soul,* and *The Set-Up,* or cameo appearances for the likes of Joe Louis in *This Is the Army* (1943), *The Negro Soldier* (1944), *Joe Palooka, Champ* (1946), and *The Square Jungle,* are the sum of the cycle's engagement with black fighters. Apart from replicating the American film industry's conscious avoidance of representing African Americans, these acts of omission were also dictated by the filmmakers' concern to represent a relatively unproblematic view of urban, ethnic, class, and gender concerns.

In the bid to address issues of individual potency and social cohesion, the socially committed filmmaker marginalized race, with the exception of the Latino protagonists of *The Fighter* and *The Ring.* Nevertheless, the ability to create analogous relationships between art and boxing was widened to suggest a link between the sport and society at large. *Golden Boy's* working title was the rather more all-embracing *American Allegory.* Writing about Ring Lardner's experiments with American vernacular, no less an authority on the centrality of sport in American life and letters than Virginia Woolf noted that "it is no coincidence that the best of Mr Lardner's stories are about games, for one may guess that Mr Lardner's interest in games has solved one of the most difficult problems of the American writer; it has given him a clue, a centre, a meeting place for the diverse activities of people whom a vast continent isolates, whom no tradition controls. Games give him what society gives his English brother."[27]

During the Depression, prizefighting, alongside baseball, was one of the most important sports in forming this social cement. The national radio networks NBC and CBS, which were founded in the late 1920s, in large part consolidated their dominance of the industry by broadcasting sporting contests. "Sports were among the first live events that radio brought into people's homes," writes the radio historian Susan Douglas, noting that "boxing in the Depression assumed special metaphorical power when, out in the streets, real workers were often fighting with real cops or other agents of management over their livelihoods and 'hard times' indeed involved direct physical conflict. Approximately 8,000 professional boxers entered the ring in the 1930s in the hope that this sport would provide their financial deliverance, and nationally broadcast fights helped revitalize the sport." Whether or not Douglas's claim that fights between boxers were linked in the public's mind to the struggles between labor and capital can be sustained, world championship matches, such as that between Joe

Louis and Max Schmeling in 1938, did work to link the nation together. And, according to Douglas, Louis "embodied America's conceits about its national strength, resolve, and ability to come back from defeat. Was America still the world's most vigorous, virile nation, despite the Depression, despite Hitler's conquests?"[28]

Many of the films in the cycle have a shared understanding that the boxing story has its roots in the Great Depression, an idea given visual expression in the opening scenes of *Champion*. While hoboing to California and the promise of a better life, Midge Kelly reveals his prowess as a fighter in railroad boxcars: "We've got our foot on a ladder. We're not hitchhiking anymore, we're riding. No fat guy in a big car is ever gonna make a monkey out of me." One review of *Body and Soul* saw the film as a Depression-era parable: "Here are the gin and tinsel, squalor and sables of the depression era, less daring than when first revealed in *Dead End* or *Golden Boy* but more valid and mature because shown without sentiment or blur."[29] Polonsky sold his story to the film's producers on the idea that

FIGURE 2 Publicity still for *Champion*. Riding the boxcars, Midge Kelly punches his way out of the Depression.

it was about the "Depression, Jews, and the fight game."[30] Though it is not discernible in the film, the shooting script locates, via an automobile's license plate, the film's setting as 1938.[31] Paul Buhle and Dave Wagner, historians of Hollywood's blacklist, argue that even though *Body and Soul* first appeared in 1947, it "could be described as the last film of the 1930s," the "culmination of the Depression generation's struggle to emancipate American dramatic art from the film corporation's control."[32] This is also true of *Champion*, made two years later, symbolized both in independent producer Kramer's behind-the-scenes battle with studio giant RKO and in its initial Depression setting. On its release, however, *Body and Soul's* reviewers did not emphasize the film's links to the 1930s; instead, they highlighted its topicality.

The *Hollywood Reporter* headlined its review "Fight Yarn Gets Rugged Treatment" and followed up with "Enterprise steps out, with a walloping fight film, exposing the vicious rackets still being worked behind the scenes of the boxing game by unscrupulous promoters and greedy managers who allow their boys to fight themselves to death. With newspapers splashing these stories all over their pages, the subject is plenty timely and also box office." *Variety* concurred with the *Reporter*, calling the film as "timely as today's headlines." *Daily Variety* filled in some of the detail concerning its timeliness: "Topical yarn obviously designed to take advantage of the recent New York inquiry into to 'sports fixing,' with an emphasis on some of the crookedness manifested in professional boxing, *Body and Soul* has a somewhat familiar title and a likewise familiar narrative. It's the telling, however, that's different and that's what will sell the film."[33] The trade press reviews that linked the film's temporal location to a contemporary concern with corruption in the fight game do not contradict the reviews and later critiques that stressed continuity with the concerns of the 1930s. The subject of boxing allowed for both versions, facilitating an allegorical reception of the film as an individual's and a community's struggle with the vicissitudes of capitalism and more simply as a melodramatic realization of the world of pugilism.

In supercharged symbolic events such as the 1938 Schmeling-Louis match, it is easy to see boxing, as Sammons does, as "a microcosm of the larger society and, as such, [it] can isolate, magnify, and amplify conditions that are easily lost or difficult to discern in the larger society."[34] On the other hand, boxing, as Joyce Carol Oates argues, "is not a metaphor for life but a unique, closed, self-referential world."[35] It is the artist or social

historian who gives boxing its larger meaning. The films generally strived for social relevance on a local level, rather than on a national scale. It is in terms of their delineation of an urban, proletarian, masculine, and ethnically defined image of the neighborhood that the more politically inspired films in the cycle find their most meaningful resonance.

In his book *Foreigners: The Making of American Literature, 1900–1940*, Marcus Klein creates a rich account of how America in myth and idea was remade at the turn of the century by Eastern European immigrants to the United States, when first- and second-generation Jewish Americans rewrote American culture in their own image. In Michael Gold's *Jews Without Money* (1930), Henry Roth's *Call It Sleep* (1934), and Daniel Fuchs's *Summer in Williamsburg* (1934), Klein traces the theme of conflict "between the old-country Jewish ideals and the powerful, disinheriting America." He reads these stories alongside James T. Farrell's *Studs Lonigan* trilogy and other proletarian novels by Albert Halper and Meyer Levin. In each case, as he notes specifically about *Studs Lonigan*, the "ghetto had served truly to be the basis of a community." The ghetto, Klein argues, whether it was Irish, Italian, black, or Jewish, "could be presented for consideration as a kind of Home Town." He continues:

> It could be celebrated not only in spite of but also because of all of its deprivations and confusions and strangeness. The urban ghetto—chiefly in New York and Chicago—was not the only place in which the new American folk had been created, but it was in fact the usual place. Moreover, to tell the tale of one's youth in the ghetto was to secure several benefits at once. One could pay one's filial respects and thereby assuage guilt. By mythicizing the ghetto, one could further emigrate from it. In addition, one could make a statement and teach a lesson to all of those official Americans who persisted in thinking that they owned the country. And altogether one could say that here, too, was a genuine and informative typicality of the true America.

The writers Klein discusses "were engaged in making cultural assertion from utterly dubious cultural materials. In all of their instances the underlying truth of the ghetto was the dissolution of the ghetto—which, because America, too, was a dubious material, was not the same thing as a process of Americanization."[36] The more socially conscious films in the cycle of boxing movies also drew upon a nostalgic evocation of the ghetto as a formative environment and as a superior moral space. The candy stores,

diners, grocers, dance halls, tenement buildings, and milling street scenes all attested to a vital life experience, while the homosocial spaces of the barber shop, the pool room, the saloon, and the boxing gym underscored ghetto life as authentically masculine.

In films such as *Body and Soul* and *Golden Boy* the images of the ghetto society of the Lower East Side echo the street life represented in films of the early sound period, notably King Vidor's *Street Scene* (1931), with its rich portrayal of a polyglot New York. In this film the boundaries between public and private space are effaced by the social and romantic commingling that takes place on tenement steps. Where the boxing film differs from its earlier ghetto counterparts is in its masculinization of street life and emphasis on the homosocial spaces of the gym or pool hall. Consequently, the boxing movie shares something of the tough-boy vernacular displayed in a film like *The Public Enemy* (1931), where the city streets are a school for tomorrow's hoodlums and racketeers. In films such as *The Set-Up* and *The Street with No Name*, films that otherwise have very little to say about the ethnic makeup of America's inner cities, the working-class or underclass environment and the masculine aspects of street life are nevertheless thoroughly highlighted.

The Set-Up's director was Robert Wise, who had learned his trade in the Val Lewton production unit at RKO. In his boxing movie Wise replays one of the unit's most famous tropes, as seen in *Cat People* (1942) and *The Leopard Man* (1943), of the lonely, vulnerable heroine walking through the nightmarish nocturnal city. Estranged from his wife, Julie, the aging boxer Stoker Thompson (Robert Ryan) is preparing for his bout against the newcomer Tiger Nelson. The film cuts backward and forward between him in the changing rooms of the arena and Julie walking the streets outside. The film's mise-en-scène and ambient soundtrack are extraordinarily effective in underscoring her unhappy and uncertain state of mind as she contemplates her husband's choice to carry on boxing, searching vainly for the win that will get him a title shot and enough money to quit the game.

Adjacent to Paradise City, the fight arena, are Dreamland, a dance hall located above a chop suey house, and the Hotel Cozy, where Stoker and Julie are staying. The names of the arena, dance hall, and hotel are lies; the truth is this is skid row in terminal city. Julie's walk begins outside the arena as she listens to the sound of the crowd screaming for blood. Chilled, she turns away and walks past the Coral Ball Room. She is immediately accosted by a man—silk tie, wide lapels, thin mustache, and a flat line in

seduction: "Lonesome?" "Like dancing?" "Want a cigarette?" "Betcha do a nice rumba." Though she dismisses him with a "get lost," his presence is threatening. At a cigar stand she listens to a live broadcast from the arena; thinking it is her husband that is being beaten, she becomes weak and sick. "What's the matter, lady," says the man behind the counter, "too rough for you?" She moves on down the street accompanied by Hawaiian music pouring out of a cocktail bar, then walks past a gang of punk motorcyclists loitering outside a tattoo parlor. A girl's scream cuts twice above the sounds of the street. Inside a penny arcade a young woman's dress is blown above her head by a blast of air from an attraction. She is the screamer. Julie's worried look turns into a smile before reality intrudes once again as a boxing arcade game grabs her attention. Back on the street, hustlers glom suckers for small change, and kissing couples pull themselves into the shadows and doorways. The roar of a motorbike engine is heard, and then the sounds and the neon light of the arcade, dance hall, and bars give way to traffic noise and the sodium glare of headlights as Julie descends some steps before halting to look over the side of a bridge at the cars, buses, and trams howling and churning into the tunnels on the busy road beneath her feet. The sequence finishes with Julie back in her room at the Hotel Cozy, looking through her window onto Paradise City and Dreamland. As she watches, from out of the alley between the arena and the dance hall, her husband staggers into the street and falls into the gutter. The small-time racketeers who paid his manager in the expectation that Stoker would throw the fight, which he wins against all odds, have smashed his right hand.

In its representation of masculine exclusivity, *The Set-Up* revels in a portrayal of low-life losers and strivers, suckers and hucksters, dreamers and fools. A similar hypermasculine image of America's inner-city underclass is shown in the story of FBI undercover operations in *The Street with No Name*, scripted by Harry Kleiner. To bring to justice the perpetrators of a crime wave that has hit Central City, the FBI agent Gene Cordell (Mark Stevens) must infiltrate the city's underworld. Assuming a false identity, he travels to Central City by Greyhound bus. The bus terminal is the first view of the town; the next view is of skid row. To make his presence known, Cordell hangs out on the streets, in bars, and in pool rooms, finally making his play to gain the attention of the mob at the boxing gym where all the local faces gather. Offering so much redundant detail in its catalogue of proletarian masculine spaces gives the film the feel of a travelogue: a guided tour of the "other side" that authenticates this otherwise formulaic police procedural.

Joseph Losey's adaptation of Stanley Ellin's novel *Dreadful Summit*, which was filmed under the title *The Big Night*, with Ellin and Losey fronting for the blacklisted screenwriters Hugo Butler and Ring Lardner Jr., prowls around nocturnal urban spaces similar to *The Street with No Name*. The pulp paperback edition of the novel tagged the story as "Eight savage hours of whiskey and women," but it is in fact a rather sensitive portrayal of a young man's rite of passage.[37] It is an Oedipal tale marked by the teenager's witnessing his father's humiliation at the hands of a sports journalist. Taking his dad's hat, jacket, and gun, the teenager sets out to seek revenge. Over the course of the night he visits bars and taverns and a nightclub, has his first sexual encounter, shoots a man, and watches a boxing match.

The film operates on the rhythm of first proffering the teenager the means to confirm his manhood and then having him come up short when put to the test. He turns to the local druggist to borrow some money to get him to the fights, where he hopes to confront his father's tormentor, but ends up having to earn the money by babysitting. At the fights he is fleeced by a penny-ante chiseler, and, after turning down a drink offered by a fight fan (stoically played by Robert Aldrich), he notices that his father's hat has been stomped; pushing the hat back into shape he misses the fight, which lasts all of forty seconds. Failure follows upon failure. At the Florida Club he becomes inebriated and visualizes his father being beaten to the rhythm of a wild drum solo. The jump blues pumped out by a small black combo segues into a slow vocal and piano number performed by a black torch singer—"too young to be loved" is her lament. Much later, the teenager encounters the singer outside the club. He tells her he thinks she is "the most wonderful singer in the world." To his naive advance she responds with a smile, but then he follows up with "You're so beautiful, even if you're. . . ." His racism breaks the spell, and his journey into the night continues—his encounters stalling rather than propelling him into manhood.

Boxing, then, whether the film dealt with ethnicity or not, helped to authentic a view of the inner city as essentially masculine. At a point in time when this version of the ghetto was being embellished, rising standards of living, particularly among first- and second-generation Jews, and the geographic and economic distance of the authors of the films and novels that documented urban life, meant that ghetto representations were imbued with nostalgia. In his classic volume on boxing, Liebling

wrote about what he considered would be the last great moment in the sport—the last few years of the 1940s and the first years of the 1950s: the end of Joe Louis's reign and the rise of Rocky Marciano and Sugar Ray Robinson. Nostalgic before the fact, Liebling noted that full employ-ment and the late school-leaving age militated against the "development of first rate professional boxers." But the deleterious effect of good eco-nomic conditions was nothing compared to the calamitous impact of television on the sport. Utilized "in the sale of beer and razor blades" (Wednesday night fights were sponsored by Pabst, Friday night fights by Gillette), television networks by "putting on a free boxing show almost every night of the week, have knocked out of business the hun-dreds of small-city and neighborhood boxing clubs where youngsters had a chance to learn their trade and journeymen to mature their skills. . . . Neither advertising agencies nor brewers, and least of all the networks, give a hoot if they push the Sweet Science back into a period of genre painting. When it is in a coma they will find some other way to peddle their peanuts."[38] In his biographical portrait of the former featherweight champion Willie Pep, the sportswriter W. C. Heinz noted how "in those days . . . boxing and Milton Berle sold TVs. Guys who didn't have sets gathered in bars or in homes of others who had sets to watch the fights."[39] Sammons concurs with these journalistic accounts: "When television merged with sport, America's games were changed forever. . . . By 1952 experts reported that the ranks of professional boxers had been depleted by 50 percent and 'town fight nights' had been wiped out."[40]

The first championship match broadcast was between Joe Louis and Billy Conn in 1946, a match watched in the main on television sets located in local bars. The match received over two-thirds of the listening figures for radio, which dwarfed the television rating. Despite low viewing fig-ures, the bout acted as an important word-of-mouth advertisement for the new medium. The 1948 fight between Louis and Jersey Joe Walcott was equally effective in the promotion of television viewing; the Hotel New Yorker reported that 150 rooms equipped with television sets were sold out to guests wishing to view the fight. One year later, a televised fight in New York City was seen in 16,500 bars and restaurants. "By 1952 televised prize-fights reached an average of 5 million homes; the figure rose to 8.5 million in 1955," Sammons notes, and the "new technology transformed prizefight-ing from a closed attraction to a mass spectator sport."[41]

The sport became increasingly commercialized and nationalized. By 1950, boxing was effectively under the monopoly control of the International Boxing Club, which in turn was controlled by Frankie Carbo and organized crime. In the late 1950s and the early 1960s, *Sports Illustrated* campaigned relentlessly against mob control of the fight game, observing that in less than a generation it had gone from "an exciting sport to a perverted racket."[42] When Midge Kelly in *Champion* is wavering over whether to betray his manager and accept the mobster's conditions for a shot at the title, he is told he has a choice to either tear up his old contract or get a "liquor license and a television set." Boxing, organized crime, booze, and television were made for one another.

The popularity of boxing on television inevitably led to drama programs devoted to the sport. In March 1955, *Requiem for a Heavyweight* was broadcast—the first ninety-minute original television drama. A critical and popular success, the Emmy Award–winning show was written by Rod Serling and starred Jack Palance, a role that links back to his parts in *The Big Knife* and as an ex-boxer in *Halls of Montezuma* (1951). *Requiem for a Heavyweight* was remade in 1962 as a feature film starring Anthony Quinn. In recognition of the film's precursor it begins with a slow tracking shot along the bar in a saloon, one close-up of a plug-ugly following after another as they gawk up at an offscreen television set broadcasting a live boxing match. At the end of the tracking shot the scene abruptly cuts to the point of view of a fighter being pounded by the fists of Cassius Clay. Like the neighborhood boxing gyms and arenas in films such as the *The Set-Up*, *The Big Night*, and *The Street with No Name*, this form of mediated, televisual communal consumption of boxing was close to becoming a thing of the past by 1962, another mourned-for homosocial space. Moreover, boxing itself had been superseded in the television ratings game by the rival sports of basketball and football.[43]

Cassius Clay represented the new media-savvy boxer, a fighter who personified the youthful vigor of the Kennedy years, and though he, more than any other fighter before or after, was linked to a wider set of social concerns, boxing was a spent social force. Marciano's biographer makes the argument that he was the last of the great heavyweights at a time when boxing meant something to the American public. Clay/Ali, on the other hand, "was a political and social force that transcended his sport (and all sports for that matter). His individual brilliance and charisma did not restore the

kingdom of heavyweight championship boxing but merely obscured the fact that it had crumbled years before."[44]

In the postwar cycle of boxing movies, Quinn's fighter represented the final appearance of the defeated yet noble prizefighter—the dispossessed son of the 1930s. *Requiem for a Heavyweight* was the last evocation of a nostalgic vision that the cycle of boxing movies had told over and over again:

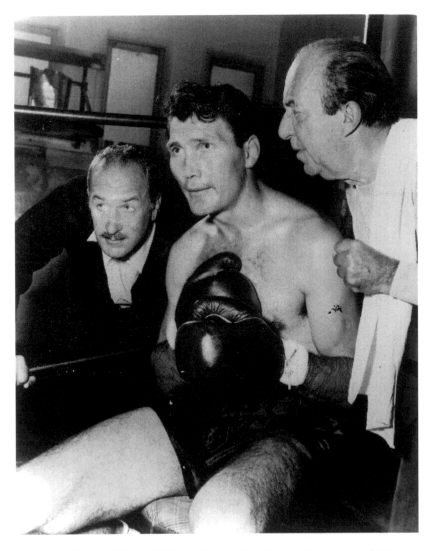

FIGURE 3 Publicity still for the TV drama *Requiem for a Heavyweight*, starring Jack Palance (center).

communal, ethnic, masculine values eroded by the strictures of a domesticated, feminized, private sphere of consumption. Quinn plays an aging boxer who has fought too many fights. After his final bout his face looks like fresh chopped meat. A doctor revokes his boxing license, and the old pugilist is forced to look for a new career. A monarch for the masses was nowhere to be found.

2

War Fever

• • • • • • • • • • • • • • • • • • • •

Korea—Timely! Powerful!
Exploitable!

Korea was of the moment. The war itself would be the subject of films
from the time hostilities broke out in June 1950 and would remain a topic
of interest for producers and audiences after its end in July 1953. This
chapter looks at how the industry responded to the hostilities and con-
siders two interrelated cycles—combat and home front movies. In the
World War II domestic drama, civilians were shown as having an essential
role in the war effort, but the Korean War had little immediate impact on
home life unless family members were serving in the armed forces. For
many Americans the war's meaning was obscure or uncertain, and the
films in the cycle work hard to address doubt or any misapprehension
about why America was again at war. Fritz Lang's *Human Desire* (1954)
is an exemplar of how incomprehension and ambivalence filter the way
the war was understood; hence, I open it up to extended analysis. Oth-
erwise, this chapter concerns itself with commonplace elements that are
shared across the cycle, whether that is film's inability to react quickly to
unfolding events in the public sphere, the repeated theme of sacrifice in a

time of plenitude, the remodeling of existing forms and types to better fit contemporary concerns, or the profuse use of stock footage that at once confirms and negates any claim the films make toward an authenticity.

At the end of World War II, and in recognition of Soviet control of the north and U.S. control of the south, Korea was divided along the thirty-eighth parallel. The uneasy recognition of this state of affairs ended when North Korean forces moved south on June 25, 1950. A Soviet boycott of the United Nations allowed a Security Council resolution to be passed authorizing a collective military response to the incursion. Though twenty countries took part, or offered material support, the United States provided almost 90 percent of the armed forces mustered to resist the Communists. The counteroffensive rapidly pushed the North Korean forces back across the thirty-eighth parallel to near the Yalu River that divides China and Korea. The perceived threat to their border saw the Chinese enter the war, and UN forces were in retreat throughout the long winter months. By Christmas, over a hundred thousand UN military personnel had been evacuated by sea at the port of Hungnam and then carried south to Pusan. At the end of January the UN line was finally held and then stabilized. Having regrouped and reequipped, UN forces were able to push back and by March had retaken Seoul and by the close of May had secured the ground along the thirty-eighth parallel. During the remaining two years of the war, fighting continued while protracted armistice negotiations were under way, but little territory was lost or won. A demilitarized zone along the thirty-eighth parallel was established and holds to this day.

"Pix Biz Spurts with War Fever" was the *Variety* headline of August 9, 1950. Following the news in June that the United Nations would intervene in the Korean conflict, the journal reported on how the film industry was gearing up to exploit public interest in the war: "Circuits throughout the country previously fed up with the cycle of war pix, both new and old, are again showing a revival of interest in the shooting epics because of the Korean situation. Reports from the field indicate that exhibs are convinced that the wide excitement of the public over Korea and its military events is reawakening a taste for battle scenes."[1] Looking across recent cycles of pictures that included "crime, high-budget western, psychological drama, [and] whodunit," *Variety* noted that the latest, "and perhaps most topical," was the "airplane cycle": a group of films that was "tied in with the current situation in Korea" and elsewhere and with the technical development of "particular planes and training of fliers." Republic was leading the way,

"rushing into production *Wings over the South Pacific*," a film that told the story of the B-29 bomber in World War II but attracted "headline interest by showing the fighting power of these planes in the Korean war." Other listed productions from Republic included *The Battle for Korea* and *The Red Menace*. RKO announced three air pictures, including *Flying Leathernecks*, which was also expected to overtly link the last war and the present one; Howard Hughes's *Jet Pilot*; and *High Frontier*, a film about long-range bombers. Twentieth Century–Fox's *Halls of Montezuma* was predicted to carry "plenty of air footage," as would its story of an aeronautical engineer, *No Highway*. The report concludes with a note on Universal-International's production *Aviation Cadet*, which "deals with [the] training of fliers for air corps, but [the] script will be revised slightly to bring in mention, at least, of Korea. This rolls late next month."[2] The register of film titles also recorded a hike in war-themed pictures (and science fiction movies, another iteration of the period's fascination with technological innovation).[3]

As the war took hold of the public's imagination, the film industry exploited this interest by refitting existing movies to better align them with events. World War II films are repositioned to make capital out of a perceived renewed enthusiasm for war movies, or are retooled so the films themselves, perhaps through an introduction over a stills montage, make a direct link with the conflict in Korea. Documentaries are refigured with added material that also develops this correspondence, as happened with Paramount's *Cassino to Korea*, which opened in October 1950, and the technologies of warfare, particularly as represented by the "airplane cycle," are given an added appeal by their predicted role in the present conflict. The retrofitting of film product to meet the demands of topicality is driven in part by the length of time it takes to produce a movie that is responding to news and current affairs. Comic book publishers, for example, would have stories dealing with the topic out on the streets within weeks of America's involvement, but Hollywood's first two combat movies that covered the war would not appear until six months after the start of hostilities, in January 1951.

In July 1950, *Variety* had reported that the war in Korea was a feature in producers' plans. By the year's end, it was verifying this by noting that there were "8 War Pix among Top 50 Grossers."[4] Those films were all set during World War II, but their box office success was felt to bode well for the imminent arrival of a slew of Korean-themed films that were being led by Lippert Pictures' *The Steel Helmet*, directed by Samuel Fuller, and the Eagle-Lion–distributed Walter Shenson production *Korea Patrol*.

Prerelease publicity for *The Steel Helmet* announced that it was "Timely! Powerful! Exploitable!"—and ready for January exhibition.[5] Review screenings in Hollywood were held on December 27, a day after those for *Korea Patrol.* Though both were independent productions, *Patrol* at fifty-nine minutes running time was designed for the bottom of a double bill and described by *Variety* as an "okay exploitation feature on opening of the Korean War . . . and as another in the cycle of films upcoming on Korean fighting." If the review of this first feature film devoted wholly to the war was fairly matter-of-fact, emphasizing what the picture would and wouldn't do for exhibitors, the journal's review in the same issue of Fuller's movie, which had a running time of eighty-four minutes, was by contrast highly laudatory: "a sure money film . . . a grim, hardhitting tale that is excellently told." It also emphasized the film's topicality: "Timely exploitation values are supplied in a story that makes no bid for obvious sensationalism but has it." The review notes, too, how the film, on the heels of *Battleground* (1949), *Halls of Montezuma* (1950), and others, "follows the current vogue of concentrating on the personal involvement of a small group, rather than encompassing whole armies at war."[6]

Showing executed American prisoners of war enhanced *The Steel Helmet*'s exploitation of its timely sensationalism, such war crimes having become public knowledge in the late summer of 1950. These news reports were often illustrated with photographs of GIs shot in the head and with hands tied behind their backs, which Fuller replicates in the film's opening sequence. More directly he drew upon a short article in the September 4, 1950, issue of *Life*, which details the miraculous escape of Cpl. Roy L. Day Jr., one of only five to survive from a group of thirty-one men of the 1st Cavalry Division captured by North Koreans and gunned down when American troops approached. Accompanying pictures of the aftermath of the massacre, the story highlights the role of chance in a soldier's survival: "Unaccountable things happen on a battlefield. A rifle bullet smacks a soldier's dog tag and glances off. Another pierces a man's helmet, spins around inside of it and spits out the front harmlessly. A grenade drops in someone's lap, but it turns out to be a dud. How long can a soldier's luck last?"[7] Fuller takes the detail of the bullet harmlessly spinning around inside a helmet and uses it to explain how Sergeant Zack (Gene Evans) lived through his execution. With typical bravado, Fuller later turns the tables on this scenario by having Zack shoot an unarmed Communist prisoner. The director, the producers, and publicists made a good deal out of this facet of the

film. Initially they played on the news that the War Department had given its approval to depicting this illicit act, thus clearing a path with the Production Code Administration. On January 3, 1951, *Variety* reported that in a "radical departure from tradition the War department has okayed" the scene of the killing, even though it was in "violation of the Geneva Convention rules." A week later it was reporting that the U.S. Department of Defense "denied specifically that it had granted its seal of approval . . . and that they cleared it only insofar as to grant permission for the Signal Corps to furnish footage for background scenes." Furthermore, the "army considers the film in its present version to be unauthentic." Authentic or not, by the following week *Variety* was noting that *The Steel Helmet* was doing "boff" box office in five of Los Angeles' small-seater cinemas and that the downtown United Artists theater was having the best trade in two years with the film.[8] And, despite lack of official approval, the film played on every army and air force base in the continental United States. A War Department spokesmen said: "There is a difference between the army officially not objecting to a motion picture, and the army giving its seal of approval. The army does not censor pictures."[9]

While depicting the war was in itself timely and thus exploitable, and the image of executed American soldiers and the minor controversy over the depiction of the shooting of an unarmed Korean certainly added to the film's appeal, topical elements were also framed in terms of racial representation. In its report on the top grossers of 1950, *Variety* noted the success of the "flock of moneymaking Negro prejudice films" that "threw askew the theory that filmgoers didn't want 'problem' pictures." *Pinky* (1949) had led this cycle, recording fifth place in the previous year's box office listings, but it was strongly suggested that interest in the topic was on the wane, with poor showings for both *Intruder in the Dust* and *No Way Out*. The latter, it noted, "suffered the usual fate of a tail-ender in a cycle."[10] Matching the "problem" picture with the war film, *Home of the Brave* (1949) told the story of a Negro GI. Based on a 1946 drama, the film switches the race of the main protagonist from Jewish to Negro, in part responding to the currency of the emerging cycle of problem pictures discussed by *Variety* and also capitalizing on the 1948 order that the U.S. armed forces be fully integrated. *The Steel Helmet*, like most other Korean War films, acknowledges and exploits the fact of desegregation.

James Edwards played the role of the Negro GI in *Home of the Brave* and would replay that part throughout the 1950s. In 1951, he appeared in

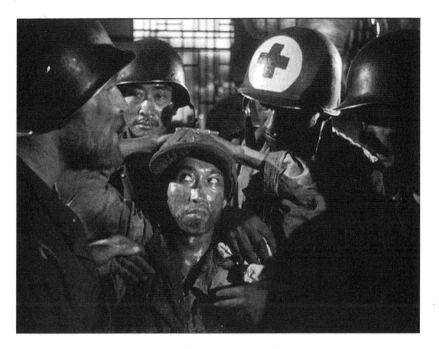

FIGURE 4 Frame grab from *The Steel Helmet*. Harold Fong (center), Richard Loo (center left), and James Edwards (center right) give a face to the faceless.

Steel Helmet and *Bright Victory*, then in 1957 in *Battle Hymn* and *Men in War* and in 1959 in *Pork Chop Hill*. He also appeared as a lame Korean veteran in Kubrick's *The Killing* (1956). The matching of actors to racially defined roles was also noticeable in the casting of Asian Americans. Harold Fong appeared in both *The Steel Helmet* and *Korea Patrol*, and alongside Philip Ahn and Richard Loo would continue to be a regular in such films. As highly visible character actors, these players give the face to the faceless, and they provide, as Will Straw has shown, a social everydayness: "Reduced, much of the time, to fleeting moments or undeveloped functions within films, small players raise the question of social identity in its simplest form—stereotypification."[11] Race as a storyline, however, barely figured in the cycle, though it has a displaced role in *The Glory Brigade* (1953), which features a company of U.S. engineers working alongside Greek soldiers. Prejudice and suspicion of the other have to be overcome in order to defeat the common enemy, just as it was in *Home of the Brave*. The *Hollywood Reporter* noted that the film offered the novelty of the "hitherto

untouched subject of other nationalities in the UN struggle against the reds."[12] The novelty element would fast diminish as subsequent films in the cycle exploited the narrative conceit of conflict between allies, as is seen with the Americans and the British in *Target Zero* (1955), which *Variety* characterized as a "regulation war-action programmer."[13]

Alluding to desegregation (or even its displacement) provides a link between film and its wider contexts, small compensation, perhaps, for the fact that as a topical medium film is a tardy respondent to unfolding events. The delay between occurrence and representation is exemplified by the fact that the most significant episode of the war during the autumn of 1950 was the UN retreat following the intervention of Chinese troops at the end of October 1950, which was when Fuller's film was in production. Those momentous events would provide the context into which the film was released and to which it could only allude at its conclusion with the imposition, over the final image, of the line "There is no end to this story." That is to say, events in this war are still ongoing and inconclusive. Representation of the winter months of 1950 and 1951 would became the topic of Fuller's next film, *Fixed Bayonets!*, which was produced in the summer of 1951 and released in December of the same year.

The producer John Houseman calculated that making an A picture within the Hollywood studio system during the 1940s usually took twelve to eighteen months:

> The average writing time for an adaptation was around five months; for an original rather more. After that, there was a period of gestation to allow everybody to criticize and tamper with the script; this created the need for revisions which took another three months. Then came casting. And while we had not yet reached the fantastic level of titanic negotiations that came later (as the business began to fall apart), it often took three or four months to find the right actors for a picture. Finally, a director having been chosen and having almost certainly demanded rewrites which might take another eight to fifteen weeks, production would start. The average shooting schedule for an A-picture was between seven and twelve weeks, and editing and scoring took another three to four months after that.[14]

With independent productions in the 1950s that timescale was clearly shortened, but not significantly. Low-budget film companies did not have to deal with marquee stars, the finessing of scripts, long shooting schedules,

and a lengthy period in postproduction, which in good part explains why Lippert and Shenson were the first producers to deliver combat pictures.

In commentary on the cycle, the trade press showed it was fully conscious of the contradiction produced in the pursuit of topicality through a medium that was inevitably going to be six months or more removed from the contemporary events it was purporting to represent. Helping to deflect attention away from the idea that film lacks immediacy in responding to events, and an element common to all combat films of the period, was a disproportionate use of stock footage, which suggested through extended montage sequences that the movies in the cycle had an affinity with the newsreel. However superficially, the incorporation of actuality into a fiction film provides an illusion of topicality that helps close the gap between the event and its depiction. Though stock footage can blur awareness of a film's fictive status and its lack of immediacy in reporting current affairs, the fact that it is formally marked through being mismatched with studio footage highlights its presence, drawing notice to the idea that it is imported, and thus revealing rather than concealing the fiction. The integration of library footage gives the appearance of proximity and immediacy that partly ameliorates the fact that when dealing with unfolding events films work best with generalities and universals; otherwise the depicted action is at risk of appearing anachronistic and thereby undermining a film's topical appeal.

Variety, which regularly reported on the use of stock footage in its reviews of war films, praised *The Steel Helmet* for its economy with library material, noting "only minor use of actual combat footage in the picture." By contrast, at the end of its review of *Korea Patrol* it criticized the film because the "clips do not always match the photography of Elmer Dyer." The enthusiastic use of mismatched film of combat action sequences and views of military materiel and maneuvers is notable regardless of a film's cost, but low-budget independent productions such as United States Pictures' *Retreat, Hell!* (1952), Ivan Tors's *Battle Taxi* (1955), and Viscount's *Tank Battalion* (1958) are particularly egregious in its use. Because buying library footage was relatively cheap, small-scale productions could be padded out. "Will you look at that," says an actor in *Retreat, Hell!*, gazing offscreen, and we next see images of air attacks, which are poorly harmonized with the studio action. "Wow, there's a fight I'd like to get into," says another actor in *Tank Battalion* as he peers through a periscope, whereupon we are shown stock footage masked to widescreen to suggest his point of view.

Stock footage quickly became a convention within the cycle, recognizable in the degraded images of Communist troops, usually on the march or lobbing mortars, or through poorly matched film stock and confused moments of screen direction. As *Variety* noted in its review of *Battle Taxi*: "The finished product emerges as a lower-case programmer at most, with stock footage used liberally and in some instances not fitted in smoothly. Overall result is a picture of limited conviction, the story being of no help."[15] The sequences sourced from film libraries account for a good third of the film, which mixes newsreel of Communist troops with aerial shots of strafing, bombing, and napalm attacks, and copious footage of American jet fighters. This material is intercut with static scenes shot either inside a tent that functions as the command center for air rescue or inside the cockpit of a helicopter. The disproportionate use of stock shots is compounded when a good five minutes of this short film (eighty minutes) is given over to an illustrated lecture on air-sea rescue, which incorporates a sequence from a projected 16 mm film.

Battle Flame (1959), a late entry in the cycle from Allied Artists, though produced nearly four years after *Battle Taxi*, was described by *Variety* in almost identical terms as clichéd, rambling, and "just another programmer . . . interlaced with nondescript stock war footage."[16] Some lessons had been learned in the interim, however, such as better matching studio footage with acquired film by means of the copious use of smoke or half-light in the staged shots, helping take the edge off the sharp disjunction between grainy newsreel and overbright studio scenes. Nevertheless, *Battle Flame* still used standard means to incorporate the footage, such as showing marines looking through binoculars and then cutting to the library shots.

The actual production of stock footage is the subject of *Battle Zone*, a 1952 Allied Artists release, which features the U.S. Marine Corps Motion Picture Production Unit. John Hodiak and Stephen McNally play World War II veteran combat cameramen brought back together by the action in Korea. A large portion of the film is set in Camp Pendleton, the major marine base in California, where we watch raw recruits trained to be photographers and filmmakers. Like *Battle Taxi*, the movie features a sequence that incorporates the screening of a 16 mm film. The lecturer explains that the job of the photographic section is not just to get the shots of combat but to undertake routine assignments, such as filming wave formations that will be studied to help plan for sea landings. The dreary images of seascapes are soon forgotten when the talk concludes

with the observation that a "camera is a weapon, just as big guns are weapons." Combat footage is what matters, regardless of the actuality of the work undertaken by the marine film unit.

Battle Zone traces the war from its beginning in the summer of 1950 to the intervention of Chinese troops and the long winter of 1950–1951, with stock footage used to depict the marines embarking in San Diego, a naval bombardment of the Korean coast, an amphibious landing, and the march to Seoul. McNally's and Hodiak's characters, whose point of view through their Bolex cameras the stock footage illustrates, cover these events. The narrative conceit has the intended effect of naturalizing the discontinuity between the library and studio-shot scenes, though the disjunction between the sources remains as perceptible as in any film in the cycle. Nonetheless, *Variety* evidently thought the conceit was a success, noting that the "studio-staged war is well-handled, and the cut-ins of actual combat footage are a good match."[17] Limited production resources that dictate the need for library footage ensure sameness between films, a fact underscored when *Battle Flame* reuses staged —not actuality—scenes shot for combat sequences in *Hold Back the Night* (1956). Chuck Connors is simply

FIGURE 5 Frame grab from *Battle Zone*. Steve McNally shows raw recruits how to turn a movie camera into a weapon of war.

replaced in the later film by Scott Brady, though even when reusing studio-created footage the filmmakers still manage to mangle screen direction.

On rare occasions stock footage can provide novelty—such as scenes of the demolition of Hungnam shot from a departing naval vessel at the end of *Battle Flame*, which are truly impressive and little used elsewhere in the cycle—but repetition, not variation, is key. The excessive, repeated use of stock footage within individual films and across the cycle blurs any distinction its use might once have given; instead it produces uniformity and standardization in representing the conflict, with films becoming increasingly formulaic and predictable. But then distinction is not always a desired attribute, as the following repetition in titling suggests: *Battle Zone* (1952), *Battle Circus* (1953), *Battle Cry* (1955), *Battle Taxi* (1955), *Battle Stations* (1956), *Battle Hell* (1956), *Battle Hymn* (1957), and *Battle Flame* (1959). These are just the war films from 1952 to 1958 that start with "battle"; at least double that number use it as noun or verb elsewhere in the title.

A good number of lower-budget movies also create an inescapable sense of similarity across the cycle by setting static, interior scenes with long dialogue exchanges under canvas. *Hold Back the Night*, *Battle Taxi*, and *Battle Flame* all have lengthy and numerous sequences staged inside a tent, which, with the undistinguished stock footage that precedes and follows these moments of dreary exposition, further dissolves a film's individuality. If the staging of interiors is repetitive and lacking in distinction, then so are the outdoor settings.

Generally the cycle's exteriors were filmed in the Lone Pine region of the Sierra Nevada in California, a setting already overly familiar through its use in a multitude of westerns. *Hold Back the Night* tacitly admits as much when Mongolian cavalry—"Chinese Comanche"—undertake an attack; "What next in this crazy war," says the lieutenant. The Korean War film becomes a western or the western is reimagined as a Korean War film.[18] Either way, repetition cleaves to variation. Such in-jokes ("Chinese Comanche" in the hills of Lone Pine) add to the panoply of self-reflexive moments—linking with other types of self-referencing, including formal play with the film's means of production, casting, narrative formulae, familiar and recurring settings, repetitive titling, and the prolific use of library footage—that afford a sometimes obtuse and sometimes conscious articulation of the cycle as a provider of regular novelties.

Strip away the topical from a film such as *Battle Circus* (1953), take out the stock footage of aerial combat, the individual acts of heroism, and the

moments of exegesis devoted to the logistics of warfare (most notably the sequences of making and striking camp so a mobile hospital can keep pace with the front line), and the film is revealed as utterly formulaic: a hospital drama, complete with doctor/nurse romance, with Korea as the added novelty As if to underline this fact, the film closes with an image of the romantic couple silhouetted against a Korean night sky. Topicality—Korea—gives a generic, enduring story currency and novelty. This theme of timelessness and timeliness is introduced in the opening text scrawl: "This is the story of the indomitable human spirit—it takes place in Korea."

Casting is crucial in maintaining correspondence between convention and the topical, as it provides for an added level of verisimilitude, particularly with this cycle's key theme of experienced servicemen returning to active duty, which is given traction by the use of male stars who came of age, or prominence, during the previous war. Glenn Ford, Robert Mitchum, William Holden, and Dana Andrews, for example, all trade in representations of masculine fortitude undiminished in the years since the war's end. In *The Hunters* (1958), Mitchum plays a pilot living on his past reputation as a World War II ace who must prove he can still meet the challenges of combat. The film returns repeatedly to the question of whether, at his age, he still has what it takes. Mitchum's maturity and experience are contrasted with the juvenile high jinks of Robert Wagner's character, whose dialogue, daddy-o, is littered with bebop hipster phrases. The trope of continuity and of youth learning from experienced elders is supported, even determined, by such casting decisions.

Though the star system and authenticity are often at odds, contradictions are alleviated by casting players with a track record commensurate with the generic demands of the story—stardom followed Mitchum on the back of his portrayal of an infantryman in *The Story of G.I. Joe* (1945). Dana Andrews had played a veteran in *The Best Years of Our Lives* that supported his role in *I Want You*, a 1951 domestic Korean War drama. With his numerous portrayals of hard-bitten but vulnerable westerners, and through his roles as an officer under pressure in *Twelve O'Clock High* (1949) and *Only the Valiant* (1951), Gregory Peck was well versed for his part in *Pork Chop Hill*.

In *Pork Chop Hill*, Lt. Joe Clemons (Gregory Peck) confronts a wounded yet gung-ho private, played by the diminutive actor Robert Blake, by asking him "Who do you think you are, Audie Murphy?" The question is meant as a throwaway remark, something to indicate the line between real and fantasy heroics. It would be a trope used repeatedly in

Vietnam War narratives, though John Wayne would substitute for Murphy. The substitution, however, is not exactly seamless, because Wayne did not have a war record, whereas Murphy, who was the most highly decorated soldier of World War II and, by the time *Pork Chop Hill* was released in May 1959, had appeared in twenty-four films, suggested a much more complex alignment of Hollywood and the real.

Produced late in the cycle, *Pork Chop Hill* tests the compact between authenticity and formulaic filmmaking in a highly mannered fashion. Down to just twenty-five men, running low on supplies, refused permission to withdraw, and with the Chinese army readying to attack, Clemons has reason to be pessimistic, but his disposition takes a momentary turn for the better when a young officer appears. Finally, it seems, those in command have recognized the need for reinforcements. The officer is not a warrior; he is a journalist sent to get the story and some pictures of one of the few "successful American actions." He is quickly disabused of his and his commander's mistaken view of the battle. This failed PR attempt, like the line of dialogue about Audie Murphy, works to counter accusations that the filmed drama is a fantasy rather than a factual record, as is relayed in the opening credits: "This is a true story, based on the book by Brig. Gen. S.L.A. Marshall, U.S. Army. In most cases not even the names of the people have been changed." Assertions of authenticity aside, what makes *Pork Chop Hill* interesting in this regard is the highly conscious manner in which it reveals the mechanics of its own production and thereby contradicts the claim it makes to an unmediated truth, or at least toward a generic truth suitable for formulaic filmmaking.

As the American soldiers advance up the hill toward the entrenched Chinese positions, a remarkably clear and undistorted voice of a Communist radio broadcaster is heard, amplified across the battlefield by a set of unseen loudspeakers. The broadcaster calls the present assault pointless and absurd, and stresses the commonalities between American and Chinese soldiers. The scene foregrounds psychological warfare as a novel element of modern conflict, a familiar trope in Cold War films of the period, but in doing so the ambient sounds of battle are displaced, first by the voice of the announcer and then by the music he cues on a phonograph. The artifice of reproduction—microphones, recordings, and amplification—is underscored, producing a marked passage where the formulaic reality of war is made strange and unfamiliar. The codes and rules of generic war films are momentarily suspended.

FIGURE 6 Frame grab from *Bombers B-52*. In need of urgent nighttime maintenance, the fighter plane is lit up by floodlights as if on a stage set—a moment of self-reflection.

Tracking shots up and down the hill and at a ninety-degree axis are made highly visible (as are the crane shots used in the trench sequences); they are numerous and are utilized brazenly. The lighting scheme is similarly bold: as day turns to night, faces are lit from the front (in a break with continuity the defending faces of the Chinese are also illuminated). The camera movements and lighting setups record the steady advance the troops make up the hill; however, their progress is stalled when they reach a band of razor wire stretching across the line of attack. The wire was supposed to have been obliterated in earlier strafing missions. Under darkness and harassed by machine-gun fire, the troops are beginning to cut their way through when, as with the intervention of the broadcast, their activities are disrupted, this time not with sound but by the sudden illumination of the battlefield by a bank of floodlights manned by their allies. The film's artifice is literally highlighted. Caught in the light, the soldiers become even more vulnerable and panicky.

Pork Chop Hill was not alone in its formal acts of self-reflexivity; *Bombers B-52* (1957) constructs a similar scenario around lighting. Urgent night maintenance on a fighter plane demands it be lit up, thus drawing enemy (and audience) attention to its position. With the bank of lights surrounding the aircraft, the scene resembles a highly fabricated setting located on a sound stage, which indeed it is. In such cases, the revealing of the film's means of production (albeit in a manner that does not manifestly violate its ontological status—these are not avant-garde movies) is targeted at the formal elements: sound, lighting, camera movement. Such moments of

FIGURE 7 Frame grab from *Pork Chop Hill* of a cutaway of the model of the hill. The bayonet's tip picks its way along the dark runnels that map the hill's defensive trenches.

self-reflexivity are common to films appearing at the end of a cycle when consciousness on the part of producers and audiences over a film's formulae has become maximized, intensified, and hence readily identifiable. The motor that drives the fiction becomes exposed, its moving, standardized, and interchangeable parts revealed and opened to scrutiny.

To explain and visualize the realities the advancing troops face, the makers of *Pork Chop Hill* resort to yet further articulations of artifice and abstraction to add to their play with light, sound, and camera movement. This is done by cutting away from the scenes of action to a model of the hill in an operations center. After its location is established, the model is shown in isolation through a number of cutaways. A bayonet held by an unseen officer is used as a pointer to indicate the various troop movements that he is describing. With the tip of the bayonet inserted in the model's dark runnels that map the defensive trenches around its summit, these cutaways have an uneasy and disturbing symbolism. The blade appears to be picking at a wound, laying it open, suggesting the bloody traumas inflicted on the bodies of soldiers that (self-)censorship will not allow to be shown and that are certainly not seen by those who command operations.

Like the heightened formal elements, the use of the model draws attention to *Pork Chop Hill*'s representative strategies, which contend with the

taking and the holding of space and the temporal constraints imposed by such a task. For the filmmakers this is both a set of abstract ideas about film form and a concrete framework for the film's diegesis. In the telling of its story, time and space, and their relative value, are determined not by some verifiable measure but by leaders sitting around a negotiating table. Again and again the arbitrariness of the need to hold this hill, for a given length of time, is underscored. The hill may be symbolic to the negotiators, a set of map coordinates, but to those fighting it is real. The film's attempts to depict this contradiction account for its mannered approach to artifice, abstraction, and symbol.

Home-front movies were less inclined to such levels of artfulness. *I Want You* (Goldwyn) was produced in the early months of the summer of 1951 and released just prior to Christmas that same year. The film opens with an aerial view of a midsized Connecticut town. In a voice-over the narrator describes himself as occupying the view of a bird, or a bomber pilot, or an angel, and tells us the time is early summer 1950, "which seems long ago." That long-ago time is just before American involvement in the hostilities in Korea. The film's story is about the effect of that conflict on one family. In the shadow of the recent world war, the Greers have to learn to adjust to a new age of war readiness. Men who were too young to fight in Europe and Asia are now being called up, and reservists with families have to put duty to country first. The film spans summer into fall, from a young woman returning home from college to her boyfriend leaving as a soldier. Structured around arrivals and departures at the train station, *I Want You* emphasizes continuity, with three generations of the Greers having served their country.

Except for a brief interlude when the young recruits are on furlough, *I Want You* is located wholly in the town and concerned solely with the home front, ending with the marriage of a soldier before he is sent overseas. While attempting to be timely with its theme of recent sacrifices and sacrifices yet to be made, the film is careful in not overly fixing links to the present and thereby hasten its obsolescence. Instead it gently forces social and political themes that in the context of the first years of the 1950s might be seen as constant, or at least generally pertinent to broad events in the public sphere; hence the voice-over's ambivalence around whether the time of the story's setting is recent or "long ago." The theme of a lasting commitment and duty to one's country would be relevant throughout the war and would have a significant presence in films made after the cessation of hostilities.

I Want You deals with the war's impact on a community while the conflict was still ongoing; Fritz Lang's *Human Desire* (1954) deals with the figure of the returning veteran soon after the war's end. The armistice was established at the close of July 1953, and the film went into production in December and premiered the following August. The movie opens with an impressive series of traveling and interior shots of a locomotive as it speeds through a landscape composed of natural vistas, industrial environments, small towns, and railroad sidings. Inside the locomotive, its engineers, Alec Simmons and Jeff Warren (played respectively by Edgar Buchanan and Glenn Ford), are shown at ease in their jobs and with each other. The sequence is without dialogue, and over the noise of the engines the two communicate through mime—a cigarette held up by Jeff for a light from Alec's pipe, Alec pointing to nose and pocket watch to confirm they are running to time—and they exchange smiles. Nearly four minutes have elapsed before the first line of dialogue occurs. The wordless acts of communication are a necessity due to the noise inside the locomotive's cabin, but they also suggest an intimacy and friendship between the two men.

Variety's reviewer, however, did not find the film's opening to be impressive; he found it vacuous and considered the lack of narrative exposition irksome: "Fritz Lang, director, goes overboard in his effort to create mood. Long focusing on locomotive speeding and twisting on the rails has obscure value for it is neither entertaining nor essential to the plot."[19] The lengthy introduction is not entirely devoid of meaning, because we learn much about Jeff; he is confident, composed, and assured at his work, and happy to be in another's company. When the locomotive has pulled to a halt, a railroad worker has a short exchange of words with the two engineers:

WORKER: Good to see you, Jeff.
JEFF: Town looks good.
WORKER: Eighty percent better than Korea, I bet.
JEFF: One hundred percent.
WORKER (JOKINGLY): No medals?
JEFF (WITH GOOD HUMOR): They ran out of them.

As Jeff says, things look good, and they look good because he has returned from Korea and is now doing the job he loves alongside fellow workers and friends. He has not returned as a decorated war hero, and, as we learn in the following sequence (reinforced in a subsequent scene), neither was he an

officer. He is an ordinary American worker and ex-soldier. As he walks to the yardmaster's office, fellow railroaders greet him: "How's the soldier?" says one. "How come they didn't make you a general?" says another. All are genial, none are garrulous. They are emotionally reticent, but affable. From the yardmaster we learn that Jeff has been away for three years and forty-three days (a time span that suggests his enlistment refers as much to the war itself as to personal circumstances). The precision and disinterest with which the yardmaster imparts the information affirms he is a bureaucratic functionary, but his parting words, "Welcome home," freely given, suggest he is also glad to see Jeff back at work, back home, and back from Korea.

The returning veteran is warmly received, but there are no formal celebrations, no strings of bunting, no brass band or cheering crowd, no local grandees giving speeches. Jeff's return details his reintegration into the community's social fabric: a quiet homecoming without ceremony. *Variety* was as unimpressed with this sequence as it was with the opening traveling shots. The reviewer queried why the filmmakers would spend so much time and effort communicating the fact that Ford's character was a Korean war veteran: "There's not much point in this, considering that Ford's background has little bearing on the yarn."[20] If these aspects of the film's beginning, which constitute around ten minutes, had little narrative value, why did the filmmakers give so much screen time to showing Jeff at work and place such stress on his backstory as a veteran of Korea? The answer lies in the film's sources and in how its filmmakers wanted it to be received with respect to contemporary social concerns.

Human Desire is an adaptation of Émile Zola's novel *La bête humaine* (*The Human Beast*), published in 1890, though more properly it is a remake of the Jean Renoir movie of that novel made in France in 1938, which starred Jean Gabin (the Columbia producers Jerry Wald and Norman Krasna having purchased the rights from Renoir's producer Raymond Hakim). Lang's version would undergo considerable revisions from its sources, most notably in the moral compass within which the three main protagonists operate. Unlike Gabin's psychopathic character, Jeff Warren is essentially a good man. He is tempted, but he is not finally corrupted. His desire for another man's wife takes him to the edge, but he does not yield to her allure and take the fatal step of killing her husband. Within this scenario, making him a war veteran has the dual function of suggesting he is someone who is capable of killing, indeed has killed, and someone who has integrity, who understands the distinction between fighting for one's

country, which involves killing others in uniform, and murder in order to sate one's own desire. And making Jeff a veteran of the war in Korea, not just any war, makes this scenario topical, which gives the film a proximity to current affairs it would otherwise lack.[21] The film insists that Jeff's being a veteran is important, which is why the *Variety* reviewer paused and then questioned its significance because he could not find reason enough for it in its narrative demands. The reason lay elsewhere.

The specificities of the war in Korea are never alluded to or directly addressed in the film, and the only material objects that link to Jeff's war experience are a kit bag that contains his cap and boots, nonchalantly unpacked and cast aside, and his uniform and a kimono he has brought back from Tokyo for Alec's daughter. Any of these things could have been brought back less than ten years earlier by a veteran of the Pacific theater of war, but then that war is no longer timely and topical. As a current signifier the war in Korea at this point is neither enduring nor especially evanescent, but it is sufficiently contemporary and general to remain salient long enough that any events that might occur while a film was in production would neither invalidate nor contradict its topicality. The filmmakers sought a contemporaneity they thought would resonate with an audience.

Though it has no affective narrative function, having the lead play a Korean veteran is tied to the film's formal and representational strategies: its depiction, in *Variety*'s words, of the "wretched" and "sordid" among the lower orders. In this aspect, *Human Desire* corresponds to the cycle of Italian neorealist films that were then being distributed and exhibited in the States and, given its immediate source, to the French prewar noirs.[22] It is therefore not a coincidence that the film's scriptwriter, Alfred Hayes, had helped write both *Bicycle Thieves* (1948) and *Paisan* (1946). Both neorealism and French noir prioritized the rendering of working-class life, and *Human Desire* replicates this worldview, but it is also very precise in its articulation of a view of proletarian life that is not politicized, as the European films were thought to be, or, more pertinently, the cycle of films with low-order themes made by recently blacklisted filmmakers with presumed Communist sympathies, such as Robert Rossen's *Body and Soul* (1947), Abraham Polonsky's *Force of Evil* (1948), Jules Dassin's *Thieves' Highway* (1949), Cyril Endfield's *Try and Get Me* (1951), and John Berry's *He Ran All the Way* (1951).[23] All these films, even if they have postwar settings, are, in one way or another, held in thrall by the politics of the 1930s and directly influenced by the events of the Great Depression. Though it shares an

interest in the working class, *Human Desire* refuses an easy alignment with the Hollywood left and their "un-American" films, and the film's references to the war in Korea make it resolutely of the present. Unlike Rossen, Polonsky, Dassin, Endfield, and Berry, Lang is not contesting the past or addressing class inequalities. Neither is he concerned with labor exploitation, social unrest, unionization, and ethnic conflict.

What the film documents is a white American working-class culture that is fraternal, mutually supportive, democratic, and patriotic. It is a Cold War view, not a view formed in the ferment of the Depression as is the case with so many boxing movies. The film's representation of working-class life is also gendered and time-specific: the men work—they are in full-time employment—and the women look after the home. The men are good at their jobs: they are highly skilled and efficient, which is why so much time is spent showing them at work on the railroads in the film's opening ten minutes. Talk is limited: the men don't ruminate on and debate what they do; they just act. Lang, as if he were Howard Hawks, pauses over these small moments of masculine endeavor and the men's professional and comradely exchanges. The un-American film, on the other hand, showed workers as unemployed, dispossessed, and emasculated.

The assistant yardmaster, Carl Buckley (Broderick Crawford), however, is careless and unprofessional and is sacked for allowing a load of fresh food to go untended. He lives in a house surrounded by a white picket fence that abuts directly with the railroad sidings—a parody of bourgeois respectability and property ownership. His wife, Vicki (Gloria Grahame), is first seen reclining on a sofa, her leg held high for our contemplation. She pops candy into her mouth while jazz plays loudly on a phonograph. Though never switched on, the television set in the living room further suggests this is a space for those easily distracted by superficial pleasures. It is a childless abode. The jazz and the noise and vibrations from passing trains rattle the house. The contrast with the Simmonses' family-centered home is profound.

Repeatedly, and with some intensity, Jeff studies a ticket-for-two for the railroad's annual dance and frolic. The question that is raised is which girl he will take as his partner. Will it be Vicki Buckley or Alec's daughter, Ellen? His eventual decision will be based on making a choice between competing objects of desire and between competing values. Vicki's indolence and her liking for jazz, television, and candy represent a self-indulgent lifestyle that rejects a work ethic and moral certainty for easy and immediate

gratification. On the other hand, Ellen represents a communal, fraternal, domestic, and democratic way of life based on honest labor and a moral compass that is unquestioned, not least where gender roles are concerned. The choice is between cultures defined as inauthentic (popular music, for example, mediated through technologies of leisure) or authentic (the unmediated pleasures provided by the annual work dance and frolic).

Asked by Ellen what he will do now that he is home, Jeff answers: "All the time I was overseas I figured that if ever I got back to running an engine again, I'd be the happiest guy in the world. Nothing but a lot of fishing, trains, and for excitement, a big night at the movies." "Did you leave something out?" she asks, before providing the answer for him: "A girl! . . . The right girl for the movies." Having been away at war, Jeff has gained enough distance to see what is really important in life: work and leisure. When it comes to romance (and marriage), though, it is the woman who has to act as his interlocutor. It is Ellen who explains to him (and will show him) what going to the movies is truly all about.

This small undemonstrative, self-reflexive moment where the act of cinemagoing is alluded to is echoed in other films that focus on the domestic front. As the camera drops from a bird's-eye view to reveal the town from street level at the beginning of *I Want You*, the first building shown is the local movie theater and the next is the church. The war, the community, and the cinema are also at the heart of *Starlift*, which was released in December 1951, around the same time as *I Want You*. The film is a vehicle for Doris Day and Ruth Roman and conforms to the format of the 1944 *Hollywood Canteen* movie, with servicemen entertained by a cavalcade of movie stars. While on furlough two air force men go to see a movie that stars the ingenue Nell Wayne (Janice Rule), who, as chance would have it, comes from the same small town as Cpl. Rick Williams (Ron Hagerthy). Through the agency of Roman and Day, and with the help of numerous stars, the film conspires to bring together this unlikely but well-matched couple—uniting small-town America with Hollywood while the country prepares for war.

As *Variety* reported, *I Want You* was beholden, if not actually a follow-up, to Goldwyn's 1946 production *The Best Years of Our Lives*, which also starred Dana Andrews.[24] The focus in the latter on recuperation shifts in the former to being prepared for war. War preparedness is now understood as being perpetual and is something that is echoed throughout the cycle. *Battle Circus* (1953), for example, has two military surgeons discussing

this state of affairs: one puts it plainly that he's had enough of the ugliness and stupidity of warfare. "It's a job," replies the other. But it is a job that has no apparent end: "Other jobs get done. We never catch up." Produced late in 1954, a good year after the war's end, and directed by Mark Robson, who also helmed *I Want You*, *The Bridges at Toko-Ri* rehearses an allied theme, and one found in other films in the cycle, such as *Submarine Command* (1951) and *Retreat, Hell!* These films dramatize the conflict between responsibility to family and oneself and duty to brothers in arms and country, as experienced by World War II veterans as they are called on to fight in Korea. *Bridges* ends when the ultimate sacrifice is paid and William Holden's character is killed in action, leaving behind a young widow and two children. The message is that the sacrifice, despite the uncertain resolution of the war, has not been in vain. The very fact that this needs to be stated so unequivocally suggests unease around a truce defined in terms of opposing sides respecting an abstract map reference—the thirty-eighth parallel: neither victory nor defeat but stalemate.

Pork Chop Hill (1959) repeatedly returns to the question of whether it is worth fighting for a line on a map, which it amplifies by focusing on the last major military operation of the war. What was being fought for was a negotiating position more than an actual hill. The battle was an exercise in brinkmanship, and so the sacrifice the soldiers were being asked to make is difficult to comprehend and hard to justify. Dialogue between officers underscores this dilemma: "Is the hill worth it?" an officer asks Clemons, who replies, "Worth what? It hasn't much military value. I doubt if any American would give you a dollar for it. Probably no Chinese would give you two bits. The value changed sometime; sometime when the first man died." At the close of the film and after a few brave men have held out against unbelievable odds, relieved eventually by fresh troops, and before a full account of the loss in lives has been declared, a voice of authority tells viewers that "millions live in freedom today because of what they did."

But that barely pulls the curtain over the image of the war as an absurd play. The war as illogical and meaningless was also the theme of Anthony Mann's *Men in War* (1957), which focuses exclusively on a platoon of troops cut off from its battalion, surrounded by the enemy, and out of radio contact. The arrival of a colonel and his sergeant momentarily promises to relieve their predicament, but the officer is in a catatonic state and remains mute throughout the film. Leadership is compromised, and the objective to take Hill 465 in order to break out of the impasse is random;

the rationale for the war has become obscure. The lieutenant (Robert Ryan) wearily declares toward the film's end: "The battalion doesn't exist, the regiment doesn't exist, command headquarters doesn't exist, the USA doesn't exist—we're the only ones left to fight this war." When the hill is finally taken there are only three men alive. The cost is calculated when the lieutenant reads a list of the dead and the sergeant throws medals over the ridge toward the bodies that litter the hillside. It is a secular litany with benediction—an empty ritual, another abstraction.

The idea that the war was absurd was a position articulated after its end; it was not the dominant line on the conflict, which, as with *The Bridges at Toko-Ri*, was increasingly about the contradictory need for sacrifice in a time of prosperity and abundance. *The McConnell Story* (1955), *Bombers B-52*, and *Battle Hymn* (1957) also express this theme. Their narratives concentrate on the years 1950 through 1956 but incorporate a World War II backstory. *Bombers* belongs to the cycle of movies that celebrate American weapons and firepower, which, perhaps a little obliquely, might also include the westerns *Winchester '73*, *Colt .45* (both 1950), and *Springfield Rifle* (1952). The other two films are biopics; *Battle Hymn* is an adaptation of a bestselling autobiography that tells the story of a World War II fighter pilot who, between wars, became an ordained minister before returning to combat duties in Korea. It is also something of a retelling of Sergeant York's story about how duty to God and country can be resolved—a literal version of the sentiments of "The Battle Hymn of the Republic," performances of which bookend the story and from which the autobiography and film take their title. *The McConnell Story* is based on the life of a triple-ace jet fighter pilot. All three films are essentially domestic dramas.

The McConnell Story makes explicit the theme of sacrifice through the office of Gen. Otto P. Weyland, chief of the Tactical Air Command, USAF, who appears after the opening credits. Weyland tells the audience that the liberties they claim and the lifestyles they enjoy are paid for by the sacrifices his men make every day in defense of the everyday: "These freedoms are yours, you own them outright, they have been paid for by the sacrifices of dedicated men." McConnell's story begins before World War II and ends after Korea, when he is killed flying the new jets needed for an ever-vigilant USAF. In the film's 109 minutes significant time is given to showing off developments in aircraft technology, aerial stunts, and dogfights. It is ostensibly "Mac's" story, and we see him doing exactly what he desires and

what he is good at, but he is not making any sacrifices whatsoever in pursuit of his ambitions. All the losses are borne by his wife, who must repeatedly repress her needs in order to yield to his calling, to the air force, to the country, and to the greater good, even in peacetime. Her compensation is to see her lifestyle transformed from living in run-down rooming houses before World War II, a trailer through the war years, and officer's family quarters during Korea to, eventually, a modern Arizona ranch house with all the latest conveniences and labor-saving devices. She may lose her husband, but she gains a consumerist paradise.

In *Bombers B-52* Karl Malden plays an air force engineer who has to choose between serving his country, even after taking part in Word War II and Korea, and enjoying the benefits paid for by the sacrifices he and others have made. A new age rich in consumer goods beckons, exemplified by his appearances on television quiz shows and the prize money he wins, but in the end these are mere blandishments compared to the meaningful and fulfilling duty found in maintaining the air force's new fleet of B-52s. Like *The McConnell Story*, the film compensates for the men's duty to their calling by providing the women with an extraordinarily lavish lifestyle. The latest lines in consumer goods are all attainable and desirable, it suggests. Beautiful clothes, a suburban home filled to bursting with new furnishings in an abundance of space, and the latest-model automobile are the prizes not for winning a war but for maintaining war preparedness. Technological innovation in aircraft design, in kitchen appliances, and in automobile styling are all displayed and celebrated.

The film depicts a world of middle-class affluence and prosperity, collapsing any distinction between the domestic and the military, between a Cadillac and a bomber, and it is all filmed in sensational WarnerColor and CinemaScope—providing a maximized vision of prodigious acts of consumption on the part of individuals and government. Such expressions of aspiration and desire for material goods are remorselessly exposed and satirized in Richard Hamilton's 1956 pop art poster, "Just what is it that makes today's homes so different, so appealing?" The emphasis placed on distinctiveness in the work's title is a rhetorical device, because Hamilton reveals it to be nothing more than an illusion. His "home," like Korean war movies, recycles stock images. The formal attributes of collage, the cut and paste technique, renders rather than conceals the act of fabrication and reiteration. His picture creates a new context for mass-produced imagery, exposing the fantasy of idealized domestic environments and the only ever

barely hidden truth that such imagery is, in contradiction, just another standardized expression of a consumer's yearning for distinctiveness.

Korean War movies dealt ostensibly with an extraordinary set of events, but repetition across the cycle, most conspicuously in its use of stock footage, effaced difference and produced a uniformity that transformed the particular into the quotidian. The uniqueness of the conflict was folded into everyday life, and in the process the war was remade into a standardized novelty and a suitable subject for formulaic topical filmmaking.

3

Got-to-See

• • • • • • • • • • • • • • • • • • • •

Teenpix and the Social
Problem Picture

In a December 1956 edition of *Variety* a full-page advertisement for a
United Artists–distributed double bill of *The Wild Party* and *Four Boys
and a Gun*—a "Sensational Package"—was sold as "The Shock Stories
Behind the Rock 'n' Roll Generation." *The Wild Party* starred Anthony
Quinn and promised to reveal "The New Sin That Is Sweeping Amer-
ica!" A Louella Parsons quote tagged the film as being as "modern as next
month." With no featured starring roles, *Four Boys and a Gun* carried the
tag line "THESE KIDS ARE GOING STRAIGHT . . . to the electric
chair!" The Quinn vehicle is a kidnap drama; the film it was double-billed
with centers around the question of which of four young hoodlums will
take responsibility for a murder committed during the robbery of a boxing
arena. Neither film has anything to do with rock 'n' roll—the claim was
no more than an expedient exploitation of the latest musical fad, a means
toward hyping the idea that the movies were intimately tied to the here-
and-now. The marketing hangs on the promise of topicality (the stories
behind today's headlines that are "as modern as next month") coupled with

shocking revelations (the new sin), producing a compact of public issues, topicality, sensation, and commercial exploitation, or a compact of the social problem picture and the teenpic.

The social problem film was not a major part of 1930s and 1940s production schedules, but it did have a significant role. As Tino Balio notes, the industry defined itself as a "purveyor of entertainment"; it did not profess to provide an analysis of society or the economy: "Any attempt to do so would have opened the industry to the charge of producing propaganda. Moreover, any proposal to solve a social problem would carry a political liability and fragment the audience." Hollywood, however, was not above the exploitation of the day's headlines provided it could make money without knowingly alienating any part of its audience. As Balio reminds us, Warner Bros. was the past master of this strategy. Darryl F. Zanuck, head of production at the studio until 1933, called these films "headline" pictures, a story type that had "the punch and smash that would entitle it to be a headline on the front page of any successful metropolitan daily."[1]

Key films within this headline picture trend were gangster films, including Warners/First National's *The Doorway to Hell* and *Little Caesar*, both 1930, followed in 1931 by *The Public Enemy* and *The Finger Points*, alongside Fox's *Quick Millions*, Columbia's *The Last Parade*, and MGM's *The Secret Six*, among many others. Criminal life and the justice system were dramatized in *I Am a Fugitive from a Chain Gang* (1932) and in prison movies like *The Big House* (1930), *The Criminal Code* (1931), and *20,000 Years in Sing Sing* (1933), which ran alongside short cycles of pictures exposing shyster lawyers, corrupt politicians, and yellow journalists. The effects of the Depression were represented in films like *Wild Boys of the Road* (1933), *Our Daily Bread* (1934), and *Black Fury* (1935). Slightly later in the decade lynching would be the hot topic in *Fury* (1936) and *They Won't Forget* (1937), and native fascism in *Legion of Terror* (1936) and *Black Legion* (1937). But as memorable as many of these titles undoubtedly are, the films were anything but the norm in Hollywood's production schedules. Their political message was often muted, if not emasculated, by their avoiding an overly complex account of the problem depicted and by their reluctance to point the finger of blame at any recognizable group or sector of society. As Balio writes, the "studio typically sidestepped issues by narrowing the focus of the exposé to a specific case or by resolving problems at the personal level of the protagonist rather than at societal level."[2]

Though they were marginal in terms of production numbers and performance at the box office, Richard Maltby has argued that social problem films were nevertheless important because they enabled Hollywood to make a "claim to cultural integrity . . . by dealing responsibly with issues of political import to American audiences."[3] With the breakup of the vertical integration of the studio system in 1948, the number and importance of social problem films increased.[4]

In an article for the *Motion Picture Herald* in September 1958, one of the key producers of 1950s social problem films, Stanley Kramer, wrote that producing "want-to-see" product was not enough; a film had to offer "something special." It had to have "got-to-see," giving it "that peculiar power or 'electricity' or magnetism that will tear the people away from their television sets or whatever else maybe keeping them from the box office. To define it further: the 'electricity' may be generated by a powerful story, sex, religion, spectacle, or any one of a dozen other items."[5] Part of this embracing of controversial subjects involved the regular headline-grabbing sensation of the moment—the juvenile delinquent. Three films that dealt with this phenomenon have left a lasting impression: *The Wild One* (1953), *Blackboard Jungle* (1955), and *Rebel without a Cause* (1955). Their standing as landmark films owes much to the now iconic casting of Marlon Brando as Johnny, the leader of the Black Rebel Motorcycle Club in *The Wild One*, and James Dean as the disaffected suburban kid in search of a potent father figure in *Rebel*. *Blackboard Jungle* gave center stage to the story of adults trying to contain teenage delinquents in an under-resourced urban school, but in its use of what would become a worldwide hit record—Bill Haley & His Comets' "Rock around the Clock" over the opening and closing title sequences—the film, in retrospect, seems to have been the herald that loudly announced the arrival of rock 'n' roll. Yet, however important these films were and are, they tell only a limited story of how Hollywood producers exploited the figure of the juvenile delinquent and attempted to capture the attention of the newly identified niche market of teenage consumers.

The production history of *Rebel* shows how the film conforms to a set of conventions, even as it stresses its distinctiveness. Its director and project originator, Nicholas Ray, understood his story of a juvenile delinquent to be informed, if only in a negative manner, by prior representations of deviancy among America's youth. Ray explicitly rejected the social rationalizations found in films such as *Dead End* (1937)—youth go bad because of social,

economic, or cultural deprivation. Neither did he want to exploit the sensational angle as the film's chief selling point, as was the case with pictures produced by Ida Lupino's production company, such as the story of teenage pregnancy in *Not Wanted* (1949). The title of his film came from a nonfiction case study of a teenager. Ray disliked its story of a working-class urban psychopath but retained the title because it evoked the French existentialist Albert Camus's *The Rebel*—"I revolt, therefore I am."

Indicative of the commercial imperative that lay behind the project, writers with a proven commercial track record were brought in to work on the script. The bestselling novelist Leon Uris, whose book *Battle Cry* had recently been turned into a financially successful film, undertook the first attempt. When Uris's vision of the film no longer matched Ray's, the novelist Irving Shulman was engaged. He appealed to Ray because he had written the hot book on youth culture gone wrong, *The Amboy Dukes* (1946). At the same time, Ray was concerned that *Rebel* should not overtly repeat tropes found in contemporary depictions of teenagers—not just those in Shulman's work but also those in MGM's imminent adaptation of Evan Hunter's bestseller *The Blackboard Jungle*, which had been published late in 1954. Ray was also concerned with how his film would link with the newspaper and magazine coverage of the delinquency problem. Writing about the evolution of the story, he noted: "'I didn't have any clear idea as yet what I wanted. I only knew that my newspaper clippings and the things I had seen were driving me in a different direction. I was trying to dramatize the position of normal delinquents.'"[6]

Ray was working with and against the sensational material that was circulating freely, while trying to produce a screenplay that rejected the perceived clichés of earlier films dealing with juvenile delinquency and one that would not simply echo contemporary pictures. At the same time he was exploiting the broad interest in deviant youth, he was also trying to create an artistically meritorious and authentic drama. As such the film is both a unique artifact and one example among many of 1950s productions on the topic of juvenile delinquency.

The backdrop to this exploitation of youth was a bid by filmmakers to capture an emerging adolescent audience for films through linking their product to the wider explosion in consumption among that target group. The rock 'n' roll movie, for example, was explicitly tied to the soaring sales of prerecorded music. In January 1958, *Variety* reported that the music industry was gearing up for another year of "rapid growth," confident that

gross sales of records "will hit the $400,000,000 level, continuing the 20–25% annual rate of expansion of the past ten years."[7] This was in strong contrast to dwindling film attendance. During the late 1950s *Variety* ran a series of news items on Hollywood's "lost audience." One such piece was the December 1956 headline article " 'Lost Audience: Grass vs Class'— Sticks Now on 'Hick Pix' Kick," which revealed how acute the problem of declining box office takings had become with a particular exhibition sector.[8] Maltby writes: "Between 1947 and 1963, 48 percent of four-wall theaters closed, at the rate of about two a day. In 1956, of the 19,000 theaters operating in the US, 5,200 were operating at a loss and 5,700 were breaking even; 56 percent were failing to make a profit."[9]

The theaters that closed were mostly small subsequent-run houses. While competing leisure activities were the root cause of the declining audience, the type of product offered by exhibitors nevertheless came up for repeated scrutiny. In answer to the question of what kind of picture was required to "lure the so-called 'lost audience' back to theaters," *Variety* offered the counterintuitive response that the best way to compete against television was not necessarily to play "big, expensive blockbusters and unusual, off-beat films with adult themes that TV could not handle," but to program mass-appeal family fare and action pictures. Though product of this type could be found in "abundance on television," it was precisely such material that some sectors of the exhibition end of the market were demanding. After attending the annual Allied States Association convention, which was dominated by neighborhood, small-town and rural independent exhibitors, *Variety* found there was a marked schism between this constituency and key exhibitors based in large cities over what sort of movie best suited their needs.[10]

One small-town exhibitor explained: "The city boys insist that the day of small, family pictures is over, and it's only the big ones that get folks away from the TV sets. However, in small situations my experience tells me our people are not much attracted by sex themes, boudoir Olympics, swishing deviationists, and sanguinary violence as they are by the corny, light-hearted, pure entertainment type of offering."[11] This was not a new argument, at least in terms of the differing demands of producing films for metropolitan tastes and for the rural and small-town audiences.[12] In other words, old insights were being recycled concerning how Hollywood failed, if not for the want of trying, to produce films with universal appeal for audiences with highly distinct tastes.

But if the film with universal appeal increasingly appeared as an impossible ideal, the sharpened awareness of the importance of teenagers (and their avid consumption of pop music) as a distinct and significant audience was not ignored. In the same *Variety* article another "hick" exhibitor claimed that Hollywood no longer put money into developing young talent and that its present stable of stars were now too old to appeal to a younger audience. Hollywood, he claimed, looked to other media to produce the new stars, and he cited Elvis Presley as a case in point. *Variety* noted that the demand for "teenage pictures" is coming from "all quarters—from small theaters as well as large circuits, from rural towns as well as big cities. The cry to assuage [the] teenage market is so great that many observers are already expressing the fear that the only outlet for the mature films will be the art houses. The key, big city houses, of course, are not abandoning the blockbusters, which have turned out to be their biggest coin makers."[13]

Discussing the aftermath of the 1948 Paramount decision, an antitrust action brought, in part, by independent exhibitors who claimed free trade was infringed by the major studios' policy of enforcing block-booking practices, Maltby writes:

> Starved of product by the majors' policies of phasing out B-features and the medium-budget pictures, faced with competition from television, and deserted because of migration to the new suburbs, the "Mom and Pop" theaters in inner cities, neighborhoods, and rural areas closed in droves, while the majors' now separate production-distribution and exhibition operations remained relatively healthy.[14]

Two weeks after the "Grass vs Class" item, *Variety* headlined with "Teenage Biz vs Repair Bills: Paradox in New 'Best Audience,' " which further complicated the debate over how non-first-run houses could best respond to dwindling customers. The problem was that the new pictures with "built-in teen appeal" tended to attract an unruly crowd; money taken at the box office and concession stand needed to be measured in light of increased vandalism and security costs: "Many theatremen are doing some serious soul-searching and are asking themselves if the 'monster' they've created is a good thing after all. In their appraisal of the situation, their thoughts are somewhat schizoid." The item noted that the profit to be made on teenpix was not spectacular but did surpass the return on "regular product."[15]

In spring 1959, the British film critic and Hollywood émigré Gavin Lambert (who had a small behind-the-scenes role in the production of *Rebel without a Cause*) published extracts from his diary in *Sight & Sound*, a journal he had edited from 1949 to 1955.[16] His notes provide a valuable rumination on the state of Hollywood filmmaking in the mid-to-late 1950s. Lambert claimed there were three distinct modes of production: the blockbuster, the sensational quickie, and the "Desperation Picture." That is, the filmmaker has to "think big, or think in terms of a quick buck," and anything else is "desperation." Lambert expended little time and energy in explaining the blockbuster, which he thought was as "bad as waking up with a hangover. And there is no pleasure to look back on." The "Desperation Picture," he said, cost around a million dollars to produce, was filmed in black-and-white, and was without a top-ten money-making star. His examples included *The Defiant Ones* (1958), starring Sidney Poitier and Tony Curtis, who play two prisoners on the lam learning to work together and overcome racial prejudice; *I Want to Live!* (1958), starring Susan Hayward and based on the true story of a woman sentenced to death for murder; and *God's Little Acre* (1958), adapted from Erskine Caldwell's bestseller, which was "a sensationalized freak show. Eccentricity, squalor, and hot-breath sex have become merely titillating factors, not aspects of human life to be explored and interpreted."

Remarkably, he saved his most favorable critical comments for the sensational quickies—juvenile delinquent pictures, which he thought were a "fairly accurate account of contemporary tribal rites and customs, and the relief of looking at young people instead of old stars pretending to be young. The motives of these pictures are honestly unserious—it's only when they affect moral concern, in fact, that they become boring." He looks at three 1958 pictures, *Hot Car Girl*, *The Cry Baby Killer*, and *The Party Crashers*. The stories are in their titles, but are they exploitative, amoral films as they are so often accused of being? Lambert did not think so: "When they show rebellious violence as something enjoyable and alluring, as well as dangerously compulsive, they are being honest. After all, it's the way the characters get their kicks, and the films describe it, and the consequences. Slice of life films, rather; unclenched and superficial, but with a genuine vitality."[17] The cycle of teenage melodramas Lambert latched on to are, for the most part, updates on the crime movie with imported teenage characters. *The Cry Baby Killer* reworks the hostage scenario that had recent antecedents in *The Dark Past* (1948), *Jeopardy* (1953), and *The Hitch-Hiker* (1953). The producer of *The Cry Baby Killer*, Roger Corman, had already reworked the

scenario a year earlier in *Rock All Night* (1957). Teenagers were also levered into the heist movie with *High School Big Shot* (1959). Three 1958 films, *High-School Confidential!*, *Stakeout on Dope Street*, and *The Cool and the Crazy* exploited the recent notoriety of *The Man with the Golden Arm* (1955) and lifted the theme of drug pushing and addiction into the teenage melodrama. *Hot Car Girl* reflected the cycle's fixation on mobility, car culture, and illicit behavior. But the juvenile delinquent film could also simply exploit its own headline-grabbing potential, as with *The Party Crashers* or *The Delinquents* (1957). The ad for the latter proclaims: "A smashing exposé of today's children of violence."

While teenpix exploited current moral panics, whether related to gang culture, street violence, petty crime, narcotics and alcohol abuse, out-of-marriage sex, hot rods and motorcycles, beatniks, or rock 'n' roll, they also incorporated existing movie forms, such as horror and science fiction, to produce such deliriously titled films as *I Was a Teenage Werewolf* (1957), *Teenage Caveman* (1958), and *Teenagers from Outer Space* (1959), as well as updated genre stalwarts like the western and the gangster film. Like the gangster film, the JD movie had a tendency to pontificate on current social concerns, as articulated in the opening of *The Delinquents*:

> The story you are about to see is about violence and immorality—teenage violence and immorality—children trapped in the half-world between adolescence and maturity, their struggle to understand, their need to be understood. Perhaps in his rapid progression into the material world, man has forgotten the spiritual values which are the moral fiber of a great nation: Decency, Respect, Fair Play. Perhaps he has forgotten to teach his children their responsibility before God and society. The answer may lie in the story of *The Delinquents* in their violent attempt to find a place in society. This film is a cry to a busy world—a protest—a reminder to those who must set an example.

And the film closes with an appeal to "help halt this disease before it cripples our children, before it cripples society."

The Wild One had also been introduced with a stentorian, self-serving foreword: "This is a picture of shocking violence. It couldn't have happened in most American towns . . . but the fact that it happened in this town, and in this way, is a stern warning that it must not happen again." Released in the final week of December 1953, *The Wild One* was based on Frank Rooney's story in the January 1951 issue of *Harper's* magazine, "Cyclists'

Raid," which in turn was based on a 1947 *Life* magazine page devoted to hoodlum motorcyclists running wild in the California town of Hollister.[18] The film's producers had a prolonged series of negotiations with the Production Code Administration (PCA) over how to "tame" the story's more sensational aspects, particularly the degree of violence and lawlessness the filmmakers wished to depict. The PCA reviewers of the first script, and its subsequent drafts, thought that, at base, the story promoted antisocial behavior. The initial report noted:

> The callousness of the young hoodlums in upsetting the normal tenor of the life in a small town, the manner in which they panic the citizens, the ineffectiveness of law and order for the majority of the script, the brawling, drunkenness, vandalism, and irresponsibility of the young men are, in our opinion, all very dangerous elements. They cannot help but suggest to younger members of the audience, it seems to us, the possibilities that lie in their power to get away with hoodlumism, if only they organize into bands.[19]

As was usual, the PCA and the film's producers worked together to downplay the story's more problematic escapades and to emphasize its "affirmative values." By building up the figure of authority, for instance, they hoped to counterbalance the town's hapless law officer; they also ensured that all lawbreakers are seen to receive a just punishment, and that Johnny (Marlon Brando) is not viewed as a hero. In their own support, the producers explained that the film would play a social role in alerting the citizenry to the stark fact that it must confront a "problem which had to be faced by every American community." Nevertheless, the film stirred up controversy on precisely the ground upon which it sought to deflect criticism. Trade press reviews were unanimous in their condemnation of its sensational aspects. The *Hollywood Reporter* noted that its "main appeal would seem to be to those lawless juveniles who may well be inspired to go out and emulate the characters portrayed."[20] *Variety* wrote:

> *The Wild One* is an artistic picture for hoodlums. The real-life counterparts of the leather-jacketed vandals . . . will buy it. City houses that draw on this type of patronage can do business, probably will, although exhibs should bear in mind that this class of audience is credited with cost of the vandalism in theatres. Otherwise, it will be a tough selling job to attract the mature filmgoer who usually buys artistic pix.[21]

Private individuals also corresponded with the PCA to register their dismay at a movie of such "low morals, unadulterated viciousness, disrespect for law and order and complete ridicule of the citizenry of our towns," which would surely have the effect of raising "the percentage of juvenile delinquency at least 5% throughout the nation."[22]

On December 9, 1955, a crowd of around 2,500 students gathered together in Montreal to protest about the rise in tram fares. The protest ended in a riot. The media called the students leather-jacketed hoodlums. The *Michigan Daily* reported that the rioters were "mostly youths and many wearing leather jackets, a garb that has become a symbol of youthful rowdyism here."[23] Montreal's *Gazette* similarly noted the rioters' dress code: "Most of the serious damage was done between about 6:30 P.M. and midnight by gangs of youths, some in black leather jackets associated with teen-age troublemakers but many in ordinary hats and overcoats of good quality."[24] Two years after the release of *The Wild One*, that is, shortly after the riot, the consul general of the United States in Montreal wrote a report on the Quebec Board of Censors' decision to ban the film, which cited the movie as "the stimulus for creating the 'black leather jacket' juvenile gang problem Montreal is currently suffering." He noted that the problem was "minor" compared to that faced in some American cities, most notably New York, and that with little evidence the media had blamed the "Montreal Tram Riot" on youths wearing "leather jackets" as inspired by the movie. Whether this was a concocted moral panic or not, the media quoted a number of sociologists and psychologists who were, observed the consul general, "unanimous in seeing the problem as simply the natural adolescent need to belong and desire to wear the 'uniform' of the time which changes with succeeding generations."[25]

Regardless of whether it was youths in ordinary hats and good-quality coats or those in black leather jackets who were instrumental in causing the riot, the movie's influence on youthful fashion was unquestionable. The black leather jacket, Levi's jeans, and engineer boots, as worn by Brando, became the uniform of choice to express youthful rebellion, most potently evoked in late 1970s punk styling. Its more immediate influence could be seen in the cycle of JD movies that followed. *The Young Savages* (1961) illustrates just how iconographic the black leather jacket had become in defining young hoodlums. The film is set in East Harlem and begins with a scene of Puerto Rican teenagers enjoying ice cones while hanging out on tenement steps. Dressed in dark glasses, a short-sleeved

shirt, and chino pants, one of the teenagers plays the harmonica. The scene is placid, an apparently carefree documentary image of urban street life. The view cuts to a high-angle shot of the side of a building; under the titles and tranquil harmonica music, the camera pans down to reveal gang names among the graffiti and then shifts left as street urchins swing from fire escapes littered with drying laundry.

Bearing down the rubble-strewn alley come three young men in black leather jackets, Levi's, and engineer boots. The music switches to a discordant percussive sound that matches the protagonists' quick march along alley and street—their dress code, and disregard for their surroundings and the people they come into contact with, alongside the music and fast-paced cutting, enunciate a threatening and violent presence clearly at odds with the opening scene on the tenement steps. As the trio pass by men involved in street gambling, children playing, and market traders, viewers are shown the commingling of everyday urban life familiar from such films as Morris Engel's *The Little Fugitive* (1953) or James Agee's *In the Street* (1948). The three teenage thugs continue on toward their target—the Puerto Ricans— and the scene climaxes with switchblades pulled from pockets and the brutal stabbing of the harmonica player, who we later discover was blind. These "young punks," as Assistant DA Hank Bell (Burt Lancaster) says, referring not just to the threesome but to the city's hoodlums in general, have been terrorizing Harlem.

The black leather jacket has become a maximized, intensified, and concentrated part of the movies' iconographical means toward the identification of juvenile delinquency. Complex or nuanced study of character motivation can now be substituted with imagery that is immediate and unambivalent and that promises visual impact. From the terrorizing of Hollister inhabitants to the story told in *Life*, then reworked as fiction in *Harper's* and eventually adapted to the movie, through the Montreal Tram Riots and social problem pix like *Young Savages*, via the fetishistic appropriation of the iconography in the underground classics *Scorpio Rising* (1964) and *Bike Boy* (1967) by Kenneth Anger and Andy Warhol respectively, or through its further exploitation in the late 1960s and early 1970s cycle of biker movies, and its iconic rearticulation with punk—the dialogue about black leather jackets in life, art, movies, journalism, fashion, censorship, and sociology has continued to flow back and forth.[26]

Lawrence Alloway argued in the early 1970s that Americans had a "high tolerance of violence" not because they had grown inured to violent images

FIGURE 8 Frame grab from *The Young Savages*. John Chandler Davis (center) plays the leader of a gang of leather-jacketed punks.

propagated by the movies and other media, but because movies increasingly relayed the idea that there was an association between violence and serious social concerns. He wrote: "Consider two treatments of anti Semitism, both of 1947: one, *Gentlemen's Agreement*, treats the subject in terms of a soap opera about career, the other, *Crossfire*, in terms of a murder mystery culminating with the killer being shot down in the street." With the latter, "social problems and issues are presented in terms of vivid action. As a result, the capacity of violent movies to deal with situations less tranquilizing than the drama of earlier days was enhanced." In these films, violence is not the "athletics of an adventure film but the emblematic expression of current tensions."[27]

The violent "emblematic expression of current tensions" is a major motivating force behind Roger Corman's 1957 production *Teenage Doll*, a film that exploited a contemporary fascination with girl street gangs. Following an animated credit sequence and a foreword, the movie begins when a middle-aged worker in rolled sleeves and apron appears in a doorway that leads to an alley. He is carrying a large bowl of water that he idly throws over the top of a clutter of trashcans. The water slops into the gutter, and the camera follows its passage as it gushes over the dead body of a teenage girl. This single take, which ends with a cutaway to a patrolling police car,

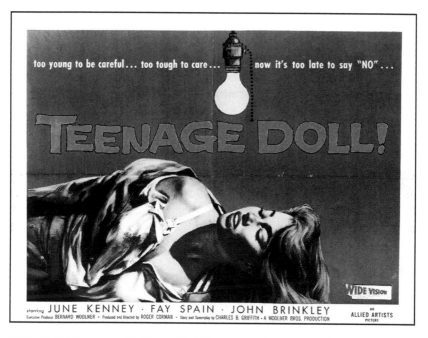

FIGURE 9 Publicity poster for *Teenage Doll.* The image and text suggest the girl has been sexually assaulted.

grabs the viewer's attention. Sensational, melodramatic (the music track peaks in accord with the visual revelation), hard-hitting, and loaded with narrative potential: Who is this girl? What happened? Was she murdered? Was this a sex attack? The latter seems certain given the tattered and torn state of her clothing, particularly after her body is discovered and she is turned over with her undergarments prominently displayed. Tag lines on lobby cards and posters with an illustration of the dead girl lying under a naked electric light bulb would also seem to support this conclusion: "too young to be careful . . . too tough to care . . . now it's too late to say 'NO.' " Despite the warranted supposition that the girl had been sexually assaulted and murdered, she was, we learn, accidentally killed during an argument with another girl. The film's foreword is constructed to enable ambiguous readings, in particular over just what sickness is situated at the heart of society: "This is not a pretty picture. . . . It could not be pretty and still be true. What happens to the girl is unimportant. . . . What happens to the others is more than important; it is the most vital issue of our time. This story is

about a sickness, a spreading epidemic that threatens to destroy our very way of life. We are not doctors . . . we can offer no cure . . . but we know that a cure must be found." The film's trailer also keeps us uncertain about what aspect of teenage life is to be explored, though the emphasis is clearly on the thrill of sex and violence. Scrolling across the opening of the trailer are the words "YOU WILL REMEMBER TEENAGE DOLL." This promise is followed by a voice-over that echoes the first line of the foreword and adds: "Packed with shocking realities of what is happening today. In your city, your town, your neighborhood, thousands of young girls are becoming teenage dolls. . . . Girls who learn the naked facts of life too young, too soon, and the hard way. . . . Hell cats in tight pants, running in packs, hunting down any girl who dares defy their jungle code. . . . Fearing them, girls become captives of teenage hoodlums. Thrill hungry sensation seekers." The trailer concludes with shots of a teenage rumble over which the text scroll announces: "THEY MAKE THE HEADLINES THAT *SHOCK* YOU! THE BRAZEN AND THE BOLD." The promotional emphasis is placed fully on the promise of witnessing illicit and transgressive sexual activities woven into a series of violent escapades. The film's particular appeal to the sensational and the thrilling is figured around contemporary teenage subcultural mores, rituals, and malfeasance.

What gives the film's publicity and its foreword a sense of directness and immediacy is the attraction of the film's topical message (today's problem, today's headline) and the problem's location in your city, your town, your neighborhood. The film's materials personalize the impersonal and individualize the general, while at the same time universalizing the story to be told: "What happens to the girl is unimportant. . . . What happens to the others is more than important; it is the most vital issue of our time." This is all couched within the discourse of exploitation, within the titillating combination of violence and sexual thrills.

The story centers on Barbara Bonney (June Kenney), an eighteen-year-old middle-class girl who has fallen for a young hoodlum, Eddie Rand (John Brinkley), the leader of a neighborhood gang who call themselves the Vandals (the girl gang members call themselves the Vandalettes). Their rivals are the Tarantulas and their sister gang the Black Widows, to whom the dead girl, Nan Baker, belonged. Nan also had an eye for Eddie, and her confrontation with Barbara on the roof above the alley brings about her accidental death. When the leader of the Black Widows, Hel (Fay Spain), finds a clue to Barbara's involvement, she and her gang set out to exact

revenge for what they believe was an act of murder. The plotting of their revenge takes up much of the film's narrative, which moves toward a confrontation between the gangs and a rumble in a junkyard.

The Black Widow membership is made up of five girls, all underprivileged. The background of each girl is introduced in the form of a vignette of her home life. Squirrel is the daughter of Hispanic parents who run a cheap clapboard restaurant. Lori, who has charge of her younger sister, lives in squalor and survives on money sent by their absent father—a career criminal on the lam. May lives with her older sister, who is dating her boss because she is fed up with meatloaf and wants to taste caviar; but the depressing scene of her and May arguing about the affair only works to underscore the impossibility of social mobility—caviar for today maybe, but meatloaf again tomorrow for sure. Hel has a hapless father who is financially dependent on his wife and uses what money she gives him to pay for the services of prostitutes. Finally, Betty is the daughter of a police officer, who lives just above the breadline and has no spare cash that she can steal. The low-rent, low-life world of the film's story is well matched by the limited budget available to Corman and his set dresser, Robert Kinoshita, who places the action of the film in a small number of highly effective sets, which for external scenes include the alley with the trashcans, a wooden flight of steps leading to the rooftop from which Nan fell, the electric power station where the Black Widows plot revenge, a lumber yard, a deserted warehouse, a gas station, and the auto junkyard, interspersed with short scenes shot on actual streets and back alleys. There are single-room internal sets for each of the Black Widows' homes, while Barbara's home is constructed of two large rooms and dressed with good-quality furnishings. The biggest set is reserved for the Vandals' subterranean clubhouse, access to which is gained via a caged service elevator that is raised and lowered by the occupant pulling on a rope.

The only girl in the film who does not wear a jacket sporting gang insignia, and the child of a white-collar father and his housewife, Barbara clearly does not belong to the world of street punks. As Eddie says, her real "crime" was not an involvement in Nan's death but the fact that she had "stepped out of her class." Barbara's mother, a grotesque parody of girlishness with her hair ribbons and braids, had an affair in her teenage years with a hoodlum who had been killed on a liquor run from Canada into the States. The thrill of the old romance is palpable, but so is her desire for security provided by a staid marriage to a dependable but ultimately boring

man. Barbara, it is implied, must also negotiate that choice. Near the close of the film, Eddie surveys the options open to her—she can be arrested for murder, be killed by Hel and her gang, or become a runaway. When Barbara despairs at the limited opportunities, Eddie responds, "At least you have a choice." His point is that for the working-class and underclass protagonists—the gang members—there are no viable choices open to them. This environmentalist (naturalist) explanation—the kids are formed by the world they grew up in—is supported by an adult protagonist's claim that hoodlums are not born, they are made.

According to Steve Neale (drawing on Maltby), although the postwar social problem film continued to reflect the liberal vision of society "governed by the principles of consensus and co-operative individualism" that upheld so many of the New Deal–era social problem pictures, the body politic was now perceived not as a site of populist striving but as an "efficient, just and tolerant society managed by people of reason as well as good will, [in which] social problems were caused by social deviants, and social deviance was a psychological condition characterized by irrationality and ignorance."[28] The ultimate outcome of these shifts was the figure of the psychopath exemplified in postwar gangster pictures where the mentally deranged killer comes complete with Freudian over- and undertones and any number of psychoanalytical explanations for his or her deviancy. This causal explanation also underpins an understanding of deviancy in social problem JD films with contemporaneous settings like *Rebel without a Cause, The Young Stranger* (1956), *The Young Savages* (1961), or *Hoodlum Priest* (1961).

The psychotic character is there in *Teenage Doll* in the figure of Wally, a member of the Vandals, who is left to guard Barbara. Wally is a small mass of contradictions—childish but adult, geeky compared to Eddie but sexually threatening toward Barbara, dumb but smart. He, as much as any character, gets to "voice" the prevailing theory on juvenile delinquency, chiding Barbara with a satiric "My mummy and daddy don't understand me so I got to go out and be a juvenile delinquent." But Corman's low-budget exploitation thriller also shows just how persistent certain social theories can be, in this case the dominant environmentalist explanation for deviancy, and how inconsistent films are in taking up a particular theory—never mind what call they might or might not make to topicality, the importance of their social message and dire warnings of teenage misconduct.

The dramatic tension and conflict in *Teenage Doll* are not the result of a generation gap, or a psychological disorder, such as in *Rebel without a Cause*, but are instead the result of social tensions and differences. In terms of her dress, deportment, sexual naiveté, upbringing, home environment, and values, Barbara—"that dumb square broad," as one of the Black Widows calls her—offers a strong contrast to the tomboy demeanor of the Black Widow gang members, who are uncultivated, undereducated, vulgar, violent, and sexually experienced—or, at least, sexually knowing. The film is littered with coy images of girls in various states of undress, indicative of its intent to titillate, just as the gang violence promises thrills, and the representation of the female gang offers the twin attraction of sex and violence in a combination that is both novel and licentious. Within the confines of the social problem picture, Corman was pushing against the envelope of what was considered an acceptable representation of America's deviant youth. A reviewer in *Variety* thought, however, that the representation had become cliché and offensive: "Another juve delinquency cheapie. Clumsily executed. For the sex and sadism fanciers. . . . More and more, these delinquent pix, tailored strictly for the exploitation market despite their pious declarations, are beginning to display a deadening monotonous sameness."[29] To this reviewer, the filmmakers' declaration of public concern expressed in the film's foreword was no more than a ruse behind which to sell cheap thrills. The tension between commercial demands and social responsibility that lay behind the production of social problem pictures is here laid bare, but it is also present in all films that are ripped from today's headlines so they have that "got-to-see" element.

Discussing the shifts in the representation of juvenile delinquents across the 1930s, Maltby writes: "After more than a decade of generic dilution, the descendants of *The Public Enemy* [the long-running serials featuring the Little Tough Guys, the East Side Kids, the Bowery Boys, and the Dead End Kids] were finally rendered harmlessly entertaining to the juvenile audiences to whom they appealed." What was now offered was "an interminable comedy of bad manners, ever more divorced from its sociological and cinematic origins."[30] The 1950s depictions of juvenile delinquency returned to these origins, but like the 1930s cycles, they soon became dissipated and far removed from the daily headlines, less interested in documenting crime among the young than in recording innocuous youthful leisure activities: beach parties and surfing, for instance.

In his review of Roger Corman's 1966 biker movie, *The Wild Angels*, and the cycle of films that followed in its wake, Alloway argued that topicality was at the core of the cycle, with "subjects that are more like headlines than plots." He also noted that the deterministic "causal narrative structure" of 1930s crime films had faded in the 1950s when "shocks and sensations were demonstrated more than they were analyzed."[31] As an example of this modification of conventions he compared the new biker movies to their precursor, *The Wild One* (1953), commenting on how that film had the outlaw bikers ride toward fixed cameras, while the contemporary films used mobile cameras. In the former the "camera's point of view is separated from that of the intruders"; in the latter the point of view is the gang's: "By matching the riders' speed the camera shows them, in fact, using the highway like a room, relaxing, talking, drinking as they go. Only the background moves."[32] This paradoxical image of domesticated outlaws, in movement but somehow static, a fantasy of contained rebellion, is first-rate film criticism, but Alloway is also telling us something about how films change and about the meaning involved in those changes. He concludes his account by contrasting Brando's outlaw figure—inspired by the French actor Jean Gabin's tough but melancholic characters—and the protagonists of the new cycle, who are "presented in a detached, statistical spirit." The characters' motivations in *The Wild Angels* are negligible when compared to those in *The Wild One*, not much more than "statements or actions, not . . . sequences or developments." As such, motivation in the film is equivalent to that found in pop songs on 45 rpm records, which have typical rather than personal referents. Motivations become personal only to the extent to which they "touch on our statistically shared rather than our private roles."[33] That is, popular culture is linked to our own lives through the personal characterized in statistical terms. The individual is defined, in contradiction, by his or her resemblance to those who form a crowd.

Though all films are caught up in the imperative to keep up to date, some are more highly charged by a link to contemporary material culture. This is the point that Alloway makes when, through the prism of *The Wild Angels*, he looks at the shifting meaning of Nazi regalia, which is heavily featured in the film. He notes that the only helmets worn in *The Wild One* are World War II–style "Nazi coal-buckets," and these are also present in Corman's film. The bikers in *The Wild Angels*, however, also wear a range of German military insignia, including Iron Crosses, and a large swastika

flag is prominently displayed during the culminating funeral meeting and procession. He writes:

> The point is made early in the movie that a Nazi emblem is "garbage" to some-
> body old enough to have killed its original wearers in World War II. Now,
> however, the once-loaded symbol has been separated from its caste functions
> via the intervening comics and movies about "good" Germans. The deadly
> symbol becomes optional ornament. Its World War II significance is almost a
> lost language as it is incorporated into a *style* of personal adornment. . . . Like
> classical ornament which descended from temples to fireplaces, from Trium-
> phal Arches to dressing rooms, in 18th-century architecture, the Swastika and
> the non-Christian Maltese cross are general again, like the "S" on Superman's
> chest, like two-image Batman rings.[34]

The artist, sociologist, and member of the Independent Group John McHale notes that the new media landscape of the 1950s represented an acceleration of everyday life that required "an array of symbolic images of man which will match up to the requirements of constant change, fleet-ing impression, and a high rate of obsolescence. A replaceable, expendable series of icons."[35] Echoing McHale, Alloway writes that the movies pro-duce a great awareness of the "dimensions of living" but also amplify those dimensions so that American life takes on the appearance of a "drag strip of hotted-up crisis. . . . This aggrandized present induces anxiety partly because, by a curious twist, American practicality, the ethic that something can always be done, gives equal urgency to both marginal and central prob-lems. The mass media's social effects have been subject to such a process of intensification." In Alloway's view, this is less a moral problem than a causal effect of conservative forms and technological innovation that is most "fully visualized and articulate when the subject is violent."[36]

Violence in America's movies became Alloway's focus. Toward the end of a piece in a 1969 issue of *Vogue*, he introduces a forthcoming series of film shows at the Museum of Modern Art, New York, that he had pro-grammed. The series examines "the themes and conventions common to groups and cycles of films" and is "intended to reveal some of the charac-teristic patterns of cinema."[37] The program of action movies mapped vio-lence as "the recurring and typical element" of certain film cycles produced between 1946 and 1964. Alloway's project begins with film's topographi-cal and sociological terrain, particularly its indexical rendering of highly

topical or public affairs content. Films are shaped, he argues, by contemporary events, the war in Vietnam, for example, but the war alone does not account for the general tolerance of violence in the movies. It is a movie's conventions that govern the heightened use of violence in certain situations because it enables an expedient solution to any given problem: "Violence as motivation gives the maximum definition to a story."[38] This is necessarily so in movies that are averse to producing long and complex explanations for any given dramatic situation. Because film violence is conventionalized, it is generally unremarkable. However, as conventions mutate, change makes the representation of violence remarkable. The critical furor that blew up around Sam Peckinpah's *The Wild Bunch* (1969) is a good example of this process. The director's use of slow motion drew attention to the impact of projectiles on bodies, unsettling spectators who had become complaisant about violence in westerns, but this innovation soon became a stylistic trope, something expected in a Peckinpah film. Once audiences have absorbed the novelty of representational shifts, they become the new conventions.

Representations of violence are tied not only to cycles of innovation and convention but also to contemporary concerns. Alloway writes: "At the movies it is the recognition of topical material within traditional forms, the capacity of the norm to absorb new elements, that is a particular pleasure." Considering the shifts in cycles of action movies before and after World War II, he noted a variety of factors at play, which included the diffusion of a more dogmatic skepticism (that is, a refusal to accept things at face value), the popularization of psychoanalysis (not least, as we've seen, in the construction of the social deviant), and a vernacular existentialism, which questions authenticity in characterization. These shifts "turned the prewar action film (basically athletic and cheerful) into the more savage, more pessimistic film of violence with its gallery of extreme situations and desperate heroes." Postwar audiences became accustomed to the "spectacle of violence and death in a context of psychic depth, institutional doubt, and existential solitude." Violence in the movies was presented as a drama of "social risk."[39]

As the movies dramatize risk defined by the topical, so movie producers look to proven formulae as a base for these stories. Alloway argues that in predicting what an imagined future audience would want to see, movie producers "have to extrapolate present successes into probable future trends, and you must protect your film against obsolescence during

production." Obsolescence, however, was also a fact of film. Movies rapidly disappear from view when the audience turns to new attractions, but the high rate of consumption, the expendability of films, was compensated for by the prolongation of ideas and the durability of conventions in film after film. The temporal span of an individual movie's existence, or the duration of a film cycle—its "usability"—was thus a principle of Alloway's criticism: "Thinking in terms of a time scale for art forms makes it possible to take ephemeral art as seriously as the presumptively permanent."[40] The fugitive nature of individual films, the cumulative span of the films that form a cycle, and the long duration of a film trend that is formed from film cycles are the basic temporal units that Alloway identified and examined.

Alloway's theory enables an examination of a film's commonality with other films. This commonality is considered not only in terms of content, form, and style but also through inquiries into production, distribution, reception, and the consumption of repeatable experiences. In addressing vital questions about the formulaic nature of film, he proceeds from the understanding that film is a popular art and is also an industrial art. The terms of his inquiry are thus framed by an investigation into the contradiction between film as a manufactured, standardized, product and film as an art form and practice. Films recycle themselves; stories, formal elements, characters, and so forth are defined through recurrence, but the process of reiteration is always open to modification. Conventions are not immutable; they are susceptible to augmentation. The challenge Alloway poses is to understand this unstable combination of repetition and difference. In sum, his film criticism offers the most advanced thinking on the oxymoronic concept of the production of regular novelties.

4

Teenpic Jukebox

• • • • • • • • • • • • • • • • • • • •

Jazz, Calypso, Beatniks, and Rock 'n' Roll

> I'd say it was a "mixed-up" rhythm:
> blues, an' Latin-American, an' some
> hillbilly, a little spiritual, a little African,
> an' a little West Indian calypso . . . an' if I
> wanna start yodelin' in the middle of it, I
> can do that too.
> —Bo Diddley on Bo Diddley

In an aside to his discussion of *Hot Rod Girl* (1956), the teenpic historian Thomas Doherty noted that the jukebox in the teenagers' hangout is playing "bad jazz" when, he suggests, their music of choice should be rock 'n' roll.[1] Marshall Crenshaw echoes Doherty in his analysis of *High School Caesar* (1960): "Yes, the film is peppered with rock 'n' roll moments, but the squares who produced it still reverted to swing-type music for the dancin' and romancin.'"[2] With the benefit of hindsight we know that the hip juvenile delinquent listened to rock 'n' roll, and we also know

that the key authenticating performances for post-1960s music critics are Jerry Lee Lewis's pyrotechnics at the start of *High School Confidential!* (1958) or Gene Vincent's street-punk snarl in *Hot Rod Gang* (1958) or *The Girl Can't Help It* (1956).[3] But this restricted view ignores the rich diversity of musical styles and genres that were on display in 1950s teenpix, not the least of which might have been bad jazz.

The material objects that are littered throughout a movie register its temporality, as does the popular music played both diegetically and on the music track. Used over the opening sequence and combined with an image of a hot rod careering along a desert road, Elvis Presley's "Hound Dog" is sufficiently representative of the 1950s to be able to locate, within a few years, the historical moment of *Indiana Jones and the Kingdom of the Crystal Skull* (2008). Not just a temporal signifier, the soundtrack also enables the critical labeling of one film as authentic and another inauthentic. Looking back at the canonical "rock 'n' roll" movies of the 1950s, the film critic Mark Kermode notes that "these films have gained a nostalgic appeal as a result of their seminal pop content—they got the music right, and that was enough."[4] Despite this received wisdom, rock 'n' roll was as much a fabrication as any musical form and should not necessarily denote a more certain authenticity or a more appropriate signifier for mid- to late-1950s youth culture than any number of other music types.

Noting the value or the appropriateness of one musical moment over another is not, however, the point of my contention that Doherty and Crenshaw have misunderstood the musical cues in *Hot Rod Girl*, or, following Kermode, that some films got the music "right" while others just "didn't get it." Instead, I want to argue it is the teenpic's incorporation of a diverse range of musical styles that makes it worthy of our interest. When we look across the trend in teenage-oriented movies, rather than at individual pictures, or individual moments within a film, the sense of the fullness and variety of 1950s popular music culture becomes apparent: for example, rhythm and blues as represented by such distinct talents as the Platters, Chuck Berry, the Treniers, Julia Lee, Fats Domino, Little Richard, the Moonglows, and Frankie Lymon and the Teenagers; genres as diverse as folk, rockabilly, swing, West Coast cool jazz, and bebop; and Latin music such as the mambo, the rumba, the cha-cha-chá, and Caribbean calypsos. Contending with this array of talent and styles begins with the acknowledgment that musical variety is what the films offer—a fact that seriously challenges the tendency toward a blinkered view of teenpix as being dominated by a soundtrack of rock 'n' roll.[5]

FIGURE 10 Publicity still for *The Girl Can't Help It*. Gene Vincent and His Blue Caps in an iconic rock 'n' roll pose.

Jazz does not fit our contemporary image of teenpix defined in terms of an accelerating culture driven by hyperchange in fads and fashions. Viewed retrospectively, the big beat of rock 'n' roll seems to better suit the temper of the times and makes a more appropriate accompaniment to teenage lifestyles than a dissonant, or otherwise, jazz score. This scenario is underscored in countless fifties retro-movies, from *American Graffiti* (1973) and *American Hot Wax* (1978) via *Diner* (1982) on to *Indiana Jones and the Kingdom of the Crystal Skull*. The two-minute-plus rush of rock 'n' roll—destination nowhere, with Chuck Berry's "No Particular Place to Go" a highlight of the idiom—perfectly fits the received image of the 1950s JD and the creed of "live fast, die young" much better than jazz, whether it be bebop, cool, or cocktail lounge. With the advent of rock 'n' roll, jazz moved out of the lowbrow milieu of dance and sex music, out of the public spaces of the saloon and into the private space of the bachelor pad with high-end hi-fi as promoted in *Esquire* and *Playboy*.[6] Rock 'n' roll

took on the mantle of "noise," while jazz, at least in its more commercial forms, fitted into the background. Rock 'n' roll's 45 rpm headlong rush to completion—like a drag race—was opposed to jazz's 33⅓ rpm circular routes inscribed on a long-playing phonograph record. Rock 'n' roll was hits, short, sharp jabs. Jazz was ideas in abstract motion and ill suited to accompany teenage rebellion.

But that is a backward-looking gloss placed on 1950s teenage culture. The actuality of the teenpix soundtrack was that jazz continued to have a dominant role into the 1960s, at least nondiegetically. Inside the world of the story an assortment of musical styles was highlighted on jukeboxes and through personal appearances by singers and musicians. Further-more, in the 1950s the designation of a musical performance as "rock 'n' roll" was less a definition of a particular type of music and more often the identification of the music's presumed audience—the teenager. The 1956 double bill of *The Wild Party* and *Four Boys and a Gun* was marketed as "The Shock Stories Behind the Rock 'n' Roll Generation," yet, as noted in the previous chapter, neither film had anything whatsoever to do with rock 'n' roll music.[7]

The film and jazz historian David Meeker described *The Wild Party* as a "cheap melodrama set partly in a jazz club where the characters are all lost, derelict, or unreal and where action is lurid and largely incompre-hensible. Features almost continuous jazz on the soundtrack."[8] *Four Boys and a Gun* is based on a pulp novel first published in 1944 and centers around which of the four young hoodlums will take responsibility for a murder committed during the robbery of a boxing arena. It featured jazz arrangements by Shorty Rogers, who had previously produced the juke-box jazz heard in *The Wild One* (1953). Similarly, and despite its title, *Rock All Night* (1957) barely, if at all, featured rock 'n' roll on its soundtrack. In its review of the film, the *Hollywood Reporter* claimed the fad for rock 'n' roll had "run its course" but that this would not affect its success because the "title is somewhat misleading. . . . Not much time is wasted on music and what there is contains as much straight jazz and ballad singing as rock 'n' roll."[9] Not featuring the music it was ostensibly exploiting in its marketing was a common story for many of the films that were promoted via rock 'n' roll.

The apparently misleading exploitation of "rock 'n' roll" was also used in the promotion of nightclubs. The soul music historian Robert Pruter writes: "In 1956 Chicago's black nightclubs reacted to the emergence of

rock 'n' roll with alacrity, but also with utter misunderstanding of what was going on. Just as Kaye Starr exploited the trend with a puerile and inane pop tune, 'Rock and Roll Waltz', the nighteries responded in a similarly ridiculous fashion. In May the Grand Terrace presented a 'Rock & Roll Revue' and in September the Roberts Show Club mounted a 'Rock & Roll and Mambo Revue', while the Club Delisa offered 'Rock & Roll Capers.' " None of these shows had anything to do with rock 'n' roll music or with any vocal groups or other rock 'n' roll acts, Pruter says; "rock 'n' roll was just a phrase attached to the shows in order to appear trendy."[10]

Wild Party and *Four Boys* use "rock 'n' roll" as a sensational and highly topical tag on which to build an advertising campaign for what are essentially crime and social problem pictures, but it is reasonable to expect that a movie advertised as featuring "The Wonderful Story of Today's Rock 'n Roll Generation" would include rock 'n' roll music, as in the case of *Rock, Pretty Baby*, starring Sal Mineo and John Saxon. The film held out the promise that you could "Rock to 12 Wonderful Tunes." The tunes, though, are either substandard Bill Haley impersonations, like the title track, or dreamy romantic show tunes. The latter are sung in the diner and at the beach by the future bestselling poet Rod McKuen. Henry Mancini scored the film and composed the original numbers, but he had no feel for or understanding of rhythm and blues, the root music of rock 'n' roll, and so his contribution amounted to little more than anodyne pop tunes. As one encyclopedia entry on the film notes: "During the 1950s, there were two sorts of teenage movies: the lousy and the extremely lousy. *Rock, Pretty Baby* is among the latter because we're concerned with music, and the music stinks."[11]

Rock, Pretty Baby was not designed to catch the ear of rock 'n' roll connoisseurs twenty, thirty, forty, or fifty years after its initial release, but was produced to momentarily hold a teenager's interest and then disappear. John Mundy notes that these films, "operating at the margins of the Hollywood canon, lived with and acknowledged their ephemerality. In a sense, that very ephemerality was the justification for their existence."[12] *Rock, Pretty Baby* might gain a second life as a rerun, but more likely, after its first go-around on the theater and drive-in circuit, it would be sold on to television as part of a package. The film and the music were thus inevitably conceived as disposable products, with built-in obsolescence, evanescent attractions within a passing fad aimed at that most capricious of consumers—the teenager.

The presumption that underlines this chronicle of music in the teenpix is that the film and music industries operated with little artistic regard for the individual film or platter, and less still for how posterity might view their productions. Indeed, it is arguable that they had no conception of interest in a movie or disk extending much beyond its initial release and economic exploitation.[13] The teenpic or 45 rpm disk was conceived as just another item in an assembly line production of a repeatable experience. A consumer's relationship to a particular film or disk was considered to be transient, a passing distraction; it was not expected to last. When the products of the entertainment industries are viewed as essentially ephemeral, received film or music history is altered: the focus shifts away from documenting a chain of extraordinary artistic interventions into the flow of commerce (Elvis at Sun, Beatlemania, Bob Dylan going electric—unique moments that uniquely make demands on our attention) and instead moves interest on to how production was predicated on short-lived cycles tied to broader trends. The process of repetition marked by incremental innovation, or readjustment rather than distinction, becomes the subject of critical inquiry.

The entertainment industries fed upon fads that were understood to be expressions of consumer desire, which having been identified were then developed and exploited. The extraordinary turnover of records— approximately a hundred 45 rpm singles were released weekly in the late 1950s—suggested how difficult it was for producers to second-guess fads. Rather than hope they would hit pay dirt by backing a specific craze and then hazard a commercial flop at the box office, the norm was to spread the risk.[14] Rock 'n' roll's broad and uncertain musical characteristics (what do the Robins and Link Wray have in common beyond the fact they both made disks with "mambo" in the title?), compared to, say, the mambo or calypso, was therefore a boon to producers in marketing their teen-oriented product.[15] As with jazz, a music always amenable to change and development, the protean nature of rock 'n' roll accounted for its relatively long-lived existence as a key factor in producers' attempts to appeal to teenage consumers—it could suggest a youthful attraction without overly determining what was on offer.

Like seasonal fashion changes, film and music cycles contain within themselves the promise of their own demise. In a 1957 scholarly article on the "natural history of fads," the authors announced that there was an identifiable pattern to a fad's life cycle: "discovery of the potential fad,

promotion by the discoverers and/or original consumers, labeling, dissemination, eventual loss of exclusiveness and uniqueness, and death by displacement." The sociologists Rolf Meyersohn and Elihu Katz were discussing, among other things, the contemporary fad for rhythm and blues among teenagers and the feedback from mediators such as disk jockeys that could lead to success *and* failure in the marketplace: "The skewed feedback of the music industry is responsible in part for the volatility of its fads; exaggerating as it does the tastes of an already erratic group considered as its primary audience, its fads fluctuate beyond all expectation. . . . Hence, while the feedback from consumer to producer makes, at first, for a frenzied increase in a fashionable product, it may also make for a more rapid saturation than is warranted or, if the gauge is placed somewhere else in society, for an oversupply."[16]

"They 'calypso'—They 'rock'—on the prison farm that makes them wilder!" ran the poster tag line for *Untamed Youth* (1957), roping together two highly topical musical styles. One of these was the fad for calypso, in vogue from 1955 to 1958 and briefly exploited by low-budget independent filmmakers. Part of *Variety*'s remit was to spot such fads and to predict whether it would last long enough to form a cycle. Its front-page headline report in a December 1956 edition was on the "Hot Trend: Trinidado Tunes—Calypso-Caribe Takeover Kick."[17] Herm Schoenfeld reported that "the calypso beat, which has been picking up momentum in the past few months, is now getting a national showcasing in niteries, concert auditoriums, college balls, and on disks." The motor behind this interest in the Jamaican beat was the growing profile of Harry Belafonte, but *Variety* also put it down to increased U.S. tourism to the Caribbean, where "Yanks have become hep to that territory's native music." Central to *Variety*'s report was the question of whether calypso would "overtake rock 'n' roll in the pop music market." In the trade press there was something of a consensus over rock 'n' roll's demise. The *Hollywood Reporter*'s April 1957 review of *Dragstrip Girl* (which was double-billed with *Rock All Night*) noted that the film "seems to cover the two major interests of the younger set, hot rods and hot music, although the rock 'n' roll phase apparently is somewhat in eclipse to calypso at the moment."[18]

The basic premise of calypso surpassing rock 'n' roll in popularity was followed through in three independent movies that were produced during March and April 1957. Bel-Air Productions' *Bop Girl Goes Calypso* was released in July; a month earlier Clover Productions exhibited *Calypso*

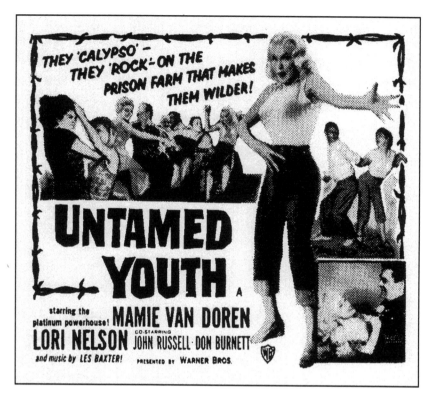

FIGURE 11 Trade press advertisement for *Untamed Youth*. "They 'Calypso'—They 'Rock'—on the Prison Farm That Makes Them Wilder!"

Heat Wave; William F. Broidy Productions pipped both by releasing *Calypso Joe* in May. Though Harry Belafonte, who had starred in *Carmen Jones* (1955), maintained an extraordinary popularity, Hollywood's fascination for calypso lasted only as long as it took for the three films to be conceived and released.

The fad for calypso was loosely tied in with the folk revival, in part through the unlikely link of the Kingston Trio's 1958 hit single "Tom Dooley." The band's name was chosen to suggest a Jamaican connection, and their version of the murder ballad was based on a 1951 syncopated arrangement recorded by the Folksay Trio.[19] Folksay's guitar and banjo player, Erik Darling, was also responsible for the "Banana Boat Song," which he performed as part of the Tarriers in *Calypso Heat Wave* and which Belafonte turned into an international hit. These suggestive interchanges

reveal the extraordinary commingling of popular musical styles during the 1950s. The calypso fad followed hard on the Cuban heels of the postwar vogue for Latin dance music that had its origins in Havana: the mambo, the cha-cha-chá, and the rumba, driven by percussion instruments such as the maracas, conga, bongo and campana. Against the grain of received wisdom on the antecedents of rock 'n' roll as being an unholy alliance of jazz, blues, and country music, the Cuban music historian Ned Sublette argues that rock 'n' roll owes much more than is commonly acknowledged to contemporary Latin music. Rock 'n' roll was, he stresses, "a negotiation between the . . . enormous popularity of Latin music at the time, and the degree to which African American music was swinging"—a description that adds depth to *Variety*'s claim that calypso was but a "swinging improvisation on Afro-Cuban and jazz themes." Sublette writes:

When "Rock Around the Clock" hit Number One in July 9, 1955, *Billboard*, the record it displaced had held the spot for nine weeks: "Cerezo Rosa," or, in English, "Cherry Pink and Apple Blossom White," a slowed-down cha-cha-chá by Pérez Prado. In "Rock Around the Clock" the debt to Latin music is apparent despite the swing-boogie rhythm—listen to the strong clave feel of the lead vocal. Bill Haley's less successful follow-up was "Mambo Rock," which, though it wasn't anything close to a mambo quoted "The Peanut Vendor" in three different spots. The quickie movie called *Rock Around the Clock* featured, besides Haley, a Latin band doing four numbers.[20]

Sublette's thesis is that following the U.S. embargo on trade with Cuba, the rich interaction between the island and the mainland has been forgotten, if not actively obliterated. A reading that supports his argument is that the most iconic of rock 'n' roll songs, "Louie Louie," is based upon the cha-cha-chá. But Richard Berry's number was also sung, in faux calypso dialect, as a lament by a Jamaican sailor dreaming of the girl he left behind. He wrote the song in 1956, Sublette notes, at the height of the cha-cha-chá boom. It was also at the height of the calypso craze.[21] Chuck Berry, whose understanding of the popular music market between 1955 and 1960 was second to none, used elements of Latin music in any number of his early hits: it is a major structuring figure in his top-ten smash from 1957, "Rock and Roll Music," and with "Havana Moon," released in November 1956, Chuck plundered the same musical trove as Richard Berry—a cha-cha-chá rhythm with a rock 'n' roll accent—and told the similar story of a Caribbean man

sitting on the docks sucking on a bottle of rum thinking about an American girl who has left her mark on him ("the boat she sail, me love is gone"). The turnaround is found in Nat King Cole's rendition of the Roy Alfred and Marvin Fisher composition "When Rock and Roll Come to Trinidad" (1957), where the new American music both unsettles and delights the "natives": "I heard Calypso Joe/ He hollered, go, man, go/ When rock and roll/ Come to Trinidad. . . . Now on the market street/ You hear the crazy beat/ And since they heard the news/ They're wearing blue suede shoes." The musical mode is calypso, and Cole's dialect draws from the same pool of caricature as Richard Berry's and Chuck Berry.

Unlike calypso or the rumba, rock 'n' roll is not an easily definable musical style; it is far too inconsistent and promiscuous. It is best thought of as an umbrella term for a mess of musical forms that were choked together by disk jockeys such as Alan Freed, Dewey Phillips, or Wolfman Jack. Chuck Berry's music, like Bo Diddley's, puts a stress on its polyglot being. In his seminal history of "rocknroll," Philip H. Ennis considers the genre to be a seventh stream of popular music that drew deeply from the other six streams: pop, black pop, country pop, jazz, folk, and gospel. He makes a convincing argument for rock 'n' roll as music defined by its "crossover" potential, for example, Chuck Berry's "Maybellene." Released in July 1955, the disk eventually made number one on the R&B charts and then crossed over to pop and hit number five. A cover version by Marty Robbins took the song to number nine on the country charts.[22] Nevertheless, at any given moment a particular style or figure might dominate the mix, and in 1955 into 1956 that style was best personified by Bill Haley and "Rock around the Clock" (Elvis did not break nationally until the spring of 1956).

In the Sam Katzman–produced film that took Haley's song as its title, rock 'n' roll is conceived as a found object and a vernacular music created by amateur musicians, but also as a music of mixed parentage. Bill Haley and His Comets, moonlighting farmers, are discovered by out-of-work swing band musicians who, by chance, encounter the next big thing in Strawberry Springs—pop. 1,472: "It isn't boogie, it isn't jive, and it isn't swing—it's kind of all of them." "The sound of slaughtered cows," quips one metropolitan sophisticate. "All you do is play the music upside down," explains Haley. To balance the rock 'n' roll Haley provides, musical divertissement also comes in the form of "top novelty outfit" Tony Martinez and His Band, who do the cha-cha-chá and a rumba with vibes. Freddie Bell and His Bellboys also have a featured spot with the lively "Giddy Up a Ding-Dong." The Platters,

introduced by the disk jockey Alan Freed, perform "The Great Pretender" and "Only You" with stately solemnity. But this was Haley's vehicle, with nine of his songs featured, including "Mambo Rock."

Haley, Bell, Martinez, and the Platters offered a rounded bill of musical fare —Latin, rock 'n' roll, novelty, and vocal harmony. Follow-up films in the cycle, which gave more space to musical performances, increased the breadth of musical styles on offer. After the runaway box office success of *Rock around the Clock*, which had a release date of April 1956, the small New York–based independent Vanguard went into production in August on its own rock 'n' roll film. Like *Rock around the Clock*, *Rock Rock Rock* featured Alan Freed, but here his act as master of ceremonies was given more screen time and he had more say over the acts that appeared. Via the mediating television set, Freed takes the role of interlocutor between the musicians, his core audience of teenagers, and their parents. Freed fronts his own Rock 'n' Roll Band, featuring Big Al Sears on sax, for two numbers. The vocal group sound is represented by three acts: Frankie Lymon and the Teenagers, the Flamingos, and the Moonglows. White vocal group harmony is provided in the shape of Cirino and the Bowties, who also back up the film's rock 'n' roll Shirley Temple—Ivy Schulman. Chuck Berry cuts things up with his third release on Chess Records, "You Can't Catch Me"— the A side of the "Havana Moon" 45. A Latin performer is not included in the lineup, but the Atlantic recording star LaVern Baker sings the calypso-tinged "Tra-La-La." The title song is performed by Jimmy Cavallo and His House Rockers and is done in the style of Bill Haley (though to be fair to Cavallo, he was recording rhythm and blues numbers in a similar mold to Haley as early as July 1951, when he cut a version of Jimmy Preston's 1949 floor pounder "Rock the Joint" a good ten months before Haley attempted the tune). Connie Francis provides the vocals on the two orchestral pop ballads mimed by Tuesday Weld.

Rock Rock Rock gave increased space to distinctive styles of black music—big band rhythm and blues, Berry's rock 'n' roll, three highly individual vocal groups, and Baker's calypso. The music delivered by the white performers moves from the Haley impersonation through orchestral pop ballads and hits a moment of rare frisson with the Johnny Burnette Trio's rendition of "Lonesome Train." The band is introduced by Freed, who gives a short lesson in musicology that Philip Ennis would surely find convincing: "Rock 'n' roll is a river of music; it is the flow of many streams: rhythm and blues, jazz, ragtime, cowboy songs, country, boogie songs, folk

songs. All have contributed greatly to the Big Beat." But despite the diversity on offer, the film, at least in its advertising, conflated all the musical styles under the banner heading of "21—New Rock 'n' Roll Hits."

Rock around the Clock represents rock 'n' roll as a found object, with the story focusing on how best to exploit this untapped cultural resource. By the time *Rock Rock Rock* was released the story is no longer about the discovery of the music but rather the actual fact of its exploitation—as it was in the major-studio, big-budget production of Frank Tashlin's *The Girl Can't Help It* and the Presley vehicle *Jailhouse Rock*. A third stage, rock 'n' roll's decline, is covered in *Bop Girl Goes Calypso*, wherein rock 'n' roll is presented as the craze of the moment, but one that has "peaked"—and is now "on the skids." As identified by the sociologists Meyersohn and Katz, a fad's "lifecycle" moves from discovery to promotion, dissemination, and exploitation before eventual loss of exclusivity and finally death by displacement. The stages in such a cycle are all played out within and across the scenarios of these films.[23] The events dramatized in *Bop Girl Goes Calypso* suggest that the ebb and flow of musical fads could be finely calibrated, allowing for scientific predictions of a style's rise and fall in popularity. Working on a thesis called "Mass Hysteria and the Popular Singer," an applied psychology student, Bob Hilton, played by Bobby Troup (the composer of "Route 66," the deathless tribute to America's highway), has already predicted the rise of rock 'n' roll and now predicts its eclipse by calypso.

Moving from nightclub to nightclub, Bob collects evidence for his thesis, reading a decibel counter that records the level of public response (applause) to musical performances. The film opens with yet another imitation of the Haley sound: a honking sax-led number provided by Nino Tempo and his all-white combo sweating it out in the Club Downbeat. Tempo is followed by the black vocal group the Titans singing "Rhythm & Blues" and "So Hard to Laugh, So Easy to Cry." Interrupted by a drunk who demands a calypso, the house band at the Crescendo Club, the Mary Kaye Trio (two guys in bow ties play sidekicks to guitarist Kaye), keeps him happy by playing "Calypso Rock," which alternates between the title's two musical styles—Bob Hilton's applause-o-meter hits ten! At the Seville Club, Lord Flea performs a more authentic calypso, but his audience is meager. What is needed to test Bob's prediction, and his ambition to record the first mass hysteria induced by calypso, is a white singer who can bring together the big beat of rock 'n' roll with the Caribbean rhythms of calypso. This scenario has clear parallels with Sun Records owner Sam

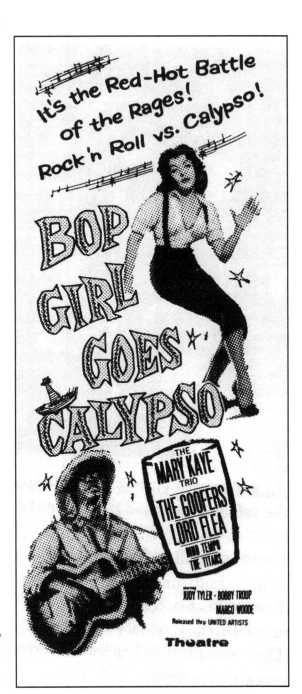

FIGURE 12 Trade press advertisement for *Bop Girl Goes Calypso*. "It's the Red-Hot Battle of the Rages! Rock 'n Roll vs. Calypso!"

Phillips's stated desire to find a white man who can sing the blues and thereby make him a millionaire—enter Elvis, stage left. Both scenarios are expressions of Ennis's conception of the "crossover" as the defining aspect of the period's popular music. As Bob explains to a nightclub rock 'n' roll singer, Jo Thomas, "We're in a very restless world, always looking for something new." As is usually the case, however, and is certainly so in this instance, the "new" is in fact little more than a reconfiguration—a crossover—of the already existing or a regular novelty.

Thomas accepts his challenge and at an afternoon rehearsal at the YMCA plays "Calypso," to a highly appreciative audience of young teenagers. Club Downbeat is given a revamp and becomes Club Trinidad, and Jo wows an adult public with "Bop Calypso," which makes it the third time—"Rock," "Boogie," "Bop"—that the film has crossed rock 'n' roll with calypso. Most of the film's original numbers were composed by Les Baxter, who, along with Martin Denny and Arthur Lyman, was responsible for exotica—a crass vulgarization of ethnic music housed in album jackets that appealed to a suburban fantasy world of desert islands populated with dusky-skinned primitive maidens.[24] Suggestive of the crossover audience the film's producers hoped to attract, the music presented in *Bop Girl Goes Calypso* is shown to appeal to both YMCA club teenagers and to adult nightclub patrons. Nevertheless, the film flopped at the box office and was quickly repromoted under the truncated title *Bop Girl*, with the tag line changed from "It's the Red-Hot Battle of the Rages! Rock 'n Roll vs. Calypso!" to "It's a Rock 'n Roll Riot."

As Mundy notes, for all the noise and bluster musical teenpix created in announcing the novelty of their particular musical attractions, they were based on long-standing formulae, either the musical, with its "integrated narrative number structure," or the revue film, which "characterized the very earliest musicals."[25] Both forms worked to contain the potential excesses of contemporary music, particularly in relation to racial concerns. Michael Eldridge has argued that the containment of rock 'n' roll's troubling racial caste was precisely why calypso was offered as an alternative. Unlike rock 'n' roll, calypso evoked "a happy-faced, tropical version of plantation-apartheid in which dark-skinned people still exist primarily to serve and entertain white people."[26] Calypso, then, could be held at one remove from the American suburban home that rock 'n' roll appeared to penetrate so effortlessly through disks, radio, and television; it represented a faraway and unthreatening black Caribbean culture.[27]

Bop Girl is cynical in its suggestion that musical taste is predictable and easily exploitable, presenting rock 'n' roll unambiguously as a novelty act. At the film's center are two performances by the Goofers; for their second number the band members are made up to look like ghouls, and they perform "Rock 'n' Roll Till I Die" lying in coffins. Their first turn begins with some athletic dancing—Cossack kicks, somersaults, splits, and so on, progressing to the point where each member of the band swings head down, feet up on a trapeze while playing his instrument, even the double bass . . . which actualizes Bill Haley's description of rock 'n' roll as music played upside down, though here the intention is to contain, within a comic scenario, the music's potential for rebelliousness.

Like that of the Goofers, rock 'n' roll performances tend to be neutered affairs in teenpix; watching Haley in *Rock around the Clock*, it is hard to imagine he once had a cataclysmic effect on his audience. In June 1956, *Look* magazine reported on one of his shows: "A tenor saxophone tilts backwards and throws insistent, brutal notes into the air. The melody is simple and repetitive. More important is the beat: it is so firm and strong you can practically walk on it. Bill Haley and His Comets are playing 'Rock Around the Clock' at the Sports Arena in Hershey, Pa., to an audience that wails, screeches, and sometimes dances in the aisle."[28] The photographs that accompany the article give mute testimony to the veracity of that description. If wild untamed rock 'n' roll performances are all but absent in teenpix, they have, nevertheless, come to dominate historical recall of the era. Reflecting on the pleasures offered in *The Girl Can't Help It*, the *Village Voice*'s film critic J. Hoberman writes: "The coolest presence ever recorded by a Hollywood camera may be the entranced Little Richard contemplating his piano as if wondering whether to pulverize or incinerate it."[29] But the fact is Little Richard did not destroy the piano; instead he gave what must be his most restrained performance ever before film or television cameras.

If the lack of interest by film historians in calypso can be explained by the box office failure of the three calypso-themed films and the subsequent lack of industry interest in producing sufficient films to create an identifiable cycle, which in turn might produce scholarly activity in order to explain the phenomenon, the general academic uninterest in the major role that jazz played on the soundtracks of teenpix is less easy to explain, even though jazz was a music wholly in keeping with the ur-text for the teenpic, *The Wild One*.[30] The rock critic Greil Marcus has called *The Wild*

One and *Rebel without a Cause* the "first rock and roll movies," and, he notes somewhat paradoxically, they had "nothing to do with rock and roll music." As music, he argues, rock 'n' roll would have taken shape without these films, but "as culture, it very well may not have."[31] Given the innumerable overt references to these two films in rock music culture through the mid-1960s and beyond, this is a fair comment, but it is also an act of cultural appropriation: Brando's character does not need rock 'n' roll to complete his rebel pose; jazz could do that as well as if not better than any other music. In 1954, jazz carried hipster credibility, and it would continue to do so until well into the 1960s, when bands such as the Rolling Stones, with their wholesale pocketing of Chuck Berry licks, Muddy Waters tunes, and James Brown dance moves, helped rewrite a history of cool.

The year *Hot Rod Girl* with its bad jukebox jazz was released, 1956, was also the year that Allen Ginsberg's *Howl* was first published, which was followed a year later by Jack Kerouac's *On the Road*. If we take these two events as seminal in any history of postwar youth culture, then jazz, not rock 'n' roll, was the delinquent's preferred soundtrack. Granted, Ginsberg and Kerouac define a rather high-end sophisticated version of 1950s youth culture, but at the lower end of the youth-culture hierarchy a similar musical alliance is played out. The car customizer and pin-striper Von Dutch, who, through his appearances in magazines, came to represent hot rod culture of the mid-1950s as much as any one man might, made jazz his music of choice. In the March 1956 issue of *DIG: America's Coolest Teenage Magazine*, Von Dutch is shown barefoot and cross-legged, wearing a beret and playing the flute.[32] By this measure, jazz in *Hot Rod Girl*, regardless of whether it is "good" or "bad," is not the mistaken choice of some hapless and terminally unhip film executive but a valid musical referent.

Released March 19, 1955, *Blackboard Jungle* featured Bill Haley's "Rock around the Clock" over the opening and closing credits, which helped to promote the disk into the *Billboard* charts in May, where it stayed for twenty-four weeks, hitting number one in July and holding on to the top spot for eight weeks.[33] Aided by the March 1956 release of Sam Katzman's exploitation of Haley and the song's popularity with the movie *Rock around the Clock*, *Blackboard Jungle*, juvenile delinquency, and rock 'n' roll became inextricably linked. "Suddenly, the festering connections between rock and roll, teenage rebellion, juvenile delinquency, and other assorted horrors were made explicit," wrote Marcus.[34] But both the film and its source novel (1954) focus on jazz as the music of the day. The long laudatory review of

the film published by *Variety* in February 1955 finished with some notes on the technical side of things and on the music used: "Used to pinpoint drama are three recordings, with 'Rock Around the Clock,' played by Bill Hayley [*sic*] and His Comets, theming the jazz beat that expresses the film's mood. Others heard are 'Invention for Guitar and Trumpet,' played by Stan Kenton and his Orchestra, and 'The Jazz Me Blues,' played by Bix Beiderbecke and His Gang."[35] For this contemporary reviewer, jazz "expresses the film's mood," and Haley's "Rock around the Clock" has the requisite "jazz beat." With the benefit of hindsight this appears as a highly perverse definition, given the iconic status of the song in rock history, but it also shows how fluid and open descriptive terms given to musical styles and forms were at this point in time.

Furthermore, as suggested in both book and film, jazz is the music that matters inasmuch as it defines its more ardent listeners as being outside a bland consumerism—separating the hip from the square. Josh Edwards (Richard Kiley) is a vocational school teacher and lover of swing; after classes he discusses the intricacies of his favorite musical performances with his colleague Richard Dadier (Glenn Ford) in a bar. They talk about Sarah Vaughan, Harry James, the Duke, Charlie Barnet, Jimmy Dorsey, Glenn Miller, and the like, while Josh lays plans for taking his record collection into class. He is intent on drawing his students into a world of art and culture accessed through his arcane knowledge of this beloved music. Edwards's plans, however, come to nothing when his collection of treasured disks is smashed. Discussing this scene, the jazz and film scholar Krin Gabbard writes that Edwards "seemed out of touch, stuffy, and elitist. A defiant youth culture built around the rockabilly sounds of Bill Haley was much more attractive for a significant proportion of the audience."[36] I do not doubt the appeal of Haley for a contemporary youth audience, but the trashing of the disks in both film and novel is not used to dramatize generational conflict through shifts in musical tastes: swing music being usurped by the rhythm and blues of, say, Johnny Ace, Chuck Willis, Chuck Higgins, or even Haley's version. The students stomp on the records not because they represent the music of their parents' generation, or because Edwards appears elitist, but because it is an action that underscores their ignorance and recourse to wanton acts of disobedience, vandalism, and violence when faced by figures of authority.

The teenagers in *Blackboard Jungle* are not being defined by the film's producers as hip—this would take a nostalgic gloss applied years after the

fact—but instead, and wholly in keeping with the film's contemporary generic identity as a social problem picture, they are being defined as delinquent, troubled youth, growing up, for the most part, in an uncaring society. As such, the film works on the generic remit of showing a problem and then asking the audience what they might do to participate in its solution. But then, rock 'n' roll as it appears in the films that followed the extraordinary box office success of *Rock around the Clock* was not perceived by the producers as hip either; beyond its immediate appeal to teenagers, it was understood to be no more than just another musical fad. To be hip you have to practice a form of cultural discrimination—a discrimination that is generally seen as illegitimate, at odds with the mainstream, and, at least in its racial makeup, following the lines laid out in Norman Mailer's 1957 essay "The White Negro: Superficial Reflections on the Hipster."[37] Here Mailer details the hipster's expropriation of blackness as a marker of nonconformist cool that is best exemplified by the Beats' fulsome and romantic view of the black jazzman as a cultural and social outlaw. The "hip," if it existed anywhere in the perception of filmmakers and industry insiders, operated in the realm of the Beats, not with the rock 'n' rollers. The racial complexion of hip partly explains why Hollywood more or less shunned stories that celebrated a culture of cool and instead chose to represent beatniks as deviant and criminal, and its adherents as psychopaths.[38]

Nevertheless, the hip could be found near the heart of Hollywood, in Cosmo Alley, to be precise, where a coffeehouse was kicking up enough of a stir that in October 1958 *Variety* ran a report on its activities and suggested that it might be a model for failing nightclubs to follow: "As the night clubs go out of business, the coffee houses are going into business. And much of the jump and excitement that has put this area's coffee house trend into night-time orbit is being given an extra shove by live entertainment. Just as the nitery shutterings detract from Los Angeles' talent showcase, so these little coffee houses are adding to it."[39] Discussing the coffeehouse located in, and called, Cosmo Alley, the reporter noted that like "most coffee houses, this one was launched in trade by the Beat Generation, but publicity that brought in the 'squares' has driven out most of the Beatniks. The crowd, nonetheless, is a 'hip' one and one that demands top off-beat entertainment." Currently holding forth was the actor and folk singer Theodore Bikel, who was joined by a "[Mort] Sahl-ish comic with routines," Lenny Bruce—"his satire is biting, his material is good, and he's a solid scorer when he 'makes the scene' at this bombed-out looking but

atmospheric coffee house." The article finishes with a survey of the area's other coffeehouses and their respective attractions.

In a short article headlined "Poetry with Jazz in Cafes Makes Bad Rhyme out of Bohemians & Minimums," *Variety* had covered the New York beatnik scene five months earlier when it reviewed the San Francisco poet Kenneth Rexroth's readings at the Five Spot—a storefront dive on the Lower East Side that was "inhabited by the bohemians, intelligentsia, artists, and a lot of characters in the genuine sense of the word." The reporter thought that Rexroth lacked the "romantic touch," but then "scholars are rarely one to stop long enough to look at the boy-girl angles." If poetry backed by jazz in niteries is to take off, he concluded, then some of the more "gifted and more handsome of the penurious actors with a poet's feel, must come in to follow up. Then perhaps shall the minnesingers and the bards fill the air with their songs." For *Variety* poetry readings were just the latest "cycle" in the niteries' "quest for new sounds and moods."[40]

If the coffeehouse beatnik scene was too limited in its appeal to become a significant cinematic attraction (not enough boy-girl romantic action), it still gave rise to a number of film scenarios, including *The Rebel Set* (1959)—"the screen's big jolt about the Beatniks—the drifters, the hipsters, and the hot sisters"; *The Beat Generation* (1959)—"The Beatnik hang out was a front for violence and weirdness"; *The Bucket of Blood* (1959)—Roger Corman's comedy of Beatnik manners; *The Subterraneans* (1960)—"Love among the new Bohemians"; and a film that had nothing to do with the Beats beyond its title, *The Beatniks*, but had the best of the advertising tag lines: "Their password was mutiny against society." The significance of this brief cycle of beatnik movies lay in their conflation of subterranean Beat culture with criminal underworlds, producing a highly sensationalized handling of the subculture. Often dismissed by scholars as false and ridiculous representations of the milieu, the films, however, never purported to be anything other than exploitative.[41] In satiric recognition of Hollywood's appropriation of whatever fad hit the headlines, Lenny Bruce was promoted via an advertisement placed in the *Hollywood Reporter* as "Soon to be seen in Sam Katzman's *Switchblade Calypso Bop Reefer Madness Swamp Girl*"—a phantasmagoric fusion of the period's subcultural fads.[42]

Coffeehouses and subterranean beatnik scenes appeared in a slew of films from the mid-1950s and into the 1960s, including *Dementia* (1955), *The Wild Party* (1956), *I Want to Live!* (1958), *A Hole in the Head* (1959), *Bell, Book and Candle* (1958), *Blast of Silence* (1961), *Two for the Seesaw*

(1962), *Greenwich Village Story* (1963), and *Night Tide* (1963). All feature the requisite jazz soundtrack and invariably have someone banging away on bongos or congas.[43] *Blast of Silence* featured a particularly impressive performance on the congas by Dean Sheldon. Indeed, these percussion instruments were at the height of their popularity and were a Latin import from Cuba, but one that was quickly domesticated, becoming synonymous with beatniks and coffee houses. Jack Costanzo billed himself as Mr. Bongo; he had earlier played with Stan Kenton and Nat King Cole, and is remembered today, if at all, as having jammed on the bongos with Marlon Brando on Edward R. Murrow's talk show.[44] But it was Preston Epps who best understood the crossover potential for this humble yet loud instrument, chalking up hit singles with "Bongo Rock"—top twenty in 1959—"Bongo Party," and "Bongo Bongo Bongo."[45]

Like Beat culture with its appropriation of Latin rhythm, or at least the promise of its rhythm, rock 'n' roll effortlessly absorbed hepcat jive. This was a form of secondhand or borrowed clothing that gave a performer a veneer of cool, for example, Gene Vincent's "Bop Street" (1956): "Hey cat, where are ya goin' man?" "Man, I'm going down to bop street." "Tell me cat, where's that di-rection?" "Man, ain't you heard? They got one of 'em in every town." "Real cool." Or Elvis Presley's "Hold it fellers, that don't move me—let's get real, real gone" after the slow opening of his third Sun Records 45, "Milkcow Blues Boogie." Teenpic and Beatnik movies just as readily crossed over, producing something akin to *Switchblade Calypso Bop Reefer Madness Swamp Girl*. *High School Confidential!* (1958) is a particularly self-conscious example of this process of exchange. Opening and closing with Jerry Lee Lewis's title song (which is also reprised midway through), the dialogue reads as if it has been ripped wholesale from the pages of the slang dictionary *The Jives of Dr. Hepcat*, first published in 1953. Beyond the hep talk between students, the only lesson they attend is given over to slang and the shifting meaning of "square." When the teacher leaves the classroom one of the students gives an impersonation of Harry "the Hipster" Gibson or Lord Buckley—comedians of hip—as if one of these "cats" had assumed the role of the teacher. After school, students meet at the club where a jazz band provides background punctuation for a beatnik chick's poetry recital—"life is dragsville, man."

In American International Pictures' *Hot Rod Gang* the crossover develops out of John Ashley's character's attempt to live a double life as hot-roddin' rock 'n' roller and buttoned-down heir to a fortune. When Gene

Vincent asks him to appear as a guest on his show, Ashley first turns him down; he cannot afford to be recognized. Then the idea of Ashley wearing a disguise is suggested. Snapping his fingers, Gene says, "I got a thought. Why not gimmick him up. You know, we got the shaggy mane, the shivery spine, and the rubbery legs, why not dress him up in a cool set of shrubbery and real classy threads. You know, like one of those Greenwich Village guys who are on cloud nine?" Ashley reappears as a "bop cat" in beard and beret.

Less intentionally humorous crossovers can be seen in such movies as Imperial Productions' *The Cool and the Crazy* (William Witney, 1958), which featured psychotic reefer-smoking JDs, and Robert Altman's debut, *The Delinquents* (1957). There is not a rock 'n' roll tune to be heard in either film; instead, the soundtracks are made up of various jazz styles. Rock 'n' roll's absence should not close our ears to these films; the music is as valid and potentially evocative of the era as anything by the established canon of rock 'n' roll performers. Where else but in *The Delinquents* can you see and hear a performance by the Kansas City jazz legend Julia Lee? What really formed the soundtrack to the mid- to late-1950s was a Babel of sounds and styles, a polyglot mix of black and white popular music enhanced by Latin music and rhythms—a series of crossovers.

Discussing the plenitude of temporal markers for 1950s youth culture and the display of adolescent activities and pranks—cruising, drag racing, sock hops, "mooning"—in *American Graffiti*, the film and music scholar Jeff Smith notes that the structuring of the film's soundtrack as if it were a radio show DJ'd by Wolfman Jack enhanced the "impression of the film's authenticity": "The radio not only serves as an overarching form of realistic motivation for the music, it also adds a certain connotative richness by marking the film's time and place as a distinctly teenage subculture, one with its own particular rituals, dialect, and consumption patterns."[46] But as he comments in a footnote, the mix of "golden oldies" or pop hits would not have been played by Wolfman Jack back in the day of his border radio broadcasts, when he parlayed a much more heady mix of blues and hillbilly tunes.[47] This was also true of other influential disk jockeys such as Dewey Phillips, who on his *Red, Hot & Blue* show gave Elvis his first radio exposure. His biographer Louis Cantor describes a typically eclectic playlist:

> On any given night listeners got what might be called a Dewey Phillips's [*sic*] amalgamated hodge-podge . . . Dean Martin's "That's Amore" followed by Big Mama Thornton's "Hound Dog;" Patti Page followed by Howlin' Wolf;

Mahalia Jackson's "Move on up a Little Higher" preceding Lloyd Price's "Lawdy, Miss Clawdy"; and then Hank Williams and Rosetta Tharpe back to back. . . . And just about the time that you thought Dewey had slipped totally out of the mainstream he'd throw Frankie Laine's "That's My Desire" on the turntable.[48]

The high impact rock 'n' roll had on the generation that came of age during the 1960s and its role in telling the history of popular music, with its often exclusive view of its music of choice as the only music that matters—before Elvis there was nothing—obscured the actuality of 1950s diverse musical cultures. The selection of distinct and varied musical styles to accompany moments of youthful activity and leisure in teenpix, some of which now strike us as inauthentic (bad jazz on the jukebox) or patently absurd (calypso eclipsing rock 'n' roll in popularity), occludes the fact that the music industry rode the wave of a phenomenal rise in sales of disks, particularly 45s, that had them chasing fads, which were often no more than phantoms—apparitions from the industry's collective psyche—in order to try to capitalize on the consumption frenzy. In the same manner the film industry sought to regain a lost audience, it too chased fads and phantoms in its appeal to the core consumer of popular music, the teenager—that most fickle and untrustworthy patron of the arts who just maybe liked jazz, romantic pop, calypso, or even Gene Vincent. Like Dewey Phillips, the film industry chose not to overly limit the music it had on offer and instead provided a varied package, some of which, it expected, would cross over and appeal to diverse and capricious teenage tastes. In a short news item on the preproduction work on the "low budget" "musical exploitation feature" *Jamboree*, the *Hollywood Reporter* noted that it would "feature 19 famous disk jockeys in a sort of musical mélange ranging from sweet music to rock 'n' roll."[49] A more apt description of the musical attractions on offer in the teenpic would be hard to find: a musical mélange, indeed.

5

Intent to Speed

● ●

Hot Rod Movies

> Studillac, Fuick, Chevrolash, Chrysoto:
> Burbank dreamed them just before he died.
> Hooded like gryphons, like the mermaid tailed,
> Sounding the centaur's educated neigh,
> They hit the town square, thirty-five in second,
> Then round and round, moths for brutal neon;
> Their headlights moons to Beeler's Cut-Rate Drugs.
> Then round, with tires baying at the curbs,
> And round again and out.
> Who hid the girls?
> —S. P. Zitner, "The Hot-Rods Ride at Dusk" (1957)

In 1949 the director of New York's Division of Safety identified the hot-rodder as an inherently lawless creature: "Possession of the 'hot rod' car is presumptive evidence of an intent to speed. Speed is Public Enemy No. 1 of the highways. It is obvious that a driver of a 'hot rod' car has an irresistible temptation to 'step on it' and accordingly operate the vehicle in a reckless manner endangering human life. It also shows a deliberate and

premeditated idea to violate the law."[1] The intent to speed was by no means restricted to hot-rodders, as film producers, distributors and exhibitors also exploited hot rod culture with calculated premeditation, tempting audiences with the promise of irresistible sensation. A reporter for *Variety* defined the still novel hot rod movie for his readers: "These are low-budget films based on controversial and timely subjects that make newspaper headlines. In the main, these pictures appeal to 'uncontrolled' juveniles and 'undesirables.'"[2] Combining lawlessness and the reckless pursuit of speed, hot rod culture was new, topical, youthful, and essentially thrilling. It was therefore apparently ripe for movie exploitation.

This chapter tracks the emergence, consolidation, and dissolution of the short cycle of hot rod movies that was exhibited from 1956 to 1958—a run of films with such interchangeable titles as *Dragstrip Riot, Dragstrip Girl, Hot Car Girl, Hot Rod Girl, Hot Rod Rumble, Hot Rod Gang, Hot Cars*, and *The Hot Angel*. The following pages consider the media frenzy that whirled around the subculture of hot-rodding, which was generally portrayed as an illicit, antisocial, and dangerous activity.[3] Through isolated films on the topic and its appearance as a motif in films that otherwise have little interest in the subject, I follow the cycle's emergence. I examine the sensationalist marketing strategies used to promote the films, which I connect to the contemporary expansion in the number of drive-in theaters. I also account for the extraordinary mismatch between the thrills promised in the sales pitch for these films and the dull action they actually provide. While showing intent to speed, few examples of the cycle delivered on the promise to thrill. Finally, I consider questions of turnover and the speed of production that marked the cycle. What pulls these parts together is a series of questions about what made hot rods and hot rod culture useful to film producers and audiences.

Like rock 'n' roll, or the moral panics inspired by the consumption of comic books, gang culture, and general delinquency per se, hot-rodding was one of numerous teenage activities that attracted the attention of the media across the 1950s. The media frenzy inspired by the subculture was certainly a significant factor in film producers' exploitation of the subject, but it cannot adequately explain why the cycle appeared in 1956–1957 rather than earlier or later. The primary reason for the cycle's formation derives from changes in the contexts of film production, distribution, and, notably, exhibition. The hot rod cycle is peculiarly tied to the rise in the number of drive-in theaters, which hit critical mass in 1956–1957, running

parallel with the cycle's peak years. Attendance at drive-ins thereafter dropped, as did the production of hot rod films. The cycle was related to events in the public sphere, as it was to the exploitation of the box office success of films such as *Rebel without a Cause* (1955), which in turn were influenced by those events—but these were contributory rather than causal factors. The exceptional shifts in exhibition practice were responsible for channeling into a discernible cycle what would otherwise have proved to be a series of disconnected cinematic instances of the exploitation of hot rods as a timely topic. Drive-ins provided the essential catalyst for the formation of the cycle, maximizing and shaping its exploitable potential for film producers and distributors.

In a 1950 *Saturday Evening Post* article, a father describes the pleasures and pitfalls of his son's hot rod enthusiasm. It is a wholly positive depiction that emphasizes the skills learned and the work involved in getting a car ready to race. The father's "peaceful evenings ended when his son bought a beat-up jalopy. The neighborhood gang emptied the icebox, filled the night with hot music—and turned the old heap into one of those souped-up speedsters they call hot rods." The article suggests hot-rodding is a legitimate and peculiarly American pursuit, a regulated activity that the police regarded as a "healthy release for the teen-age 'speed urge.' "[4] When the son's hot rod is built it will run on a purpose-built racetrack, not on local streets. This upbeat view of hot-rodding was far from typical of contemporary media coverage, which generally characterized it as a lawless activity that recklessly endangered not only the enthusiast but also other road users. The hot rod, like rock 'n' roll, was an assault on those with more mature or refined sensibilities, a very visible (and aural) symptom of youth run wild.

An example of the sensational documenting of hot rod culture was published four years earlier, in 1946, in the same magazine, which ran a short fiction piece detailing the battles between the police and "those wild kids with their souped-up cars."[5] Even more dramatically, in 1949 *Life* magazine had published "The 'Hot-Rod' Problem—Teen-Agers Organize to Experiment with Mechanized Suicide." The photo-story "re-enacts" the stunts teenagers pulled in their customized jalopies, including a game of "chicken" in which participants see who will be the first to grab the steering wheel as they hurtle along at speeds in excess of 60 mph. In another game, "rotation," the driver, having reached 50–60 mph, opens his door

and "walks along the running board and gets into the back seat. Meanwhile friend at right takes the wheel and another in back gets into the front. This continues until everybody has had a turn or there is an accident."[6]

Ten years after its first story on the subculture, the *Saturday Evening Post* was still publishing tales on the perils of hot-rodding: "They were looking for excitement, and if they hurt someone, so what?" ran the tag line for "52 Miles to Terror."[7] The magazine coverage, which documented and explained the phenomenon while also exploiting its more sensational aspects, was echoed in news items. A 1958 article in *Time*, for example, reported that "Main Street in tiny Boyd, Texas (pop. 550) is two-lane, string-straight, smooth-paved—and ideal as a drag strip for the rambunctious local hot-rodders, who went roaring through town at night, leaving empty beer cans and angry citizens in their wild wake."[8] Stories such as these, which identify hot-rodding as a delinquent pursuit rather than a legitimate leisure activity, dominated reportage of the topic.

Although there is a long history of customizing cars to improve the performance of factory-built automobiles, hot rods were essentially a postwar phenomenon.[9] According to the cultural historian H. R. Moorhouse, the technical and aesthetic modification of Detroit's products in this period created a culture with "definite values, interests, a special vocabulary and a variety of formal and informal institutions: used car lots, races, clubs, speedshops, roads, magazines, local and national associations." The media readily exploited this culture, but the hot rod fraternity also capitalized on the growth of interest in its activities. Produced by enthusiasts, *Hot Rod* magazine was first published in January 1948, with a print run of 5,000 copies. Circulation rose to 40,000 copies by issue 10. Having helped form the National Hot Rod Association (NHRA), by September 1952 the magazine claimed 15,000 members, and two years later bragged of there being over 2,700 hot rod clubs in America. By 1956 *Hot Rod* was the largest-selling automobile magazine in the country, with a circulation of around 500,000 and a readership of four times that amount. The magazine had to contend with a significant number of competing titles, as well as spin-offs in mass-market fiction, both paperback originals and comic books. Hot-rod-themed pinball machines and popular music also exploited the subculture throughout the 1950s.[10]

The synergy between the various media exploitations of the phenomenon is caught in a 1952 news item from *Time* magazine:

Nobody knows how many hot-rod racing fans there are in the U.S., but Robert ("Pete") Petersen of Los Angeles knows their lingo. At 25, he has already made a small fortune publishing *Hot Rod* and other "hogbear" (real thing) magazines for them. Early last fall Publisher Petersen and his top staff cartoonist, Tom Medley, 31, got an idea: since rodders seem to like their music as hot as their hopped-up engines, why not give them some with real "lowdown, George-gone-all-the-way" hot-rod lyrics?[11]

The idea soon materialized as a couple of disks released in 1952, "Saturday Night Drag Race" (parts 1 and 2) and "Hot Rod Harry (The Coolest Cat in Town)" backed with "Hot Rod Cowboy," recorded by the jazz clarinetist Joe Darensbourg and released on the independent label Hot Rod/Colossal. The hot rod theme added novelty to what are otherwise fairly run-of-the-mill rhythm and blues numbers. While hot rod culture was a notable theme in popular music genres across the 1950s, these country, rockabilly, doo-wop, and rhythm and blues songs were not marketed as belonging to a distinct cycle.[12] A self-identified cycle of hot rod music occurred much later, between 1961 and 1965. These hot rod disks—Ronnie and the Daytonas' "Bucket T," for example—appeared as part of the wider music industry exploitation of West Coast car and beach culture, such as the Rip Chords' "Hey Little Cobra," and the Hondells' "Little Honda." The musicians and producers (Gary Usher, Terry Melcher, Bruce Johnston, et al.) who were responsible for surf music were also behind the cycle of disks with hot rod/car themes. Here, hot rods were part of a leisure culture and had become as mainstream as surfing and as unthreatening as beach party movies.[13]

Hot rod subculture was sufficiently in the public eye in 1950 for it to be analyzed in a leading scholarly journal, and by the end of the decade it was firmly established as both leisure pursuit and professional activity, with all the attendant regulations, associations, organizations, and commercial agents necessary to support and exploit its popularity.[14] Tom Wolfe defined the subculture in his celebrated 1964 essay for *Esquire*, "There Goes [Varoom! Varoom!] That Kandy-Kolored Tangerine-Flake Streamline Baby."[15] And avant-garde filmmaker Kenneth Anger gave it a camp twist in *Kustom Kar Kommandos* (1965), which featured a hot-rodder in skintight jeans and shirt polishing his rod with a large powder puff. Some hot-rodders still ran illegal road races, as fictionalized in *Two-Lane Blacktop* (1971), but the mainstream media showed little interest in these activities. By the early 1970s, the image of hot-rodding as an outlaw

culture was almost wholly seen as a nostalgic turn, particularly after the box office success of *American Graffiti* (1973).

As a high-profile media phenomenon with obvious exploitation angles— and as a subculture based on the West Coast, which offered easy access to customized cars—hot-rodding inspired film productions early on, such as *The Devil on Wheels* (1947) and *Hot Rod* (1950), produced respectively by low-budget specialists Producers Releasing Corporation and Monogram. *Variety* reported that *Devil* was made to profit from "the current hot-rod car craze among juv America which is causing so many thousands of deaths annually. . . . The film accomplishes its goal—namely, to make audiences conscious of the peril of such hopped up autos."[16] Hot rods also featured in other films, such as the Mickey Rooney vehicle *The Big Wheel* (1949), which included them as part of its depiction of the culture of automobile racing. Rooney progresses from driving self-built hot rods to appearing as a professional driver at the Indy 500. These were all self-conscious attempts to cash in on the automobile customization fad. More peripheral use of hot rods can be seen in *The Reckless Moment* (1949), *The Lawless* (1950), *Appointment with Danger* (1951), *Crime Wave* (1954), *The McConnell Story* (1955), and *Blackboard Jungle* (1955). Hot rods appear in these films because they have use value, aiding story development and adding to a picture's topicality by providing a vocabulary for what the American International Pictures producer James H. Nicholson described as "modern expressions."[17]

The use of hot rods in such films helps to concentrate viewers' attention on issues relating to crime, class, and youth, which are linked to a reckless pursuit of speed-enhanced thrills, as well as locating these factors within the sphere of the topical. In *Appointment with Danger* a speeding hot rod distracts a motorcycle cop just as he is about to confront two murderers disposing of a body. In *The Lawless* the hot rods are unfinished, driven by teenage Latinos whose lack of wherewithal is contrasted with the Anglos' gleaming new convertibles. The Latinos' hot rod is only one step up from the clunker the young son is seen working on in the family yard throughout *The Reckless Moment*. *Crime Wave* features a beautiful chrome-trimmed and lacquered hot rod, which is used to underscore the protagonist's skills as a mechanic and onetime getaway driver. *The McConnell Story* uses a hot rod to emphasize the unruliness of the protagonist, who later realizes and legitimizes his need for speed as a jet pilot. A hot rod appears early in *Blackboard Jungle*, accentuating the film's topic of juvenile delinquency as it careers dangerously around a corner in a street race.[18]

The 1950 film *Hot Rod* deployed a trope that can be found in just about all the automobile-centric films that followed: the tussle between illegal drag racing on public highways and its containment within an officially sanctioned and organized club. Like much of the teenpix trend, hot rod movies dealt with (self-) policing and regulation of leisure activity. The teenpic historian Thomas Doherty provides a capsule description of the cycle's formula:

> The narrative of the dragstrip cycle . . . both validates and domesticates a controversial teenage activity. A . . . mediating agent, often a sympathetic cop, is the buffer between worry-wart town elders and grease monkey kids. Complicating matters is a chicken race for honor and/or an accidental automotive death, often instigated by a speed-crazy female hellcat. Inevitably resolution means the containment of teenage energies within a limited, supervised arena.[19]

More than just another example of Hollywood's simultaneous exploitation and neutering of teenage culture, this narrative of regulation was also central to the rhetoric employed by hot rod journals and associations. Moorhouse reports that the NHRA was always keen to collaborate with the Highway Patrol and other agencies:

> It liked to proclaim that its 'safety program' was 'endorsed by law enforcement agencies' and the good cop, the hot rodding cop, became a regular feature of hot rod magazines and in hot rod novels in which the hero was weaned away from wild street racing, usually after the death of many teenage friends, to a steadier world of roadeos, reliability runs, and organised drag strips.[20]

For those involved in organizing and directly exploiting the sport, the economic imperative behind this pursuit of safety and respectability is self-evident, but it was the reckless stunts hot-rodders performed on public highways that primarily attracted the purveyors of entertainment to the topic. Filmmakers took up a dual role, setting themselves up as responsible guardians and as shameless exploiters of teenage fads and customs.[21]

Neither *The Devil on Wheels* nor *Hot Rod* had enough impact on producers or audiences to help initiate a cycle, and further productions remained isolated until interest in the topic of hot rods and speed-addicted juveniles was ignited, it has been said, with the 1955 release of *Rebel without a Cause*

and James Dean's death in a car crash. Doherty argues that *Rebel's* chicken scene, with Jim Stark (Dean) and Buzz Gunderson (Corey Allen) racing each other toward a cliff edge, "inspired a souped-up series of teenage drag racing films. . . . American International Pictures set the pace for automotive exploitation, but all the usual suppliers of low-budget programmers launched vehicular vehicles in the spirit of *Rebel's* dramatic chickee run and Dean's poetic end."[22] Given all the media excitement around teenagers and hot rods, however, *Rebel* was following a trend as much as setting one. The cycle proper did not gain traction until well over a year after *Rebel's* October 1955 New York premiere, which does not suggest a direct correlation between it and that film's box office success.

The hot rod cycle began with the AIP-distributed *Hot Rod Girl*, released in July 1956, with Lori Nelson as the girl of the title and Chuck Connors as the good cop. A month later United Artists began distribution of *Hot Cars*, and in April 1957 AIP released the Golden Gate production *Dragstrip Girl*. Nacirema Productions, which was responsible for *Hot Rod Girl*, had the follow-up, *Hot Rod Rumble*, distributed by Allied Artists in May. Howco International began distribution of Marquette Productions' *Teen Age Thunder* in September. A month later, AIP released another Golden Gate production, *The Motorcycle Gang*, a virtual remake of *Dragstrip Girl* that swapped hot rods for motorbikes. Cast and crew for both movies were much the same, as were the Griffith Park locations for the race scenes. In 1958 AIP distributed both Trans-World's *Dragstrip Riot* (in May) and its own production *Hot Rod Gang* (in August). That same month, Allied Artists released *Hot Car Girl*, and at the end of the year Paramount distributed *The Hot Angel*, produced by Paragon Productions in the late summer of the previous year. The fad for the speed-crazy-juvenile-delinquent automobile movie faded by the middle of the following year. The cycle slowed down to a crawl in 1959 with AIP's *Ghost of Dragstrip Hollow* in July, before dying a death with the Filmgroup's *The Wild Ride* in June 1960 and the ultra-low-budget Arch Hall production *The Choppers* (released in November 1961 but produced two years earlier). Running alongside the hot rod cycle were other car-centric films made by the same set of companies, such as *The Fast and the Furious* (1954), *Running Wild* (1955), *The Party Crashers* (1958), and sports car dramas such as *Joy Ride, Young and Wild* (both 1958) *Roadracers, Daddy-O,* and *Speed Crazy* (all 1959). The hot rod was also a regularly used prop throughout the JD trend and featured, for example, in *The Delinquents* (1957), *High School Confidential!,* and *Live Fast, Die*

Young (both 1958). This glut of youth-centric films had intent to speed and the promise of sensations and thrills-a-plenty.

For the most part these films were the product of new independent companies that exploited the gap in the market left by the major studios, which were abandoning the production of genre films or programmers to concentrate their resources in fewer, more expensive features.[23] The lack of films designed for double-billing was partly filled by the move of distributors (and a few exhibitors) into production. In his study of horror films and the movie business of the 1950s and 1960s, Kevin Heffernan highlights the difficulties faced by independent exhibitors who were starved of product in the poststudio era. He notes that production dropped from "479 features in 1940 to 379 in 1950 to 271 in 1955, finally reaching an all-time low of 224 in 1959."[24] The shortage of product was compounded by falling attendance and by the recognition that the teenager was the primary habitual cinemagoer in neighborhood, second-, and subsequent-run theaters. As the film economist John Sedgwick writes: "With the decline in attendances the proportion of young people in the audience increased, so that by 1957 three-quarter of audiences were under thirty and half under twenty years of age."[25] Film production and marketing strategies made strenuous efforts to cultivate and retain this audience, utilizing sensationalist advertising as a key ploy.

The films and the advertising both depended on a schizophrenic conception of the teenager as not only a valued consumer but also a figure to be held in some dread. Heffernan writes: "These two trends, the courting of the teenage dollar and America's fear of its own children, would have an incalculable and irreversible effect on the horror film as the figure of the monstrous adolescent and the demonic child became staples of the genre." This is true not only of the horror film but also of other films within the juvenile delinquency trend, especially the hot rod pix. Dispensing with subtlety or concealed coercion, marketing to juveniles exemplifies a strategy that one industry insider described as "pure punch, with no dilution"—a policy encouraged by the lack of star names, who would ordinarily provide the advertisement's focus. This kind of advertising addressed what Heffernan defines as the carnival-like attractions of low-budget films, horror or otherwise. In explaining the lure he quotes the AIP producer Herman Cohen: "I always think of the title first. The story comes last. After the title come the advertising ideas—the gimmick, the illustrations, for these are what get the kids into the theatre. Then comes the story—and every drop

of blood and graveyard shudder must be as advertised."[26] In reality, however, the films were seldom as advertised.

Movie sensations were sold in the inimical style of the carnival barker. The hot rod movie promised the spectacle of "Revved-up youth on a thrill rampage," as the ad copy for *Teen Age Thunder* boldly declared. The film was promoted via an image of an accelerating culture, with young people, untamed and running wild, in a parade of thrilling scenes. Posters for the double-billed *Dragstrip Riot* and *The Cool and the Crazy* presented the seductive entreaty of a "TWIN ROCK 'N RIOT SHOW!" offering the vicarious thrills of witnessing "Murder at 120 miles per hour!" and "Seven savage punks on a weekend binge of violence!" "See Hot Rods vs. Motorcycles," screamed the ad copy. "See the 'Train Drag.' See the 'Beach Party Rumble.'"[27] The petition is to "see"—to bear witness to violent scenes, to give oneself over to sensation, to be alive to thrilling situations. The promotion of the double bill, however, exceeds what the films are able to deliver. The discrepancy between the marketing and the films' actual attractions are particularly transparent in the selling of *I Was a Teenage Werewolf* ("The Most Amazing Picture of Our Time!") and *Dragstrip Girl* ("Car Crazy! Boy Crazy! That was Dragstrip Girl") which in combination were sold as "This is it! The Double Thrill Sensation of the Century!" In such instances the marketing hyperbole becomes as much a part of the attraction as the film itself.

Just as the lurid covers of pulp magazines and paperbacks promised all sorts of wonders, thrills, sensations, and curiosities but mostly provided a seductive covering for prosaic and formulaic stories, the hot rod films similarly failed to deliver on the sensational claims of their posters. The road races limp along Los Angeles' suburban streets, violence is innocuous, and suspense and thrills are in short supply. Contrary to the excesses of the marketing hype, the films are remarkably reticent in detailing the pleasures and dangers of teenage escapades. They also counterbalance any perceived acts of transgression by emphasizing the punitive measures sanctioned by a sympathetic figure of authority.

The discrepancy between the sensational promise of the advertising and the rather affectless films needs, however, further clarification. As the film theorist Peter Wollen shows, cinematic thrills often rely on representations of speed, which "enables us to enter exposed and unfamiliar situations, far removed from the zones of safety and normality." For the cinematic representation of speed to be thrilling, Wollen insists, it must be

connected to various forms of struggle or contest—such as a race or chase sequence. But, as we can see from the hot rod movies, the mere presence of such narrative elements is not sufficient to render a film exhilarating. There are plenty of races and chase sequences in these films, but few, if any, could be judged "thrilling." Using Hitchcock movies as his example, Wollen suggests that the cinema audience does more than merely witness a thrilling event, as in the theater or the circus, but is invited to participate vicariously in the action. The "effective experience of participation," as Wollen puts it, is achieved by formal means, such as the provision of multiple viewpoints on (and within) the action, as well as a rhythmic coordination of shots to build excitement. Hitchcock himself illustrated this process by evoking a scene from *Hell's Angels* (1930) in which a pilot crashes into a Zeppelin: "We see his face—grim, tense, even horror-stricken—as his plane swoops down. Then we are transferred to the pilot's seat, and it is we who are hurtling to death at ninety miles an hour; and at the moment of impact—and blackout—a palpable shuddering runs through the audience. That is good cinema."[28]

Complementary but differently rendered "chicken" scenes from *Rebel without a Cause* and *Dragstrip Riot* provide a clear indication of how vital such cinematic articulation is to realizing the dramatic potential of a thrilling event. In *Rebel* the leader of a teenage gang dares a newcomer to a car race in which a cliff edge forms the finishing line. The first one to bail out will be the chicken. In *Dragstrip* two rivals for a girl's attention dare each other to perform a "train drag." They must park their cars across the railroad tracks, and the first one to pull away as a train bears down on them will be the chicken. Two similar scenarios, but articulated in distinct ways.

Rebel sets up its chicken scene by showing what will befall the driver who does not escape in time. A carefully elaborated series of shots provides the respective viewpoints of Buzz, Jim, and Judy (Corey Allen, James Dean, and Natalie Wood), as well as establishing the great drop between the cliff edge and the sea and rocks below. The chicken scene in *Dragstrip* does not provide an equivalent visualization of the scene and presents the event in a blunt and prosaic manner. The threat of imminent death is primarily communicated to the film's audience through dialogue; its visual representation impoverished and limited. Few resources are given over to establishing the stunt's location and the spatial coordinates, particularly those that connect witnesses to the unfolding event with the preparations undertaken by the two drivers. A crowd of teenagers gathers to watch the

stunt in *Rebel*, surrogates for the cinema audience, but in *Dragstrip* there are only two spectators—acting like seconds in a duel—who are used to provide a cursory visual reaction to the unfolding events. In *Rebel* the large audience, gathered to witness the stunt, helps to generate a sense of expectation, excitement, and fear.

In *Dragstrip* the setup involves cutting back and forth between the drivers readying their cars on the railroad track and their friends back at a diner, a scenario that takes up less than two minutes of screen time. Diegetic time is indicated by shots of a clock on the diner wall. As the minute hand moves toward seven o'clock the scene shifts back to the track, where the locomotive rushes toward a collision with one or both of the cars. The rising volume of the cars' revving engines is mixed in with the train's blaring horn, and the increasing size of its headlights indicates proximity to the potential moment of impact. Just as the crash appears to be imminent one boy pulls his car off the track to the left; the other waits a moment longer and pulls to the right. Before we know if that car has safely cleared the line, there is a cut to the front of the locomotive and then a quick cut to a shot from below that shows it moving past the camera. The scene then shifts to the diner. The two witnesses to the escapade arrive and tell the expectant teenagers (and the film's audience) what has happened. Suspense, of a limited kind, is created as they momentarily withhold their news, but is then quickly dissipated as they reveal that both drivers escaped unharmed.

The editing strategy of the sequence presents a series of alternating close-ups of the two drivers (the lights of the locomotive reflecting off their faces) and cross-cuts back to the diner. Information is withheld from the cinema audience, as it is from the waiting friends in the diner, so that suspense hangs on whether or not one of the drivers has been killed—a question that is very rapidly answered. In contrast, *Rebel* stays with the events as they unfold and shows the tragic consequences of the stunt. Whatever tension there is in *Dragstrip* is built up by cutting between the drivers, the diner (and wall clock), and the locomotive. In *Rebel* it is ratcheted up from the moment Judy stands arms aloft in the glare of the car headlights, acting as a master of ceremonies. The action is held in suspended animation until Judy leaps into the air and brings down her arms. As the cars shoot past her toward the cliff edge, she spins around, racing after them, her skirt blooming up behind her. Side on, we see both cars with Buzz's just in the lead, then a cut to the front, the cars lurching toward the camera. There follows a series of alternating shots of Buzz and Jim, and a cutaway to Jim's devotee,

Plato (Sal Mineo), with his eyes clamped tight and fingers crossed. The film then cuts back to the alternating shots of the drivers, and the revelation that Buzz's sleeve is snagged in the door handle. Jim bails, but Buzz goes over the top. Before the car explodes in a ball of fire on the rocks below, the film offers a shot that is angled from the rear seat of the car, looking over Buzz's shoulder. It is followed by a reverse shot of Buzz's agonized face, his scream carrying over to the following long shot of the two cars falling. The sequence adheres to Hitchcock's blueprint for achieving effective audience participation in a film's action, with the audience granted intimate proximity as Buzz rides to his death.

Dragstrip Riot's editing, on the other hand, rarely puts the audience "into" the action, so that we seldom share the participants' point of view. Arguably this is a formal ploy that enables a thrilling situation to be evoked but not enacted. The strategy, if it is such, is a tease. The suggestion is that the filmmakers are tantalizing their audience with the promise of thrills, but withholding that which is most desired. The strategy guards against censorship, ensuring that potentially transgressive aspects of the film are alluded to but not shown. The movie is thus rendered as a harmless and uncontroversial entertainment. The film's lack of affect, however, was more certainly a consequence of the fact that the filmmakers did not have the resources to produce the kind of finely honed cinematic rendering of danger, suspense, and thrills that was achieved in *Rebel*. The rapid speed and short turnaround time of *Dragstrip*'s production militated against an effective scenario of speeding. Where *Rebel*'s careful orchestration of the chicken scene crafts a dramatic and interactive experience, *Dragstrip* makes only a minimal gesture toward such a dynamic.

Whatever the filmmakers' intentions and budget limitations, the unresolved tension between the sensational promise of the marketing and the more sedentary and pedestrian attributes of the films needs to be placed within the context of the movie's exhibition, where the car culture on the screen mirrored the car culture of the drive-in audience. In *The Delinquents*, for example, teenage gang members ride around in cars, rumble in a drive-in theater, and hang out at a drive-in restaurant. Though drive-in movie theaters had been around since 1933, they were essentially a postwar phenomenon. There were 25 drive-ins in 1945, 800 three years later, a further 1,200 were built in the next two years, and there were 4,000 in 1956. The venues' capacity and their audiences, as Richard Maltby notes, "more than made up for the number of seats lost through other closures."[29] The

major studios, however, systematically refused drive-ins first-run releases, which was a major factor in why AIP and other independent producers were able to become such prodigious suppliers for this market.

The drive-ins were frequently demonized in the same terms as the teen-pix designed to play in such arenas. Described by *Variety* as the "stepchild" of exhibition circuits, their location, audience, and film fare marked such outdoor theaters with the taint of the marginal and the illicit.[30] Similarly, the *Hollywood Reporter* described *The Delinquents* (Robert Altman's debut) as a "sordid and depressing 'study' of what is commonly called juvenile delinquency, although depravity would be a more accurate designation in this case."[31] The film historian Mary Morley Cohen notes that the drive-ins were blamed for fostering juvenile delinquency and had a reputation for being "passion pits," but they also appealed to an audience "forgotten" by covered theaters. "To the amazement of even the drive-in theater owners, in came a type of patronage rarely seen at indoor theaters," wrote a trade reporter in 1950, "the physically handicapped, invalids, convalescents, the aged, deaf people, expectant mothers, parents with infants and small children—whole families, dressed as they pleased in the privacy and comfort of their domain on wheels."[32] While drive-ins were disreputable in their appeal to juveniles, the marginal, and the infirm, they were also accused of being a danger to people who were not attending the show. *Variety* reported that drive-ins could prove a traffic hazard, as drivers on the highways that passed them often slowed down to gawp at the illuminated screens.[33] These distracted motorists mirrored the distracted viewer in the drive-in, who, apart from the film, had many calls on his or her attention. With all the attractions on offer—playgrounds for children, shopping, eating, tournaments, contests, parades, and launderettes—the drive-in was more akin to an amusement park than to a cinema.

The drive-in's unique attraction was that it offered a part-public, part-private experience, which had the film as its main, though not sole, draw. Just as the cry of the fairground barker promised intensely thrilling spectacles that the show could never adequately deliver, the marketing of these films similarly promised the impossible. The carnival atmosphere of the drive-in and the rapid turnover of movies in the cycle, which were often double-billed for double impact, served to compensate for the hot rod movie's failure to measure up to its marketing hype. The pace at which the hot rod cycle burned itself out and consumed all the various permutations on "hot," "car," and "gang" (*Hot Car Girl* had the alternative titles *Gang*

Girl, Hot Rod Girl, and *Hot Rod Queen*) was a remarkable act of an accelerated culture. The cycle expended minor variations with giddying velocity while holding true to a formula. This unfolding of slight modulations, or the promotion of regular novelties, is particularly apparent in the posters for four films in the cycle, *Dragstrip Girl, Hot Rod Gang, Dragstrip Riot,* and *Hot Rod Rumble.*

All four posters present sensational scenes of speeding hot rods, alongside highly sexualized images of women and of young men in violent situations. Red and yellow, hot colors, predominate. The poster for *Dragstrip Girl* is split into four sections. The lowest panel carries the credits; the one above holds the film's title; the next section up has an illustration of a youth stepping between two speeding hot rods. A girl and a boy are driving the cars; to their rear is a line of hot rods racing on a circular track. The top panel is the largest of the four. Under the text "Car Crazy! Speed Crazy! Boy Crazy!" a teenager in a black T-shirt, sporting sideburns and a quiff, holds a near-prone and very buxom young lady in his arms. They are about to kiss. This insinuation of torrid desire suggests a sexual yearning that is unchecked and unfettered, like the careening hot rods straddled by the long-limbed youth. With its ostentatious flaunting of sensation, the poster promises a sexual ride that will match the helter-skelter thrills of speeding automobiles.

The poster for *Hot Rod Gang* is formed of three sections, with a white central panel separating the credit bar and the main panel. The upper section carries the film's title over an image of a jiving teenage girl. With her head flung back, her mouth agape, and a bullet-shaped bra straining her sweater to its outer limits, she offers a spectacle of unbridled ecstasy. The bearded singer and ducktailed guitarist who occupy the bottom right-hand side of the panel suggest the source of her rapture. Ripping across the top and central panels, and heading in a diagonal toward the bottom left-hand corner, is an illustration of two speeding hot rods. In the leading car, a girl in a yellow sweater stands on the passenger side, with one hand holding the windshield and the other held high. She echoes the jiving girl's ecstasy. Pulling up hard behind her is a yellow hot rod whose male passenger is likewise out of his seat, though he is leaning forward and waving a fist. The poster's address is importunate, and no less subtle than that used in *Dragstrip Girl.* "Crazy Kids . . . Living to a Wild Rock 'n Roll Beat!" runs the tag line.

Hot Rod Rumble has a credit bar over the main illustration. Beneath the title, two cars have crashed together, their front wheels spinning high

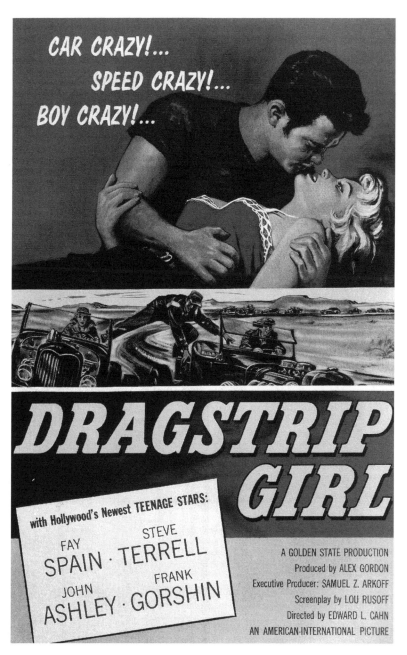

FIGURE 13 Publicity poster for *Dragstrip Girl*.

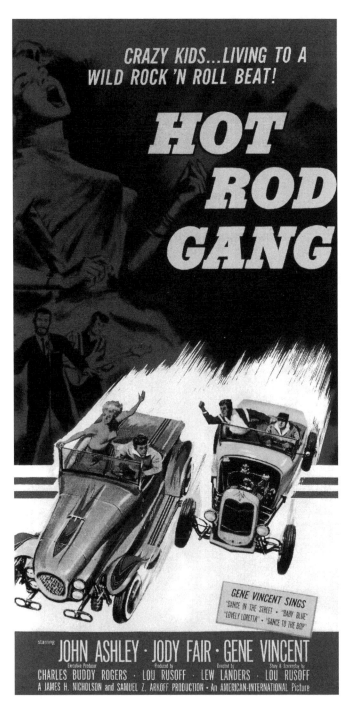

FIGURE 14 Publicity poster for *Hot Rod Gang*.

above the road. Towering over the automobiles is a strawberry blonde, her torso contorted so that she is twisting toward the viewer, providing both a sidelong glance at her chest and a view of her backside. She wears a tight-fitting white sweater, with a leather jacket draped over her shoulder. Her chin rests on her left shoulder as she looks seductively to the viewer's right. In line with her chest and head is a photographic insert with a scene from the movie of leather-jacketed youths in a punch-up. There is no tag line, but the sexual frenzy that is evoked by the images of male violence, female pulchritude, and runaway automobiles does not require textual explication.

Text, however, does help to amplify a poster's message: "MURDER . . . At 120 Miles per Hour!!" runs the tag line for *Dragstrip Riot*, another three-panel poster, which depicts a motorcyclist wielding a monkey wrench as he races alongside a sports car. As their vehicles hurtle forward, two boys are depicted in a seemingly mortal struggle. A girl in the passenger seat of the car is witness to this madness. She is wearing a red jacket, which visually rhymes with the red Triumph ridden by the boy intent on striking the driver of the car she is in. The car and bike break out of the panel, their wheels crossing into the title bar. The title's text is red and yellow, with "RIOT" at twice the font size of "DRAGSTRIP." As precise as the illustration is in its rendering of facets—for example, the pinstriping around the car's headlight, and the presentation of the cyclist's iconic leather jacket, somewhat incongruously matched with chinos, white socks, and penny loafers—the overall impression is of delirium, disorientation, a loss of bearing, and a race to the other side of rationality; the poster summons up a phantasmagoria of transgressive teenage culture.

The posters all work on a gendered demarcation of the promised thrills, articulating a link between the curved bodies of women and cars. The women function as props for the speed-thrills offered to the young men, but they are not in themselves the subjects of such transgressive fantasies. The acts of transgression are conservatively codified, both in generic and gendered terms—with men acting out violent impulses in front of women. The posters address a male audience and are symptomatic of a shift from the studio era, when films were geared toward a female audience, to the poststudio era, when young men became the principal target of film producers. This shift has been identified as the "Peter Pan Syndrome," a term used by an AIP executive in 1968 who, to quote Richard Maltby, "proposed that younger children would watch anything older children would watch, and girls would watch anything boys would watch, but not vice versa.

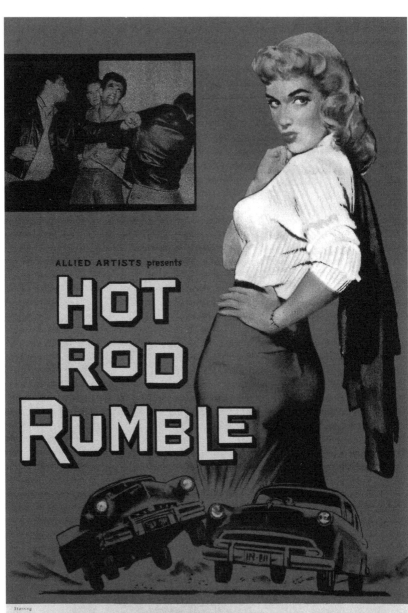

FIGURE 15 Publicity poster for *Hot Rod Rumble*.

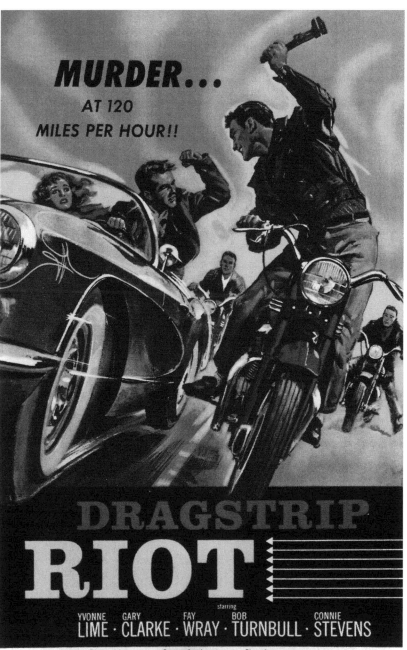

FIGURE 16 Publicity poster for *Dragstrip Riot*.

Therefore, 'to catch your greatest audience you zero in on the 19-year-old male.'"[34] In support of this observation, B movie historian Blair Davis quotes from a 1969 issue of *Seventeen*, which reminded filmmakers that "the movie Teena wants to see is the movie her boyfriend takes her to see."[35]

In the same year that the hot rod cycle peaked, the British pop artist Richard Hamilton reimagined the conflation of the curves of a pinup model with automobile styling in his painting *Hommage à Chrysler Corp.* (1957). Hamilton's abstract, punning play on an advertising cliché is rich in its allusion to consumer culture, highlighting the constructed nature of both the car and the pinup. A key theme in his work of the period was the idea of a popular culture that was resolutely defined through its topicality. The immediacy of the appeal of popular culture was part of its attraction for the artists and critics who formed the Independent Group (IG) that Hamilton belonged to, which also included Lawrence Alloway, Reyner Banham, Eduardo Paolozzi, and John McHale. As theorized by the IG, popular culture was, in counterpoint to the fine arts, defined as transient and evanescent.[36] Writing in 1959 McHale notes: "Almost as soon as a trend becomes recognizable, and can be labelled, the image series has become obsolete. . . . In such a process, the mass media, where the only real content is change, classification is permanently tentative. Expendability is built in and so furnishes an initial criteria. Rapid turnover in iconography in any sector varies strictly according to acceptance, to success which is its own accelerator."[37]

McHale's observation on expendability as a defining aspect of popular culture can also be read across the cycle of hot rod movies, which, with its intent to speed, had all the immediacy of the moment in which it appeared, drawing upon news headlines and moral panics, exploiting subcultural fads, filling a gap in the market vacated by the big studios, and taking advantage of the growth in new exhibition outlets—the drive-ins. The expendable nature of the movies was part of their appeal, and like seasonal fashion changes, the film cycle contains within it its own demise; it is dying in the very process of being born. In this context, the title of Universal Pictures' 1958 exploitation film *Live Fast, Die Young*, in which hot rods feature heavily, is especially apt.

In July 1961, the *New York Times* reported that the juvenile delinquency film cycle had come to an end: "The disappearance of the inexpensively made pictures filled with youthful crime and sex has been the result of a campaign by the movie industry that begun in 1958."[38] The paper cited as

FIGURE 17 Publicity poster for *Live Fast, Die Young.*

the principal reasons for its timely demise both the PCA's move to demand that the ages of the protagonists be raised, and the recognition that there had been a glut of such pictures in the market. This industry-led rationale for the cycle's termination also coincided with a more general falling off of interest in juvenile delinquency. This does not mean, however, that delinquency among the young decreased. The cultural historian James Gilbert notes that media reporting on the phenomenon peaked between 1953 and 1956 and thereafter dissipated, even though juvenile delinquency as a criminal problem actually increased after 1960. "By then," he writes, "the styles and behaviour of young people were less frequently denounced than they were emulated."[39] Gilbert's observation draws our attention to the fact that the exploitation of a particular social problem is not necessarily governed by the scale of its impact on the commonwealth, but is instead determined by other factors that have no particular relationship with the topical concern the media is representing. In the case of the cycle of hot rod movies, exploitation of the subculture was formed and shaped by the developing exhibition needs of the drive-in. Production of this cycle peaked at the height of attendance at drive-ins in 1956–1957 and then declined as patronage dropped thereafter; filmmakers only exploited the subculture when it had value to them that extended beyond its timeliness.

In 1956–1958 the hot rod movie filled a need for a product that was no longer being provided by the big studios, a product that was now being supplied by independent distributors and exhibitors who were moving into film production to satisfy a gap in the market. The cycle appropriated the values, interests, vocabulary, and gestures of young Americans as it also played to that selfsame youth culture. Teenagers were now one of films' most habitual consumers, fickle in their tastes, easily distracted, and with short attention spans. Within the context of the drive-in, the cycle's redundant repetition of motifs tied to automobile cultures and aimed at teenagers, alongside an acceptance of its own obsolescence and expendability, made it perfectly suitable or, more precisely, *useful* to producers and audiences alike.

6

Punks!

•••••••••••••••••••••

JD Gangsters

> This is a re-creation of an era.
> An era of jazz
> Jalopies
> Prohibition
> And Trigger-Happy Punks.
> —*Baby Face Nelson* (1957)

This chapter examines a distinctive and coherent cycle of films, produced in the late 1950s and early 1960s, which exploited the notoriety of Prohibition-era gangsters such as Baby Face Nelson, Al Capone, Bonnie Parker, Ma Barker, Mad Dog Coll, Pretty Boy Floyd, Machine Gun Kelly, John Dillinger, and Legs Diamond. Of key interest is the manner in which the cycle presents only a passing interest in period verisimilitude, producing a display of complex alignments between the historical and the contemporary. Not the least of these was a desire to exploit headline-grabbing, sensational stories of delinquent youth in the 1950s and to link these to equally sensational stories of punk hoodlums from the 1920s and 1930s.

In this chapter, the crossovers and overlaps between cycles of juvenile delinquency films and gangster biopix are considered. Iterations of the contemporary are found in the cycle's repeated use of "punk" to define the gangster, which when aligned with current portrayals of criminal deviancy categorized him as a juvenile delinquent subspecies. Deviancy is routinely explained in terms of a rudimentary psychology, which held that criminality was a symptom of psychopathic personalities and as such gangsters and juvenile delinquents are commonly and reductively described as "punks." The premise for this lies in the noun's etymology, which provokes an association between its social and sexual connotations.

The cycle of gangster biopix engaged in a congested marketplace populated with competing representations of Prohibition-era hoodlums, including television programs, paperback books, pulp magazines, radio series, comic books, and bubblegum cards. The number of films produced between 1957 and 1961 based on the lives of gangsters was not particularly high, perhaps only twelve titles; it was, however, sufficiently concentrated and visible to spur the *Motion Picture Herald* critic to note that *Mad Dog Coll*, released toward the end of the cycle in 1961, was the latest in "a recent flurry of motion pictures dealing with the lives of gangsters of the 1920s."[1] The November 1957 release of *Baby Face Nelson* effectively began the cycle. The film was an Al Zimbalist production, distributed by United Artists, directed by Don Siegel, and starring Mickey Rooney as the titular gangster. *Variety* called *Baby Face Nelson* a "hot exploitation picture!" and accurately predicted it would be followed by a cycle of such films.[2]

Independent production companies such as AIP and Allied Artists were the cycle's principal producers. In the wake of the biopic of Lester Gillis, aka Baby Face Nelson, came the AIP double-billed *The Bonnie Parker Story* and *Machine Gun Kelly* in 1958. Allied Artists released *Al Capone* in 1959, in January 1960 Lindsay Parsons Productions, with distribution by Allied Artists, released *The Purple Gang*, a story of Detroit's hoodlums. These films were followed by the Le-Sac production of *Pretty Boy Floyd* and the Warner Bros.–distributed *The Rise and Fall of Legs Diamond*, both released in February 1960. Screen Classics' production *Ma Barker's Killer Brood* opened in June of the same year and a month later Princess Productions' (Twentieth Century–Fox distributed) *Murder, Inc.* was released, which followed the exploits of killers Abe "Kid Twist" Reles and Louis "Lepke" Buchalter. In 1961 Warner Bros. produced *Portrait of a Mobster*, a Dutch Schultz biopic, and Thalia Films produced *Mad Dog Coll*, which

was distributed by Columbia. Allied Artists closed out the year with *King of the Roaring 20's—The Story of Arnold Rothstein*. Other films that shared the same period setting and that also featured gangsters include *The Music Box Kid* (1960), an independent programmer, and those that had relatively lavish production values such as *Love Me or Leave Me, Pete Kelly's Blues* (both 1955), *Party Girl* (1958), and *Some Like It Hot* (1959).

This cycle of films sat alongside the contemporary exploitation of Prohibition-era hoodlums in television, which included NBC's *The Lawless Years* (1959–1961) and the extraordinarily popular *The Untouchables* (Desilu Productions), which ran for four seasons during 1959–1963 (the first two episodes being released theatrically as *The Scarface Mob* in Britain in 1960 and two years later in the States). The first season's attractions featured most of the hoodlums also portrayed in the film cycle.³ The gangland subject matter of *The Untouchables* had been preceded by the television series *Gang Busters* (1952), from which the producers spun off a feature film, *Gang Busters* (1955), and reedited three episodes as *Guns Don't Argue* (1957), which was given a theatrical release. Gangland was also the setting for *The Roaring 20's* (1960–1962), which ran for two seasons and was Warner Bros. Television's attempt to share *The Untouchables'* success in the ratings.

Paperback publishers produced numerous titles on the lives of Prohibition-era gangsters; between 1960 and 1962 Monarch Books published biographies of Baby Face Nelson, Dutch Schultz, Legs Diamond, Lucky Luciano, Frank Costello, and John Dillinger, as well as a novelization of the film *Mad Dog Coll*. Pyramid Books carried John Roberts's novelization of *Al Capone* alongside his original novel *The Mobster* (1960), while Signet published Harry Grey's fictional account of Dutch Schultz, *Portrait of a Mobster* (1958), later to be produced as a film by Warner Bros., and his 1953 novel *The Hoods* (eventually adapted by Sergio Leone as *Once upon a Time in America*). This publishing activity only scratches the surface of the paperback industry's exploitation of the nefarious doings of 1920s and 1930s gangsters, which was complemented by the retelling of their stories in men's adventure magazines.⁴ Radio too played its part by featuring Prohibition-era gangsters in the long-running series *This Is Your FBI* (1945–1953), *Gang Busters* (1935–1957), and *Suspense* (1942–1962). Arguably more important than either magazine, book, film, radio, or even television in the contemporary proliferation and dissemination of images and stories concerned with Prohibition-era hoodlums was the comic

Crime Does Not Pay (1942–1955), published by Lev Gleason and edited by Charles Biro and Bob Wood. At its height in the 1950s, it was selling a million copies a month until it was brought to a close as part of the crackdown on crime and horror comics.⁵ *Crime Does Not Pay*, and its many imitators, repeatedly covered the careers of gangsters such as Baby Face Nelson, Pretty Boy Floyd, and John Dillinger.⁶

In order to counter claims of glorifying the criminal and encouraging acts of imitation, the Production Code Administration (PCA) had effectively thwarted the use of the names of real-life gangsters in fiction films, but following the 1945 release of the King Brothers production of *Dillinger*, the moratorium on the exploitation, in Will Hays's words, of an "actual criminal figure from current life" was effectively ended.⁷ With the breakup of the studio system, and the consequent weakening of the PCA's control over film content, the new independent production companies undertook the exploitation of the public's prior knowledge of notorious gangsters with enthusiasm. The economic logic of this production strategy was clear to all; as the *Hollywood Reporter* remarked, *The Bonnie Parker Story* "finds exploitation in the name of a real criminal instead of an established star."⁸ The use of real-life hoodlums was so profitable that in January 1958 the same paper drew attention to an ongoing attempt by Kroger Babb's Hallmark Productions to secure an injunction that would prevent Sam Katzman and Clover Productions from using the name "Pretty Boy Floyd," over which Babb claimed sole ownership. The injunction was denied.⁹ A film purporting to tell Floyd's story was eventually made, but not by either Babb or Katzman. The Le-Sac production of *Pretty Boy Floyd* was released in January 1960, just over two years after *Baby Face Nelson*.

If there was something of a rush to exclusively claim the better-known names, the roster of actual gangsters is represented, or at least name-checked, throughout the cycle regardless of who is featured in a film's title. Dillinger, for example, appears or is referred to in *Baby Face Nelson*, *Pretty Boy Floyd*, *Ma Barker's Killer Brood*, and *Machine Gun Kelly*. Actors also migrated from film to film in the cycle, or from film to television. Mickey Rooney was in *Baby Face Nelson* and *King of the Roaring 20's*; Dorothy Provine, who had the title role in *The Bonnie Parker Story*, reappeared as the lead in the television series *The Roaring 20's*; and Ray Danton played Legs Diamond not only in *The Rise and Fall of Legs Diamond* but also in *Portrait of a Mobster*. In the latter film, Vic Morrow, who played Dutch Schultz, gave a performance that was modeled on Rod Steiger's Capone

in *Al Capone*. (Both actors choose to display ostentatious supplication in appealing for understanding or trust from others. In its excess, this pretense reveals rather than hides the characters' true psychotic personalities). In such ways, actors, characters, and performances produce notable interconnections across the cycle.

The recurring use of a gallery of bit-part actors also created overlaps between the films. Before playing Al "Creepy" Karpis in *Ma Barker's Killer Brood*, Paul Dubov had occupied the same role in two episodes of the TV series *Gang Busters* parts of which were reused in *Guns Don't Argue*. Dubov also had a small part in *The Purple Gang*. Similarly Frank De Kova appeared in *Machine Gun Kelly*, *The Rise and Fall of Legs Diamond*, and *Portrait of a Mobster*, and Joseph Turkel performed in *The Bonnie Parker Story*, *The Purple Gang*, and *Portrait of a Mobster*. De Kova and Dubov had roles in the first episode of *The Untouchables*, and Turkel later appeared in the series on five separate occasions. These roles were reinforced by the numerous appearances these bit-part actors had in contemporary-set crime films and television series.

Conforming to stereotype, De Kova in *Legs* and *Portrait* played a sleazy Italian gangster, an ethnic caricature commensurate with his roles as a "red injun" or Mexican elsewhere. Turkel's pinched rodentlike features and wiry frame made him a perfect casting choice to play hoodlums who seem to have just stepped out of the pool hall or dusted their knees following a game of craps in an alley. De Kova and Turkel are part of the period's rogues' gallery—a lineup of familiar faces that help produce the period's iconography of crime.[10]

Repetition of the same library or stock footage from film to film added to the cycle's iconography. Montage sequences of newsreel imagery are endemic, with little being unique to the production in which the sequence is inserted. According to the film historian Carlos Clarens, at least a third of *Dillinger* was constructed out of stock footage, both documentary and fictional, even incorporating a significant segment of the armored car heist sequence from Fritz Lang's *You Only Live Once* (1937).[11] *Al Capone* and *The Purple Gang* (both Allied Artists productions) shared the same archive newsreel from the age of Prohibition, and the latter reused staged footage of storefronts being bombed, machine guns being fired, and cars crashing that had appeared in the former (and these images may well not have been originally shot for this production). *Mad Dog Coll* recycled both found footage of the Prohibition era and an opening shot of a burlesque marquee

that is a direct steal from the opening of Samuel Fuller's *Crimson Kimono* (1959). *The Rise and Fall of Legs Diamond* presented a twist on the use of library documentary footage by having Legs watch newsreels as he tours around Europe, a means of keeping him (and the film's audience) informed about developments in the underworld back home. *Murder, Inc.*'s montage used still rather than moving images, mixing actual crime scene photographs with re-creations that feature the film's actors. *Portrait of a Mobster* integrates period footage to provide wide shots of exterior locations before cutting to medium or close-up shots of the actors on stage sets. These were not films that made any particular claim to uniqueness or originality. Instead they made a virtue of the recycling of actors and material.

Beyond the narrative and economic efficiencies provided by shared and recycled elements, these meditations on the figure of the gangster were designed for maximum impact in their appeal to an audience with a predisposition for the sensational. As the pressbook cover for the film *Baby Face Nelson* announced, exhibitors should "SELL IT SENSATIONALLY!" The publicity claimed the portrayal of the gangster was "More Vicious Than Little Caesar! More Savage Than Scarface! More Brutal Than Dillinger!" Baby Face Nelson: "The Deadliest Killer of Them All! . . . The 'Baby-Face Butcher' who lined 'em up—chopped 'em down—and terrorized a nation!" "It slams you in the guts with a bellyful of lead! . . . Mickey Rooney as the baby-faced punk who became the FBI's Public Enemy No. 1!" This was the "shock-angle bally" that was to sell the film. The pressbook called the movie an "exploitation picture" and added that the promotional material "carries that 'extra' selling kick."[12] In its promise to deliver a "*more* vicious . . . *more* savage . . . *more* brutal" depiction of gangland violence than has been previously seen, the film's exploitative strategies are laid bare.

In all their many guises, crime films can be seen as part of what the scholar Will Straw has defined as the urban exposé, in which one finds "a variable balance between the ameliorative impulse toward documentation and the exploitational imperative to produce moments of textualized sensation."[13] This is particularly true of the cycle of crime films that paralleled the gangster biopix. In the *Motion Picture Herald* review of the contemporary exposé *Inside the Mafia* (1959), there is a direct acknowledgment of the grounds upon which the film will be sold: "Exploitation, accentuating newspaper headlines, is limitless in this particular instance." The film is a late entry in the cycle that initially exploited the topicality and headline-grabbing attraction of the findings of the Special Committee to Investigate

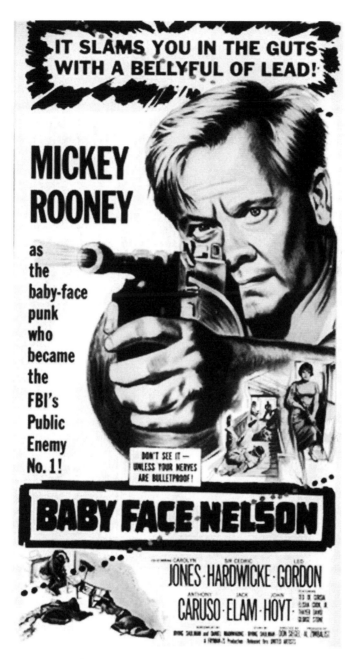

FIGURE 18 Trade press advertisement for *Baby Face Nelson*. A story with "guts" about a "baby-face punk."

Organized Crime in Interstate Commerce, popularly known as the Kefauver hearings, which ran from May 1950 to July 1951.[14] Earlier films that worked a connection with the hearings, and could claim to be as timely as today's headlines, include *711 Ocean Drive* (1950), *The Enforcer* (1951), *The Racket* (1951), *Hoodlum Empire* (1952), and *The Captive City* (1952).

Ronald Wilson notes how filmmakers' attempts "to narrate the story of organized crime produced several cyclical variants of the syndicate-film format." These included the city exposé/confidential films that Will Straw has documented and the witness protection films that Wilson engages with, as well rogue cop and police procedural films. Closely allied to these cycles are films about the labor rackets, including *The Mob* (1951), *On the Waterfront* (1954), *Rumble on the Docks* (1956), *Edge of the City* (1957), *The Garment Jungle* (1957), and *The Big Operator* (1959). Yet another variant was the cycle of gangster films with "turn-of-the-century" settings, films that purported to show the syndicates' deep roots and the authorities' response to organized criminal activities, notably *The Black Hand* (1950), *Black Orchid* (1953), and *Pay or Die* (1960). These corresponded with syndicate films such as *Chicago Syndicate* (1955), *Never Love a Stranger* (1958), and *Underworld U.S.A.* (1961) that had contemporary settings but also flashed back to provide a historical context for present-day gangland activities. Some of the films in the biopic cycle also represented this longer history of crime.

The opening narration for *Al Capone* explains that the gangster's story and the Roaring Twenties have "an important meaning for us today." At the film's close, following the revelation of Capone's death, the voice-over returns to the theme of connecting the past with the present: "We must continue to fight the remnants of the organization he built that still touches every one of us today." The film's claim to topicality lies in what it has to say about the roots of contemporary organized crime, controlled by anonymous mobsters working in combination with others. The lone gangster who controls an empire of crime is shown to be an anachronism. *The Rise and Fall of Legs Diamond* is the story of a maverick, an individual who rises to prominence within gangland; his fall comes when the criminal fraternity forms a "combine—a syndicate, nationwide." Rather than end with the demise of the individual gangster, *Murder, Inc.* begins at that point, telling the story of Lepke Buchalter and his marshaling of a gang of hit men led by Abe Reles (Peter Falk). The film spans the historical divide between the demise of Al Capone and the contemporary era. Prohibition is over,

Lepke tells Reles: "We're working now like a combination . . . like any sensible business"—or, as the DA describes the syndicate, like "a government within a government." Films such as *Al Capone*, *Legs Diamond*, and *Murder, Inc.* told the story of the origins of these combinations, which linked them with a cycle of crime films with contemporary settings that explicitly set out to expose the many arms of organized crime.

The historical setting of the biopic cycle would appear to contradict the idea that these films had the same topical relevance as those films that directly exploited the Kefauver investigations. Certainly this was the position a reviewer in the *Hollywood Reporter* took with regard to *Baby Face Nelson*, which he argued "seems as much a period piece as a 19th century Western about Billy the Kid."[15] The *New York Times* reviewer agreed, though he thought it was the film's formulaic story that was out-of-date; it was, he said, "a thoroughly standard, pointless and even old-fashioned picture, the kind that began going out along with the old-time sedans. As a matter of fact one of the few absorbing sights in this UA release . . . is a continual procession of vintage jaloppys chugging in and out of the proceedings."[16] Other reviews of films in the cycle noted the historical nature of the subject but also made the point that this was recent history; the *Motion Picture Herald* commented that *Ma Barker's Killer Brood* was "a forceful study of a not-so-long-ago crimeland era."[17] Writing in the *Hollywood Reporter*, Jack Moffitt considered the historical veracity of *The Bonnie Parker Story* in his review and added a personal angle: "Miss Provine's performance gives promise for a credible acting future. She's much better looking than the real Bonnie but, despite the accuracy of her cigar-smoking, her dialogue is monotonously on a tough key. The real Bonnie (who I knew in Kansas City) could scare you to death by smiling and saying 'pretty please.' "[18]

The dialogue between past and present is most visually manifest in the costuming. *Al Capone* takes notable care with dressing its actors in fair approximations of 1920s styles; men's headwear includes homburgs and straw boaters, rather than 1950s fedoras with low crowns and wide brims that dominate elsewhere in the cycle. Spats and co-respondent shoes (black and white, aka spectators) are noticeable, as are double-breasted suits with wide lapels worn with waistcoats. The women in the film are also costumed with some regard to 1920s trends, but their dresses are cut tightly into the waist and too much cleavage is shown. The dressing of actresses in cantilevered brassieres across all the films in the cycle, which with a tucked-in waistline and a tight skirt accentuate an hourglass figure, had little to do

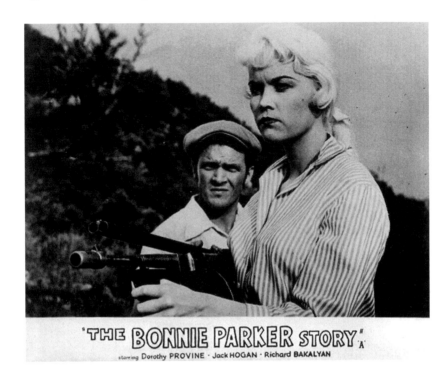

FIGURE 19 Publicity still for *The Bonnie Parker Story*. Depression-era outlaws recast for the rock 'n' roll age.

with either 1920s or 1930s fashions and everything to do with a 1950s ideal-ization of a female body shape.

Apart from some vintage cars and two verbal and textual declarations that the film is set in the mid-1930s, *Murder, Inc.* is the film least con-cerned with maintaining specific period identity; no one is dressed in thir-ties clothing. There are no homburgs, no straw boaters, and coats, hats, and shoes for both men and women are all contemporary with the film's production. The leading actress's blond hair is worn long and unpermed, which was inappropriate for women's hairstyles of the 1930s but completely in accord with the early 1960s.

Locations also offer moments of temporal contradiction and confu-sion. Much of *Murder, Inc.* is shot on stage sets, though it has some notable exterior scenes, many filmed on empty city streets. However, one short sequence uses the crowded public space of a train station. The scene is com-posed in long shot with the camera positioned high above the concourse,

FIGURE 20 Publicity still for *Murder, Inc.* Neither the settings, costumes, nor hairstyles in this film make any concession to historical authenticity

though not so far away that we are unable to identify Peter Falk/Abe Reles. As the gangster crosses the concourse, the people surrounding him go about their business, paying him no mind. It is a snapshot of a train station in 1960; there is no attempt to dress the space or the crowd in period detail. Only our having been told that the film is set in the "mid-thirties" and that the events portrayed are "factual and the people real" contradicts the scene's contemporaneity.

This disregard for historical verisimilitude is in stark contrast with the gangster pictures with 1930s settings made in the late 1980s and early 1990s, which included *The Untouchables* (1987), *Miller's Crossing* (1990), *Mobsters*, and *Bugsy* (both 1991). Anachronisms do appear in this cycle (not the least of them, in keeping with the 1950s, involving female undergarments), but there is an extraordinary obsession with period detail, to the point that gratuitous scenes and moments are given over to emphasizing costume, particularly drawing attention to men's hats. This aspect of the 1990s retro gangster film was using costuming to reinstate an image of hegemonic masculinity—a nostalgic retrenchment into outmoded gender orthodoxies.[19]

The 1950s gangster biopic cycle is not nostalgic; it is fixated on the present and concerned with marking the films as topical, so they are seen to be of the moment, producing a distinctive dialogue between "past" and "present." On *Baby Face Nelson*'s fast and free approach to historical verisimilitude, Geoffrey O'Brien in a laudatory 2006 review wrote:

Some appropriate clothes and cars are provided to avoid blatant anachronism— the cars more than earning their rental fees since so much of the movie is devoted to shots of them tooling along obscure country backroads—but otherwise *Baby Face Nelson* feels absolutely like a movie about the mid-Fifties. In fact, with black-haired Carolyn Jones (as Rooney's faithful-unto-death girlfriend Sue) coming across as an archetypal Beat Girl, [and] Van Alexander's jazz score pouring out large doses of West Coast Cool... Baby Face Nelson taps into a mood of subcultural nihilism far more effectively than those exploitation pictures that attempted to take on the Beats directly.[20]

FIGURE 21 Publicity still for *Baby Face Nelson*. As in *The Bonnie Parker Story*, the outlaw couple are reimagined for a postwar generation.

Despite O'Brien's claim that *Baby Face Nelson* stands apart from the rest of the cycle in its "lack of interest in even making a gesture toward period flavor or historical perspective," all the films exhibit readily identifiable anachronisms and use automobiles as the principal means of signifying a 1930s time period. *The Bonnie Parker Story*, which could also be said to tap into a mood of "subcultural nihilism," opens with a voyeuristic view of Bonnie undressing in a locker room. Parker's dress, undergarments, and hair all conform to 1950s styles. An instrumental rock 'n' roll soundtrack, principally produced on an electric guitar, aurally underscores the sense of contemporaneity. At the end of the title sequence the film's setting is verbally announced and reinforced in text: "Oklahoma City—1932." This announcement undercuts the preceding visual and aural clues, creating temporal instability that allows for the reception of the film as both historically located and yet contemporaneous with the time of its initial screening.

Using slang straight out of a 1950s JD or beatnik movie, Bonnie wants "kicks—real kicks, big city style." The eponymous villains in *Pretty Boy Floyd* and *Mad Dog Coll* are also out for "kicks": "power and kicks" for the former, and "killing for fun and kicks" for the latter. Apart from incorporating the occasional 1920s jazz motif into the mix, the soundtrack to *Machine Gun Kelly* is as contemporaneous as *Baby Face Nelson*'s and *The Bonnie Parker Story*'s. Rather than West Coast cool or rock 'n' roll, *Kelly* opens with a rhythm and blues mix of squalling saxophones. There are no beatnik allusions in the film, but the men's haircuts are fifties-style, and the suits are all off the rack, with narrow lapels and cut straight at the waist; only the occasional character wearing a newsboy flat cap suggests any interest in replicating thirties fashions. Returning to *The Bonnie Parker Story*, toward the end Guy (the Clyde Barrow character), eagerly defined as a white hipster throughout the film, is shown lying back in an easy chair and blowing on a saxophone; a cornet or clarinet might more readily represent the 1930s. Following the ambush in which Bonnie and Guy are killed, the saxophone is seen for a second time, now lying alongside a tommy gun in the smoking wreck of an automobile—a symbol for the bebop age, not the age of swing. With such signifying practices the film transfers the illegitimacy associated with 1930s gangsters to the unproductive society of JDs and Beats.

While films such as *The Bonnie Parker Story* make no overt claim to topicality, *The Purple Gang* does make an explicit connection with the day's

headlines. The film opens with a prologue supplied by California congressman James Roosevelt. He believes the same sickness that lay behind bootlegging is still present today; the symptoms have changed, but the illness remains the same, and only an informed and vigilant public can provide the cure. (His message will be reinforced at the end of the film, when the protagonist says in a voice-over: "The times have changed, yet the daily headlines remain the same.") A text crawl follows that aligns Prohibition-era gangsters with juvenile delinquency. The premise of the congressman's appeal for public vigilance to help counter delinquency is that *The Purple Gang* provides a history lesson from which we might better understand contemporary criminality.

A number of the films in the biopic cycle made similarly direct associations between prewar hoodlums and postwar delinquents. The independent trade journal aimed at exhibitors, *Harrison's Reports*, linked the hoodlums in *The Purple Gang* openly to their later counterparts through a use of contemporary nomenclature: "a teen-age rat pack operating out of Detroit's slums and led by the psychotic Robert Blake."[21] Similarly the *Motion Picture Herald* noted the correspondence, overtly relating the production company's exploitation of topical subjects with the film's historical dimension: "Lindsay Parsons, whose Allied Artists releases have had critical and audience acclaim for their briskness of approach and topical subjects, has turned engrossing attention to Detroit's fabled Purple Gang, the Manor City juvenile mob which emerged as one of the country's most feared band of racketeers."[22] "Rat-pack terrorists" is the term police lieutenant Harley (Barry Sullivan) uses to describe Detroit's hoodlums. When the gang was still no more than a group of teenagers running wild on Hastings Street, moving up from petty theft to shakedowns, Harley had confronted the boys' welfare worker, an earnest young woman who believed the young gangsters would respond positively to more sensitive treatment, a little "psychological readjustment." They have, she tells Harley, "grown up without love and no real feeling of security." Harley dismisses her "three-syllable words." "They are just a gang of punks," he tells her. The gang later rapes and murders the welfare worker.

The Purple Gang is forthright in its statement that delinquents, young and old, are best dealt with by direct and unfettered police action supported by a civic-minded American public. Though the film rejects outright the value of psychological explanations as a means toward solving the problem of juvenile crime, it nevertheless uses popular psychology in its

characterization of the principal characters, particularly the gang leader, Honeyboy Willard, played by Robert Blake. Willard suffers from claustrophobia, and Harley uses his knowledge of the phobia to try to get the hoodlum to crack. By the end of the film Willard is crawling around on all fours, hysterical, a broken boy/man. The psychologically fractured protagonist typifies the cycle; at the close of *Machine Gun Kelly* we are presented with the image of the abject gangster: Confronted by the law, Kelly withdraws into a fetal position at the feet of the arresting officers. By the close of *Mad Dog Coll*, the gangster is completely delusional. Coll dies in a shootout with the police in a drugstore; his death crawl takes him out onto the street; his last words are "I hate . . ." At the beginning of the film the narrator had asked the question of how Coll would have turned out if his father had been a high school principal; would he have been like other kids, or was he born different? The film does not give a definitive answer, shifting attention away from complex problems of determination by deferring attention onto the commonsensical and simplistic solution of shooting "mad dogs."

The gangster biopic and juvenile delinquency cycles shared a generalized concept of how to understand and explain criminality. For the most part the films proposed that criminal careers are nurtured on urban streets, or in an environment of rural deprivation, which was very much in keeping with earlier explanatory schemes given by the movies.[23] Social explanations for criminality, however, are often contradicted within the films by recourse to popular psychology that explains deviancy in terms of individual complexes. *The King of the Roaring 20's* is a good example of how the contradiction between determining factors works. Arnold Rothstein comes from an upper-middle-class family, but as a juvenile he spends all of his free time on the streets. Street life forms the man and helps to explain his move into a criminal career, but it is not the only explanation offered; in an echo from 1927 of *The Jazz Singer's* Oedipal mutiny, the Jew, Rothstein, rebels against the word of his father and chooses the secular streets over respectability and ethnic tradition. In this instance it is not lack of opportunity but a failure of character that explains the criminal. Whatever the explanation given for lawless behavior, whether sociological or psychological, it is always crude and reductive, a caricature of sophisticated and complex theories.

The casting of the films fostered a notable overlap with juvenile delinquency movies, both the heady exploitation films produced by AIP and

Allied Artists and those financed and distributed by the older studios that strove for a greater social realism. Richard Bakalyan, who was Bonnie Parker's husband in *The Bonnie Parker Story*, initially made his mark in an independent production directed by Robert Altman, *The Delinquents* (1957), and went on to become something of a JD icon; Vic Morrow, who played the deranged Artie West in *Blackboard Jungle* (1955), is cast as Dutch Schultz in *Portrait of a Mobster*; John Davis Chandler, who played a despicable gang member who murders a blind teenager in *The Young Savages* (1961), has the role of Vincent Coll in *Mad Dog Coll*; and Fay Spain, who had the female lead in *Al Capone*, had previously played the leader of a female gang in *Teenage Doll* and a hot-rodder in *Dragstrip Girl* (both 1957). Such casting visually linked the gangster and the JD films together, but it was also designed to garner interest from a core filmgoing constituency. As the *Motion Picture Herald* noted about the casting of the lead in *Pretty Boy Floyd*, "John Ericson, of considerable marquee weight, to the vitally important teenage film audience as well as to the post-35 age group that will patronize an appealing motion picture, tops the cast of this Le-Sac . . . attraction."[24]

The casting of Mickey Rooney as Baby Face Nelson had little to do with making connections between the biopic and JD cycles, but it was not wholly unrelated to representations of adolescence. The role helped Rooney promote a persona far removed from his origins as a song-and-dance man and the boy-next-door in the Andy Hardy series. Audience memories of that wholesome juvenile, however, must surely have informed the reception of his portrayal of a psychotic killer in *Baby Face Nelson* and his subsequent tough-guy persona in two 1959 crime films, *The Last Mile* and *The Big Operator*. In the former Rooney plays "Killer" Mears, a man on death row who leads a prison riot, and in the latter he plays the labor racketeer "Little Joe" Braun, a particularly heinous character.[25] The *Motion Picture Herald* described Rooney's gangster in *Baby Face Nelson* as a "warped sadistic killer"; the actor, it reported, "proves once again his versatility as an accomplished performer [and] sinks his teeth into the role and shakes it for everything that is in it." The journal's reviewer noted that the "physical attributes of Nelson match those of Rooney, in the two respects of short stature and a round, young face, which provides even greater verisimilitude to the role."[26]

Rooney's lack of height recalled the casting of the lead figures in the canonical gangster films: James Cagney in *The Public Enemy*, Paul Muni and George Raft in *Scarface: Shame of a Nation*, Humphrey Bogart in *The*

Petrified Forest, and, of course, Edward G. Robinson in the aptly named *Little Caesar*. Other films in the cycle followed *Baby Face Nelson* in using short actors in the lead: Robert Blake in *The Purple Gang*, Peter Falk in *Murder, Inc.*, and John Davis Chandler in *Mad Dog Coll*. Even the "distaff side of American crime" was portrayed as undersized. The *Motion Picture Herald* suggested that Dorothy Provine's portrayal in *The Bonnie Parker Story* might not be credible to some audience members who "will challenge the excess viciousness attributed to a diminutive member of the fairer sex."[27]

The gangster as runt underlined a commonsense view that deficiency in height equates with an inferiority complex, and hence the resentment of and resistance to authority. *Baby Face Nelson* repeatedly emphasizes Rooney's/Nelson's diminutive stature. The gangster is infantilized in both name and body, from sloshing around in a bathtub to being picked up off a bed by a policeman as if he were a child, and when Nelson first meets John Dillinger it is at a children's playground. The gangsters sit on swings, above which a sign reads: "No Children over the age of 12." Coded messages between mobsters that appear in newspaper advertisements ("Baby—call. Daddy needs you") further instantiate the infantilization of adult men. It is Dillinger, significantly known as "the Big Man," who names Lester Gillis "Baby Face," but it is Gillis's girl, played by Carolyn Jones, whose surname, Nelson, becomes his alias. Lester, it is suggested, is just a little too ready to lose his patrilineal privilege when he takes her name. After cooling him down following a killing by repeatedly calling him "Baby," Sue says, "You've got all of me but my name. Why don't you take that too?" "Yeah, okay," replies Gillis, "any name's better than my old man's."

In terms of characterization, the figures in the film are all drawn with broad strokes, as caricatures rather than nuanced and complex individuals. Dillinger—the Big Man—played by Leo Gordon, and the "brain guy," played by the lanky Jack Elam, contrast with the pint-sized Rooney. The use of other undersized actors like Sir Cedric Hardwicke, who plays the mob-employed doctor who tends to Baby Face's wounds, and Elisha Cook Jr., playing a gang member Nelson knocks around, compounds the film's reliance on caricature. The *Hollywood Reporter* indirectly called attention to the film's cartoonlike presentation when describing its characters as "stark" and "flat." The film, it argues, has "none of the contemporary effort to provoke and understand the how and the why. The characters are vicious but flat and never very interesting."[28] Taking a banker hostage, Nelson rides with him in the back of the getaway car. Noticing that he has an inch or

two in height over the man, Nelson pulls himself higher in his seat and asks the hostage whether he has considered using lifts in his shoes. The banker replies he is wearing them. With caricature, size matters.

This period of film production was a high point in the popularization of psychoanalysis as a means of explaining character motivation, such as that seen in the cycles of police procedurals and rogue cop movies. Will Straw has noted that the cycles display a "transformation of police characters from undeveloped ethnic figures of ridicule or inconsequence to fictional persona whose characterological density is the pivot around which narratives frequently turn." The gangster biopix resolutely reject psychological depth and complexity. In contrast to the generic novelty of policemen as "bearers of class resentment or disgust at urban degradation" in *The Prowler* (1951) or *On Dangerous Ground* (1952), the gangster is a ready-made, familiar, conventionalized and standardized figure.[29]

It was, however, precisely this very lack of psychological subtlety in American action movies and their use of the visually arresting image that would appeal to the cinephiles and cineastes in France. Jean-Luc Godard wrote in 1959 of François Truffaut's *Les 400 Coups*, then in production, that its "dialogue and gestures [would be] as caustic as those in *Baby Face Nelson*."[30] Later, Anglo-American critics with a cultish appreciation of postwar American films, such as Geoffrey O'Brien, would echo Godard's sentiments: "You keep waiting for the false note—the grandiloquent symbol, the self-conscious lyrical touch, the hammy emotional explosion, the heavy-handed injection of sociology or psychology—and it never comes."[31]

The pop-Freudian explanation for the gangster's "warped sadism"— that he is undersized and has an Oedipal complex—is as sophisticated as the films get in "explaining" their characters' subconscious motivations. *Mad Dog Coll* opens with the title character walking through a cemetery at night, dry ice swirling around his ankles, as if he's in a scene from a cheap horror movie. Coll stops before his father's grave and fires a machine gun at the tombstone—a fantasy that sees him obliterating the man that beat him senseless for being a mama's boy. By the film's close, Coll is completely delusional and psychopathic, symbolically killing his father again and again.

Alongside rudimentary articulations of Oedipal complexes, visual images of emasculated men appear in all the films in the cycle. In *Machine Gun Kelly* two minor characters are used to maximum effect: the fey Fandango, whom Kelly employs to ferry booty from bank and kidnapping jobs, and Harry,

FIGURE 22 Publicity still for *Machine Gun Kelly*. Gangsters, big guns, and Freud.

who might or might not have lost the use of his right arm when mauled by a lion. Harry now runs a gas station behind which he has a small zoo stocked with monkeys and a mountain lion. Fandango dips into the takings from a bank job, and Kelly punishes him by pushing him against the lion's cage; he loses his left arm. Toward the end of the film Harry and Fandango are placed side by side, two matched one-armed men. Among the many instances of the signifying of impotence in the film, the most withering occurrences are built around Kelly's frailties. His girlfriend tells Kelly that she had "mothered" him until he was able to prove he was a man, but when tested he falls short of the potent ideal she desires. Faced with images of death—an empty coffin carried in the street, a skull-and-crossbones tattoo on the back of a man's hand—Kelly becomes immobilized; fear runs through him, and he is exposed as being "naked yellow." His tommy gun is revealed to be just a prop to hide his lack of virility. When federal agents at the film's close take him away, they mock the cowed gangster, infantilizing him as "Popgun Kelly."

Demeaning the gangster is a key narrative strategy in this cycle, and a primary means of achieving this is through name calling, most commonly

naming him a "punk," which takes place not only in the films' dialogue, but also in publicity and in reviews of the films. The *New York Times* thought Rooney's character Baby Face Nelson was "nothing more than a rotten, sadistic punk without one redeeming trait."[32] *Harrison's Reports* called the title character in *Pretty Boy Floyd* "a cheap punk who made it big."[33] Even Rothstein in *King of the Roaring 20's* and Capone in *Al Capone* are called punks early in their criminal careers to signify both their youth and the lack of respect they are held in by older and more powerful figures to whom they nevertheless pose an inchoate threat. In contemporary-set *Chicago Syndicate* the mob boss takes a nostalgic tour of the neighborhood he grew up in and recalls the time when he was a "young punk." Being a "punk" was something you left behind with your youth, a measure of the distance since traveled from ghetto to penthouse, from juvenile to adult, by Capone, Rothstein, and the Chicago mobster.

"Punk" is used with such extraordinary repetition across this cycle that it becomes a commonplace, barely registering when once it was remarkable. In *Murder, Inc.* DA Burton Turkus asks police lieutenant Tobin how he would deal with the hoodlum problem, and the Irish cop gives it to him straight: "Play dirty. Show the neighborhood what they are—bums, punks, hoodlums." Finally cornered and spilling all he knows to the authorities, bum, punk, hoodlum, and hit man Abe "Kid Twist" Reles tells the DA, "Any punk we hit deserved to be hit." In *Portrait of a Mobster* Dutch Schultz is confronted in the Bronx by a delegation of "spaghetti benders," he dismisses them and their attempt to coerce him into joining their Chicago organization. He tells the "greaseballs" that "in that town, any punk can be big." In *The Big Operator* a union thug asks a hardworking stiff a leading question: "When a mobster knocks off a punk, why does he always leave a dime in his hand?" The answer is that the dime shows how little his life is worth. A punk is anyone considered beneath contempt, and naming someone as such calls into question his masculinity.

In *The Bonnie Parker Story*, Bonnie is introduced waiting tables in a greasy diner. Her husband, Duke Jefferson (Richard Bakalyan), is serving a 175-year jail sentence, and as a wife of a convicted criminal this is the best job she can find. As she explains to the owner: "All I ever met was punks; they come from no place, going nowhere." She hooks up with Guy Darrow (Jack Hogan), who sports Elvis-like sideburns and a Brando-esque penchant for walking around in a white undershirt. (Guy had caught her eye

when he pulled out a tommy gun with the cool intent to impress a girl such as Bonnie with the size of his weaponry—an image of potent masculinity, a virility that has been denied to her in her relationships with "punks.") Guy, though, fails to fulfill Bonnie's desire, and toward the end of the film she tells him what she really thinks of him: "You're a punk! You can stand on your head but you'd still be a punk."

More than anything, Ma Barker hates sissies. She wants her kids to show plenty of guts, and in *Ma Barker's Killer Brood* she follows gang member Al Karpis's maxim that guts are more important than brains. Surrounded by the police, the old woman plays out her final hand and for the last time attempts to beat the sissy out of one of her boys. Cajoling a cowering Fred Barker to take action, she calls him "a gutless punk, you're as yellow as your old man." Caught between a castrating mother and representatives of the law, suitably chastened and emasculated, Fred dies a punk's death in a hail of bullets. Similarly, Charles Bronson's eponymous character in *Machine Gun Kelly* is called a punk by a Ma Barker type, who has little time for his ineffectual bragging and is able to see his virile posturing for what it is, no more than an empty gesture.

In *Portrait of a Mobster* the female lead wants a man who can live up to the masculine ideal embodied by her recently deceased father, not a punk. She's sick of weak men, she tells her policeman husband. He, though, like Guy Darrow, fails to fulfill the masculine ideal. "Lean on me," says Dutch Schultz, who exploits her frustration and dissatisfaction with her husband. However, unbeknown to her, Schultz is the killer of her father. Her punishment for having an illicit desire for Dutch is to become a lush, trapped in a loveless relationship. Good (whole) men are hard to find, this cycle of films contended, but emasculated infantilized punks seemed to be everywhere. The semantic work of the term "punk" thus undermined (and unmanned) upstart hoodlums.

"Punk" is used in the same manner in films that more explicitly exploit the hot topic of juvenile delinquency. In *Rebel without a Cause* (1955), in response to the bully, Buzz (Corey Allen), who is goading him into a fight, Jim Stark (James Dean) says, "I thought only punks fought with knives." In *Four Boys and a Gun* (1957) and *Stakeout on Dope Street* (1958), the JDs are called punks, by an authority figure in the former and by older hoodlums in the latter. In the 1961 musical *West Side Story*, Officer Krupke confronts the Jets, a street gang, and threatens to "run *all* you punks in!" and they respond, in song:

Dear kindly Sergeant Krupke,
Ya gotta understand—
It's just our bringin' upke
That gets us outta hand.
Our mothers all are junkies,
Our fathers all are drunks.
Golly Moses—natcherly we're punks!

The domestication of the word via its comic and musical inclusion in *West Side Story* was new to the movies, but not to other forms of American popular culture. The fairly common usage of "punk" in the 1930s and 1940s in newspaper comic strips, such as *Dick Tracy* and *Terry and the Pirates*, as a means to verbally demean or show a marked lack of respect toward someone, suggests its use was not considered to be particularly offensive at that time, at least in the United States, and certainly not when describing a caricatured underworld figure or street hoodlum.[34] The 1946 edition of Funk & Wagnall's *New Practical Standard Dictionary* gave a "young gangster" or someone who is "worthless and useless" as comparable definitions of the popular use of "punk."[35] This was certainly the dominant meaning in the word's use in Alex Raymond's widely syndicated daily strip, *Rip Kirby*, between August 1946 and April 1947, when "punk" was used in the story's dialogue on eight occasions.[36] The repeated use of the term in the strip suggests there was an accepting familiarity with it on the part of readers, particularly when placed in the context of crime and underworld stories.

In Great Britain, "punk," alongside terms such as "shag" and "sissy," was blacklisted by film censors and hence had been rigorously excised from American films by the PCA in the years prior to the 1950s, though it makes a remarkable, but isolated, reappearance in *Dillinger*, released in 1945.[37] Given its cinematic absence, the emphatic use of "punk" in gangster films in the latter years of the 1950s undoubtedly appealed in terms of its novelty value and its seemingly benign vulgarity; it was taken as an authentic example of lowlife slang that carried a suggestion of indecency in its use. The etymology of "punk," however, reveals the word to be rich in meaning, and utterly indecent, not least in its sexual connotations. The deep roots of "punk" are in Elizabethan slang, in which it was a common term for a prostitute; more recently, in the United States, it was a term for a hobo's or prison inmate's younger male sexual companion. If the term had any shared meaning in England in the 1950s, other than as a vernacular Americanism,

it was (conversely, given its Elizabethan meaning) used to denote a pimp, and hence its problematic standing with the censors.[38]

The post-1940s use of "gunsel" offers a parallel to "punk" in organizing a range of meanings to do with deviancy, crime, sexuality, and power. Often understood as referring to a gunman, "gunsel" is in fact a slang name for a catamite.[39] This is how the term is used by Sam Spade (Humphrey Bogart) in *The Maltese Falcon* (1941) to belittle Elisha Cook Jr.'s character, but ten years later in *Appointment with Danger* (1951), it is used unambiguously by Alan Ladd's postal inspector to describe a gunman. The shared context of commonly recognized acts of deviancy, criminal or sexual, has helped to promote the misrecognition of the meaning of "gunsel." As a prison slang term, the root meaning of "punk," like "gunsel," signified the passive, often coerced partner in homosexual acts. The way "punk" is used in the gangster biopic cycle, there is little, if any, overt signifying of its sexual meaning. The word's sexual connotations, nevertheless, lie behind all of the putdowns that seek to emasculate, diminish, and infantilize the gangster.

The homosexual undertone of the meaning of "punk" is never entirely absent, and certainly adds piquancy to an early prison scene in *Dillinger* when the more mature inmate, Specs Green (Edmund Lowe), explains his philosophy to the jailhouse novice Dillinger: "First society gets careless with the criminal and then the criminal gets careless. First thing to gum things up is a trigger-happy punk. Personally, I have no use for a punk. Some fellers, if you pat them on the back, they'll kill a man for you. If you treat a punk right, you can get the biggest man in the world killed." Though what he is saying is not readily apprehended by the naive Dillinger, Green is obviously describing his young jail mate. This point is confirmed to the audience almost immediately when Green introduces Dillinger to his fellow gang members, including Kirk Otto (Elisha Cook Jr.), who spits judgmentally in his direction and, when Dillinger leaves, calls him a "fresh punk." "He'll learn," says Green. "The hard way," says another. "I think the kid has possibilities," says Green, concluding the scene. To viewers without knowledge of the word's etymology, "punk" is used in this context as merely a way to demean Dillinger the neophyte, who has yet to earn his reputation, but if an audience has any knowledge of prison slang, then the dialogue becomes overly ripe in its sexual inference, adding much to the film's tale of criminal deviancy.

The use of "punk," with its indeterminate meaning, to help indicate a concealed deviant sexuality among the criminal classes can be found in

other forms of popular culture. In *Rip Kirby*, for example, an effeminate underworld character, Boom Boom, is twice referred to as a "punk" and also called a "perfumed little maggot!"[40] Similarly suggestive of sexual deviancy is the camp performance by Mark Rydell, in Don Siegel's JD pic *Crime in the Streets* (1956), who, alongside Sal Mineo, plays sidekick to John Cassavetes's street punk and, in the course of the film, shuns all female attention. This tacit play with the homosexual association of "punk" is made explicit in a 1958 pulp paperback by William R. Cox, *Hell to Pay*, in which a gambler is caught in a war between the syndicate and a gang of punk hoodlums in leather jackets with tall-combed greased hair, high on marijuana and the "Big H." "They're hopped-up punks, at war with the syndicate—and they kill, just for kicks" is how the cover's tag line describes the story's premise. At the close, the gambler discovers that one of his errand boys, Little Skinny, has sold him out to the gang's leader. He witnesses the two punks "fawning" over each other and smells "lavender." Little Skinny, he is "shocked" to discover, is a "deviate." With gangs of young punks going head to head with the syndicate, the gambler is a witness to a "social revolution" made up of "homosexual kids in a world of switchknives and marihuana."[41]

Best known for editing science fiction and fantasy anthologies, Leo Margulies put together a virtual primer on juvenile delinquency fiction and punks in the short story collection *The Young Punks* (1957). Eleven short tales, originally published between 1953 and 1957, are collected together to form the "savage frightening story of the teen-age jungle."[42] A number of the stories are set in city ghettos, telling tales of desperate youth in desperate situations (like *Blackboard Jungle*); others, often with a hot-rod and high school angle, are set in the suburbs, which are seemingly overrun with disturbed middle-class youth (as in *Rebel without a Cause*); a third set of stories deals with straight-out teenage psychopaths. Most of the pieces use "punk" as the noun of preference to describe and contain these youthful miscreants.

Margulies uses the standard editorial ruse of purporting to provide readers with a public service—a warning that action must be taken to solve a problem before it is too late—when what he is really selling is titillation and sensation: "All these stories have to do with juvenile malignancy. They were written to shock you and we make no apology for their stark violence. They are stories behind today's terrifying headlines—stories about a strange, new, frightening cult . . . of teen-age fury."[43] Richard S. Prather's "Sinner's Alley" (1953) is a Shell Scott mystery, part of a long-running gumshoe series that

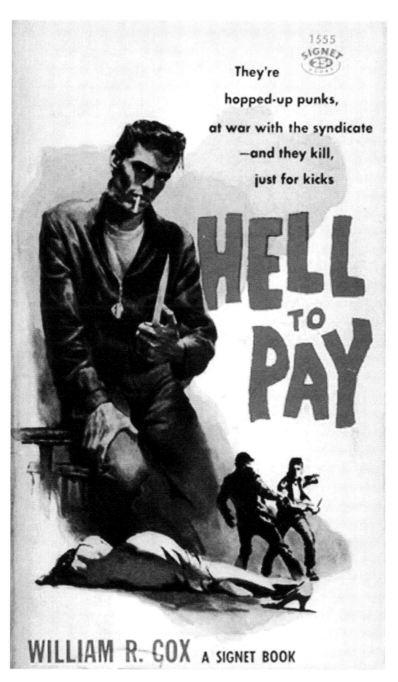

They're

hopped-up punks,

at war with the syndicate

—and they kill,

just for kicks

HELL TO PAY

1555

SIGNET

WILLIAM R. COX A SIGNET BOOK

FIGURE 23 Front cover of the paperback *Hell to Pay*. A story of "hopped-up punks" out for "kicks."

amounted to just over three dozen novels between 1950 and 1987. Scott is in the mold of Mike Hammer, all righteous fists and fury as he goes after the perpetrators of a rape and double murder. Members of the teenage Black Gang are the prime suspects. They are all "rat-faced punks"—an observation that Scott spits out every third paragraph. Hal Ellson, a top JD pulpster, provides "Walk Away Fast": A young white teenager called Irish is friends at school with a black kid called Randy. Randy invites Irish to join his gang, but first he has to undertake an initiation test, which he fails.

> "First or last, he didn't have no right to holler and run. That was the punk showing."
> "Yeah, who says he's a punk?"
> "You heard me talk." . . .
> That stops Buster for a second, but he ain't through. He's ready to explode. "I still say he punked."[44]

The original slang meaning of "punk" is given fresh exposure in "Runaway," a 1954 story in the collection written by Richard Marsten (aka Evan Hunter aka Ed McBain). Johnny Trachetti goes into hiding after being accused by cops of the zipgun killing of Angelo the Wop. While on the lam Johnny encounters a good number of the city's lowlifes; among them are a junkie, who slices open Johnny's arm with a broken syringe, a young prostitute, and five bums holed up in a disused warehouse.

> "Who you brung to dinner, Bugs?" one of the men asked.
> "A nice young punk," the big man answered. "Hurt his poor little arm, though, didn't you, Sonny?"
> Johnny wet his lips. "Yeah, I . . . I got cut." He didn't like the sound of the conversation, and he knew what "punk" meant in prison jargon because he knew enough guys who'd been in and out of Riker's Island.[45]

Johnny is soon on the run again. He has been running all his life.

The shared designation of "punk" to define delinquent juveniles of the 1950s and gangster hoodlums since the 1920s, the compact of crude environmental and psychological means to explain their deviancy, the exploitation of shock and sensation to sell these films, the lack of interest in historical authenticity and verisimilitude, and the dependence upon convention in the telling of these tales produced a formulaic, standardized

product, where differences in temporal settings are little more than superficial appeals to novelty: This ensures that even in their historical guise the films, which form the gangster biopic cycle, are topical—not only because they were part of a broad discursive contemporary fascination with crime and youth, but also because they were conceived as sensational fictions tied to the exploitation of everyday headlines about JDs, albeit ostensibly reworked as history.

7

Dude Ranch Duds

• • • • • • • • • • • • • • • • • • • •

Cowboy Costume

> The rifleman was a woman.
> Her hair was the giveaway; it lay with
> the sheen of wheat down to her shoul-
> ders, where it was caught by her Stetson,
> which had been lost in her retreat and
> now hung down her back from the chin
> strap. Otherwise, at this distance she
> could have been mistaken for a man
> with her worn levis, flannel shirt and
> man's coat.
> —Luke Short, *Blood on the Moon* (1941)

The Zane Grey series western *West of the Pecos* (1945) opens in Chicago in the year 1887 with a doctor telling an ailing meat-packing industrialist, Colonel Lambeth, that he must go west to recuperate. Lambeth's excursion turns out to be rather more exciting than it is restful. While traveling to the Pecos with his daughter, Rill, their stagecoach is held up and robbed. Later, after arriving at their destination, she is accosted in the streets by a couple

of mashers. "No country for civilized people," her father says, "especially not women." Looking at a window display that features a mannequin wearing cowboy clothes, Rill decides to transform her appearance. She ties her hair up and covers it with a Stetson, and puts on cowboy boots, blue jeans, a check shirt, and a calfskin waistcoat. Rill becomes Will. At first she fools her father, and when she reveals her new identity to him, he demands to know what's behind "the idea of this ridiculous masquerade" and emphatically declares: "It takes more than clothes to make a man." Rill spends two-thirds of the film in disguise, misleading all and sundry including the hero, Pecos Smith, played by Robert Mitchum. Only when the demands of romance intercede does the mask drop. The clothes have made and unmade the man, and they are store-bought.

Unlike Rill, Mitchum does not wear blue jeans or a fancy waistcoat. His attire generally consists of a pullover shirt with lace-up neck opening. The shirts, like his gabardine pants, are always neat and crisp and show no sign of wear and tear. He is clean-shaven and freshly laundered. Other than his two six-guns and tooled leather holsters there is nothing fancy or extravagant about the costume, but only in vague outline— the hat, the guns, and the high-heeled boots—does he resemble the late-1880s cowboy that he is supposedly portraying. Mitchum's costume is almost wholly anachronistic, similar to any set of cowboy duds that could be bought from stores, which since World War I had served city folk holidaying at western resorts and dude ranches—the sort of place where Rill bought her cowboy costume.

Mitchum's neatly tailored appearance in *West of the Pecos* is in contrast to his more rugged guise in the Hopalong Cassidy series, where he was featured in the 1943–44 season as an unshaven bad guy in worn blue jeans. Costumed as Pecos Smith, Mitchum also cuts a contrast with his role in the A-feature westerns *Pursued* (1947) and *Blood on the Moon* (1948). Both these films exude an aura of authenticity through visually differentiating themselves by their settings (interiors and exteriors) and costumes from series westerns. The latter were shot quickly and cheaply and made regular use of Alabama Hills, near Lone Pine, California. Just three hours' drive from Hollywood, Lone Pine was one of the most utilized and familiar locations for westerns. *Pursued* was filmed around Gallup, New Mexico, and *Blood on the Moon* at Red Rock Crossing, Sedona, Arizona. These outdoor spaces, miles from Hollywood, provided visual novelty and could be used

as a marketing ploy exploited in studio publicity with pressbooks stressing a film's picturesque and spectacular scenery.

Blood on the Moon begins at night as rain pours down; from behind a tree marking the horizon line, a lone rider appears. Shown in silhouette, a cowboy moves slowly toward the camera, his head bowed against the rain's onslaught. Roy Webb's music score starts dramatically, rising in abrupt movements and then falling to a more restrained refrain as if matching the shifts in the rhythm of the weather. When the rider has reached cover he makes camp, removing his sodden boots to dry out by the fire. Before he is fully settled, stampeding cattle pound his belongings into the ground. When the herd has passed he finds a boot, and then his rifle. All his goods are either lost, wrecked, or covered in mud. Robert Mitchum plays the rider, Jim Garry, who is pitched against the elements; he's a drifter looking for work who finds himself caught up in a dispute over grazing rights and in dirty deals with corrupt Indian agents.

The nocturne settings lit by moonlight and campfires (Nicholas Musuraca's chiaroscuro cinematography has everyone illuminated from below in the film's early scenes), the drenching rain and the mud set this film against the overly bright, dry, and rocky desert landscapes of Mitchum's series westerns. His costume, too, is distinct from the outfit he wore in the earlier films; it is range worn and dirty. Unshaven, he wears a short topcoat made from shearling; under this he has on a denim jacket. Over worsted pants he wears flared and undecorated leather chaps. His gunbelt is worn around his waist, not low on his hip. And in contrast to the others in the film his Stetson has a tall crown, which is pinched so that it angles back away from his forehead. That line is continued by the wide brim, which curves down at the front and is rolled at the sides. It is the style of hat worn by Tom Mix and other stars of the 1920s and it is by some degree the most mannered affectation in Mitchum's costume. Unlike Mix, whose hat was always beautifully blocked and spotless, Mitchum's has been roughly treated and poorly cared for. It will soon acquire a bullet hole to add to the evidence that it belongs to a man who has experience of hard living. His costume suggests a timeless form; he looks every bit like Charles Russell's illustration of Owen Wister's hero in *The Virginian*. The high-heeled western boots pitch his posture forward a little, the flared chaps make him appear slightly bowlegged, and the boxy denim jacket pinched at the waist and loose across his shoulders produces a center of gravity around his middle where his gunbelt rests. But however timeless he appears, his

look is very much a product of a particular vogue in postwar westerns for dressing cowboys as if they actually did manual labor.

In the roles he played in the late 1940s Mitchum evoked a physical and sexual allure that was seldom if at all seen in the performances of male actors between the wars. Mitchum's appeal resides in what the writer Dave Hickey has called his "dark contingency," which I take to mean that the preconditions of his motivations appear uncertain and probably unknowable.[1] He carries a threat of violence that might be sexual, but not necessarily. He is lithe and supple, and moves slowly and always with purpose. The waist and hips govern his movements, whether on horseback, walking, or leaning against a bar. In *Blood on the Moon* he is poised and ready to meet the unexpected, like the stampeding cattle or being bushwhacked as he prepares to cross a river. In the latter scene, Garry moves without haste away from the river, doubling back to get behind his attacker. Framed by the high buttes of Red Rock, he takes aim at his assailant, who, we are surprised to learn, is not a man but a young woman. As she stands and turns to face Garry she keels backward and, unbalanced by the lack of a heel he has shot off her boot and by the volley he fires at her feet, falls to the ground, lying defenseless on her back with her legs splayed toward Garry. Immediately the scene takes on an erotic charge. The sexualization of this first violent encounter in the film is another point where the film distinguishes itself from major prewar studio productions, which tended to use humor or a more ambivalent coding to evoke (and yet still deny) sexual relations between characters.[2] And the sexual charge in *Blood on the Moon* is clearly distinct from series westerns, which were always highly circumspect about any prurient elements.

Costume, props, setting, and character types define *Blood on the Moon* as a western like any other, but these elements also function as points of differentiation within the genre. The grading of distinction between the film's mise-en-scène and that of series westerns, such as *West of the Pecos*, is broad enough to be readily identifiable, and marketing, distribution, and exhibition would have furthered discrimination. But the film is also distinct from A-feature westerns made between the wars. Discussing the differences between detective films produced prior to the postwar cycle of films commonly called "noir," Marc Vernet argues there are four important points of distinction: "a transition towards a more serious tone, a shrinking of the frame, a change of style in the physical appearance of the actors and décor, and finally the weakening of censorship."[3] His observation can

extend across genres and fits the outline of *Blood on the Moon*, which has often been clumsily categorized as a "western noir."[4]

Vernet describes how the detective film from the mid-1940s had its comic elements stripped out so that by 1949 it had begun to take itself seriously, "to the point that it occasionally became pompous." The western would also follow this more po-faced trend. In step with the loss of humor was a move toward a more claustrophobic framing, and here too the western echoed the contemporary crime film. Though *Blood on the Moon* is set in the vastness of the Red Rock landscape, its cinematographer fills the top half of the screen with moonlit clouds that choke out the sky and create a restricted framing that is reiterated by the low-lit interiors and campfire scenes. Third, the mise-en-scène changes, so that actors, props, and settings in films made before the war look "old-fashioned," derived from "another aesthetic that makes them look too stereotypical, overdone, and thus ridiculous." The stillness that pervades Mitchum's performance, his taciturn character, and the purposefulness with which he carries out even the most banal of actions place him within the new style that Vernet is describing. Finally, censorship toward the end of the war became more flexible, so that, for example, acts of violence "as well as bodies gained access to a more direct representation: one can be struck by the fact that, from 1944 on, the female body is redrawn and exhibited, particularly through the quasi-obligatory sequence of singing in a nightclub, whether chic or not."[5] All this is seen as much within the western as it is within noirs.

The explanations for the changes outlined by Vernet are varied and complex, but they are directly tied to technological developments, such as sound recording, film stock, or screen ratio. Institutional policy, such as self-regulation of movie content, and government intervention in how the industry organizes itself—antitrust action for instance—also plays a part in transforming the state of things. Similarly, change happens as a response to competing leisure activities, altered audience demographics, and the need to meet and shape varying tastes. In this last aspect filmmakers are constantly recalibrating to accede to the demand that their films have contemporary relevance, that they be topical, and that they should be seen before their moment has passed and they become obsolete.

It is worth recalling that Vernet's four points of distinction are part of a fulsome rebuttal of the shibboleths that form much of the muddled thinking on noir as a critical category and construct of film history. The value of his argument to the present study is that it refuses to compartmentalize

film history or to proceed with a study of a topic based on the solipsis-
tic assumption that it is self-defining—a noir is a noir. In what follows I
build on these ideas and consider the ways in which the postwar western
is framed by and responds to the historical and the contemporary. I will
argue that this tension between the past and the present, which is often
occluded, becomes legible when the use of blue jeans in costuming in post-
war westerns is examined through a prism comprised of the competing
attributes of the authentic and the anachronistic.

"The blue jean—that most American of products . . ."[6] Originally pro-
duced as workwear, jeans were later adopted as leisurewear and in the pro-
cess acquired totemic value that has been used to represent inchoate and
often contradictory ideas around youth, heritage, nonconformity, free-
dom, rebellion, democracy, and America. According to the historian Niall
Ferguson, the phenomenon of how a common cotton garment became a
synecdoche for America is intimately connected to the film and marketing
industries. There is a long history of the cross-promotion of stars and jeans,
with John Wayne, Marilyn Monroe, Elvis Presley, and James Dean all hav-
ing been repeatedly photographed and filmed wearing denim. From this
foundation Ferguson retells the familiar narrative of how this prosaic item
of clothing accrued an iconic resonance that would enable it to stand as a
"politically potent symbol of what was wrong with the Soviet economic
system" and, in apparent contradiction, be the costume of choice for the
era's rebellious youth who were busy rejecting capitalism.[7] The history I tell
here is more local than Ferguson's, and the contradiction that jeans enter-
tain is not how a mass-marketed product can function as a refusal of con-
sumerism but how specific denim garments, such as Levi's 501s or a Lee
101J jacket, can be used as cowboy costumes in films set in the 1880s when
these particular designs were not manufactured until well into the twen-
tieth century. Jeans' provenance—their authenticity—and the role that
has in the costuming of cowboys in the movies are part of a complex set of
transactions that occur between the present and the past. Western movies
are not bound to uphold a faithful representation of historical situations,
events, and characters, but they must stay true to audience expectation,
which is governed by generic convention.

As produced by the San Francisco–based Levi Strauss Company in the
latter nineteenth and early twentieth centuries, functional, hard-wearing
heavy cotton twill "waist overalls" were originally designed for miners,
but other laborers were also targeted in the company's marketing. An

advertising handbill from 1899 depicts Levi's worn by a miner, a carpenter, a farmer, a railroad engineer, a mule-skinner, a warehouseman, children, and a cowboy. Before Levi's and other workwear manufacturers turned to focus more fully on leisurewear and the youth market in the 1950s, which is when the generic name for denim pants changed from "overalls" to "jeans," their most important market sector in the first half of the twentieth century was filled by railroad workers.[8]

The transport historian Christian Wolmar writes, "America was made by the railways." Literally uniting the United States, the railroads "stimulated the economic development that enabled the country to become the world's richest nation" and "also transformed American society, changing it from a primarily agrarian economy to an industrial powerhouse." Toward the end of the 1920s there were more than "20,000 daily passenger trains serving the 130 million population, a staggering 2.6 million freight cars . . . [and] 57,500 locomotives . . . [and the railroads] employed 1.6 million people." Engineers, those thousands of men who worked on the trains, wore denim overalls. Yet denim is not used to symbolize a history of American industry and labor as represented by the railroads; rather, it is the cowboy who is the worker most closely associated with the fabric. By the late 1920s Levi's and Lee, the two leading manufacturers of denim clothing, enthusiastically exploited the cowboy in the marketing of their core lines. A 1934 advertising card used in stores, for example, guaranteed that the displayed "overalls . . . are genuine Levi's worn by all cowboys."[9] Working cowboys, however, would have represented a much smaller market segment for Levi's than laborers in rail or other industries. The marketing of jeans through images of the cowboy was driven not because those depicted were the buyers the company sought above all others, but because the figure appealed to a broad consumer base.

There was undoubtedly a close association between jean manufacturers, their marketing, and what contemporary cowboys actually wore, which can be seen in photographs by Lee Russell and Arthur Rothstein for the Farm Security Administration in 1939 and in Elmo Williams's documentary *The Cowboy* (1954). Russell's photographs of a Texas cattleman portray him wearing jeans under his leather chaps and over a white shirt he has on a Levi's 506 blouse (single pocket, pleated front, cinch and hasp across the small of the back), which was on the market between 1936 and 1953. Rothstein's portraits of the rancher Walter Latta, who lived and worked in Bozeman, Montana, also show him wearing denim jeans and jacket. Williams

made his film in New Mexico, and he looks exclusively at the workaday world of the modern cowboy. The cowboys pit their skills against animals and the material world. Whatever job they are involved with, they are invariably posed in front of uninterrupted horizons. The cowboys featured in the film are all whippet-thin and wear jeans under leather chaps, matched with denim shirts and jackets. In their choice of workwear, these cowboys look like their counterparts in the advertising campaigns run by Levi's and others. The visual association between Williams's, Rothstein's, and Russell's cowboys and the marketing images produced by Lee, Wrangler, and Levi's is so extraordinarily direct and vivid that it is as if the advertising is wholly faithful to the world it depicts, or the contemporary cowboy fully conforms to an image of himself derived from advertising (and the movies). The fact of the matter is that the authentic and inauthentic are completely entwined.

A 1938 price list describes Levi's as "Authentic Western Riding Wear," but it also promotes a new line called "dude ranch duds," which would seem to contradict the company's claim to authenticity. The "high color rodeo and fiesta shirts, frontier model riding pants, and fine western featherweight worsted shirts"[10] were Levi's response to the growing popularity of dude ranches as vacation-time destination and activity. The process of workwear becoming transformed into leisurewear is readily apparent here. Dude ranching was a late nineteenth-century development of a nascent Rocky Mountain–based tourist industry that catered to vacationing wealthy Europeans and eastern-based Americans who expressed a desire to hunt, fish, and explore the frontier states. Establishment figures such as Theodore Roosevelt, the novelist Owen Wister, and the illustrator Frederic Remington did much to popularize this activity, promoting vacations in the West as a restorative escape from the travails of modernity. What began as an ad hoc arrangement—with working ranches supplementing their income by hiring out horses and tackle, and providing room and board, guides, and entertainment—became a fairly substantial concern by the end of the Great War, when European travel had been closed to Americans and the national parks promoted their attractions through a "See America first" campaign. The historian Lawrence Borne has called the interwar period of 1919–1929 the "golden decade of dude ranching."[11]

Dude ranches were predominantly located in the Rocky Mountain states of Montana, Wyoming, Colorado, Arizona, and New Mexico, which included such popular tourist sites as Yellowstone, Rocky Mountain,

Grand Teton, and Glacier National Parks. Travel to these parks had been made practical by the development of railroads, and by the mid-1920s rail companies had joined forces with ranchers to form mutually beneficial associations. A Northern Pacific railroad official wrote in 1926 that the Dude Ranch Association wanted "Young America to . . . know the grandeur of the Rockies, the traditions of the old pioneer trails, the fine spirit of the great western out-of-doors. We hope to outline a program that will bring Montana and Wyoming to the forefront as national playgrounds."[12]

Though offering an authentic western experience, dude ranches also catered to their visitors' romanticized view of cowboy life, which included dressing the part.[13] "As early as 1913, western writers made it clear that on a dude ranch everyone adopted the habits and clothing of the country," Borne writes; "they noted that the broad-brimmed hat, silk bandana, and vest were practical pieces of clothing." *Vogue* magazine in 1936 also emphasized that the "good dude" should dress like the local cowboys and even listed the essentials for a ranch vacation: "jeans, flannel or woolen shirts, leather jacket, practical underwear, lisle or wool socks long enough to come above boot tops, silk neckerchiefs, riding gloves, boots, and a Stetson hat." This aspect of dressing up and playing cowboy was readily parodied: an old ranch hand describes two dudes: "One wore lavender angora chaps, the other bright orange, and each sported a tremendous beaver sombrero and wore a gaudy scarf knotted jauntily about his throat."[14]

The mixing of the authentic with theatrical costuming is a common occurrence in Gene Autry's singing westerns, where his flamboyant western wear is contrasted with the denim overalls of those he moves among and entertains. The incongruity between the real and the fabricated does not rupture or deface the film's integrity, which might be presumed to occur if the outlandishly attired Autry were appearing in an A-feature western. Autry's horse operas run on different dramatic principles than those deployed by the major studios in their western productions. The entertainers who worked as singing cowboy and series western heroes are best understood as performers rather than actors.[15] Unlike an actor, who is expected to be subservient to the demands of character and narrative, the singing cowboy's principal role is to play himself and in doing so provide amusement and spectacle, whether this is in the form of stunt riding, musical interludes, comic passages, fistfights, or costuming. Realism in horse operas was neither sought nor valued. Performance is what is prized, such as the display of a skill like rope and lariat tricks, bronco riding, and

yodeling. The singing cowboy's gaudy costuming is distinctive, but even in extremis its antecedent is still recognizably utilitarian ranch wear.

The tension between flamboyance and function in costuming echoes the relationship between performer and audience, who are at once familiars and strangers. Autry is part of a community and at the same time outside of its bounds: a common man and a Hollywood film star. As ranch hand *and* entertainer, the figure of the singing cowboy personifies, mediates, and underscores this relationship. Any tension between the past and the present is held in check in Autry's movies, which are invariably set in a contemporary West that is in thrall to its own history. The singing cowboy's appeal is similar to the attractions used to promote dude ranches, which frequently featured in Autry's films; both offer a version of America that bridged the divide between work and leisure and between the traditional and the modern.

The contrast between the spectacle of singing westerns and the realism of feature films with a contemporary southwestern setting could not be starker, yet both forms are engaged in creating a living link between history and the present. The veteran drama *Till the End of Time* (Edward Dmytryk, 1946) reiterates the idea that the cowboy is a figure capable of mediating between a known and secure heritage and an insecure present and unknown future. Back home from the war, out of uniform and wearing a Stetson and a double-breasted suit with western-styled pockets, with a hunk of metal in his head and the tune made popular by Tex Ritter, "Jingle Jangle Jingle (I've got Spurs)" on his lips, "Cowboy" Bill Tabeshaw (Robert Mitchum) is returning to New Mexico and a new start in ranching. Mitchum plays second fiddle to beefcake Guy Madison, whose character is having a hard time fitting back into civilian life. When Tabeshaw reappears toward the end of the film, he is down on his luck and still suffering from his head wound. His earlier optimism has dissipated, and he now looks beat. The tough times he has experienced are symbolized by a change in costume: he now wears a denim jacket (Levi's 506) and jeans, which are set against the smart tailored suit he wore on his return from the war.

Though unemployed and disabled by his wound, Tabeshaw still asserts a certain masculine potency that is linked to his identity as a cowboy. He remains proud, independent, and fearsomely loyal to his friends. He is also likely to solve a problem with his fists. The film climaxes in a bar, where Tabeshaw and his buddies fight with a gang trying to recruit veterans to a racist organization. Tabeshaw sides with the black soldier he's been

FIGURE 24 Publicity still for *Till the End of Time*. Robert Mitchum wears a Levi's 506 jacket.

partnering at pinball and, symbolically, with Manny Klein, an old comrade in arms. Klein would have spat in the racist's eye if he were there, but he died fighting on Guadalcanal, so Tabeshaw spits and scraps for him. Mitchum's character represents an Americanism that confronts, confounds, and thwarts the racist nationalism spouted by his adversaries. In this instance the cowboy's deep roots in an American imaginary are important

because his heritage cannot be challenged or questioned, but so too is the manner in which the figure is able to articulate a contemporary identity, one, despite its historical reach, that is not anachronistic. The denim jacket and jeans Mitchum wears, at once thoroughly modern—straight off the rack in any contemporary store—and rich in historical resonance, symbolize this mixed state of affairs.

In 1950, four years after the release of *Till the End of Time*, Mitchum again played a modern cowboy, this time a rodeo rider. Directed by Nicholas Ray and based on a *Life* magazine article, *The Lusty Men* was one of four pictures on the topic of rodeos in development that season.[16] According to Ray's biographer Bernhard Eisenschitz, cinematographer Lee Garmes shot the film so that it looked like photographs produced for the Farm Security Administration, which gave it a "dated social realism" and added a "hint of hyper-realism before its time, in the caravan trailer interiors, for example. 'Looks like a hotel,' as a dialogue exchange put it: 'It is a hotel.' " The political, social, and cultural events of the 1930s had bequeathed a legacy that provided a prism through which Ray's characters are invariably viewed. *The Lusty Men* "is not a western," Ray argued; it "is really a film about people who want a home of their own. That was the great American search at the time. . . . And that's what it was all about." Eisenschitz concludes that the film "thus moves from nostalgic Americana to a mood of crisis and anxiety."[17]

Mitchum's costume in the film echoes this temporal tension between a lost past and an intensified immediacy, particularly the Wrangler Blue Bell jeans and 11MJ jacket he wears. The company introduced this style of jacket in the same year as the film's production. Marketing for the new product line was done through securing the endorsement of the country's leading rodeo riders: Harry Tompkins, Casey Tibbs, Bill McGuire, Bill Linderman, Toots Mansfield, and Jim Shoulders. They were all champions and appeared prominently on packaging and in magazine and billboard advertisements: "This Wrangler Western Jean has been styled by Rodeo Ben—tailor for the top Rodeo Stars and Ranchers. . . . These men . . . are successive rodeo champions. They were at the head of rodeo stars who had worn and endorsed Wranglers. Made by the World's largest producer of Work Clothes."[18] Blue Bell had been formed in 1919 out of the Hudson Overall Company and, like Levi's and Lee, specialized in denim workwear. In 1947, the company introduced the Wrangler brand, which was intended to give a new line a distinctive modern slant through its association with

contemporary rodeo champions. Ostensibly little different from its competitor brands, and in a market that allows little room for innovation, Wrangler nevertheless offered a distinctive slimmer, more streamlined fit, and, as the costuming of *The Lusty Men* indicates, Blue Bell was highly effective in working the association with rodeo. There was nothing random in the use of the Wrangler brand in Ray's film.

In *The Misfits*, John Huston's 1961 picture of a modern West that also fails to live up to the myths, the slight physical figure of Montgomery Clift wears a Wrangler 11MJ jacket with zipper fastening in combination with Lee jeans. The jacket is a good fit, slim and tidy. Clark Gable wears a Lee 101J jacket. The Lee was the first of the slimmer-fit blouses, and to an extent Wrangler simply reworked the design to make it more figure-hugging. Eventually Levi's would follow suit, dropping the boxy two-pocket and pleated 507 in 1962 for the 557XX, which is more commonly known as the Trucker jacket. In a Wrangler 11MJ Gable would have looked like an over-stuffed pillow; the Lee 101J is a little more generous in its cut.

Marilyn Monroe wears a combination of Lee jeans and a Lee Storm Rider jacket, which is essentially the same as a 101J but sports a corduroy collar and a blanket lining. Played by Eli Wallach, the fourth character in the party of misfits wears chinos and a torn and battered flying jacket made from shearling. Monroe's character notices his outfit: "Boy, that's some jacket," she says. But it is her jacket that has taken on significance: an image of Monroe in a Lee Storm Rider can adequately stand in for the film as a whole.

There is an element of gender transgression and masquerade with Monroe in denim. In *The Misfits* it visually connects her to the rest of the gang, making her part of the boys' club even as she is singled out as the object of their desire. Something similar happens in other westerns and films when a young woman is costumed in jeans. In *The Lonely Man* (1957) the female lead (Elaine Aiken) at one point wears denim pants and a man's shirt with the sleeves rolled up. She has been a dance hall girl, perhaps a prostitute, but is trying to put that past behind her. The new "work clothes" she wears suggest there is an honesty in her endeavor. She has forsaken paint and powder, ribbons and corsets. In rejecting a degraded femininity she takes on masculine attributes and values, hard physical work among them, and appropriate male workwear—pants. However, the jeans are cut tight around her backside and tapered well to the dimension of her waist, and with the shirt tucked in to emphasize her breasts, the costume both masculinizes and feminizes her.

FIGURE 25 Frame grab from *The Searchers*. With her braids, plaid shirt, Levi's, and moccasins, Laurie looks every bit the fifties teenager.

Women in jeans tend toward tomboy characteristics like Anne Baxter in *Yellow Sky* (1948). Her character has been working in abandoned gold mines, a type of activity that justifies the jeans she wears. But an audience will respond to the sight of her in these tight-fitting denims in much the same manner as the outlaws she encounters: "Kind of cute lookin'. Nice right swing of those hips too." "Yeah. And the way she tucks in that shirt." Baxter wears Levi's 501s; the arcuate stitching on the rear pockets that identifies the brand is easily recognizable, because her backside is where the camera and our eyes are so often trained. A less sexualized version of the tomboy figure is seen in *The Searchers* (1956), with Vera Miles as Laurie Jorgensen wearing at one point Levi's, moccasins, plaid shirt, and braids, and looking every bit the 1950s teenager.

For men, the costume of denim jeans and jackets represents an unassailable set of gender certainties. Like Monroe, Kirk Douglas wears a Lee Storm Rider in the contemporary-placed western *Lonely Are the Brave*, made in 1962, a year after *The Misfits*, but unlike her he is not crossing between genders; rather, he is shoring up a masculinity that is under threat from the blandishments of the modern world. Douglas's film, like Monroe's, is also about the shrinking of the West that no longer has room for mavericks, and certainly not for the anachronistic cowboy. His character

FIGURE 26 Frame grab from *Hud*. Paul Newman (right) wears a Lee Storm Rider and Brandon de Wilde a Levi's 506.

will be killed at the end of the movie, run down on a highway by a truck carrying toilets and plumping supplies. *Hud* (1963) repeats the themes of *The Misfits* and *Lonely Are the Brave*, and Paul Newman's title character similarly wears Storm Rider and 101J jackets. Hud adds a white denim Lee Westerner jacket (introduced in 1959 and soon to become a fixture of British mod fashion) to this wardrobe, which he wears in the evening when out drinking and carousing. This is denim as leisurewear, not workwear, and it tallies with Hud's disdain for his western heritage and the world his father has worked to build and now sees destroyed by foot and mouth disease. The true inheritor of the father's legacy is the youngest son, played by Brandon de Wilde, who, in contrast to Hud, wears an old, worn, slightly oversized Levi's 506 blouse—workwear, not leisurewear.

Hud was based on the novel *Horseman, Pass By*, written by Larry McMurtry, who also provided the source novel for Peter Bogdanovich's *The Last Picture Show* (1971), set in Anarene, Texas, in 1951, where, as the poster tag line puts it, "nothing much has changed." The teenage characters wear Lee jeans and 101J jackets. The last film shown at the movie house is Howard Hawks's *Red River* (1948)—a story as much about the making of the West as *The Last Picture Show* is about its end. Starring John Wayne and Montgomery Clift, *Red River* is the epic tale of a cattle drive that begins in Texas and finishes when the drovers meet the new railroad in Abilene, Kansas. With the exception of John Wayne, who wears Levi's under his chaps, none of the many cowboys in this film appear in denim clothing. In this small fact the film is at odds with the vast majority of 1950s westerns.

Wayne's Levi's are important because they maintain a line of continuity in his visual appearance that was solidified by 1939 when he starred in *Stagecoach* and then reaffirmed in subsequent films, including *The Searchers*.

Seventeen years separate John Wayne's performances in *Stagecoach* and *The Searchers*, but, apart from the obvious fact that in the latter he is no longer a young man and has gained about thirty pounds in weight, the continuity in his appearance is remarkable. In the two films he wears shirts with a placket front and, held up by both belt and wide suspenders, Levi's with long cuffs turned high above the spurs on his boots. The style of his hats stayed the same. The deployment of a familiar costume across a number of westerns seemingly regardless of the character being played by the star is commonplace, but the accent on continuity in costuming is not just there to create a correspondence between films; it also has a role within the films.

In *The Searchers*, Wayne's costume undergoes limited but significant modification, from the grays of his Confederate uniform at the start of the film to red and then blue placket shirts. The blue shirt is worn with matching Levi's and contrasting yellow suspenders, which align Ethan (Wayne) with the uniform of the young cavalry officer he encounters toward the film's close.[19] The shift from gray to blue is symbolic, suggestive of a move toward assimilation within the wider community even as he stays at its margins. This symbolic and literal transition alleviates the suddenness of Ethan's swing in attitude toward Debbie when he becomes her savior rather than, as we have been led to expect, her executioner. She is tainted by a sexual relationship with her abductor, the Indian chief Scar, to the extent that Ethan holds her to be no longer white, no longer a blood relative, and better off dead—yet he does not kill her when the opportunity arises. How do we make sense of this element of unpredictability?

The philosopher Robert Pippin has considered the problem involved in resolving the contradiction between Ethan as Debbie's rescuer and her nemesis. He writes:

> This messiness prompts another, dangerous temptation. By dangerous I mean that some common forms of "character judgments" or other forms of holism in everyday explanations of action are quite close to the typology at work in the film's treatment of racism: views about white, Indian, mixed blood, Texican, and so forth. Ford is most certainly making use of the John Wayne Type to "set up" the viewer, inducing an identification that Ford will

FIGURE 27 Frame grab from *The Searchers*. Wayne's costuming is matched with the young officer's.

completely undermine by relying on our understanding of that type, as if we know who "John Wayne" is, or for that matter as if we know what America is. One element of the enormous emotional power of that famous scene of transformation and redemption is the realization that none of these archetypes is adequate to the sudden, transformative gesture of Ethan picking up Debbie nor does it help us understand well the bitter, racist outburst of Laurie, who had been such a faintly comic and pleasant character.[20]

We are better able to understand these contradictory traits by paying attention to the film's use of costuming. The contradictions in *The Searchers* are founded on and evoked through the structural play between binary oppositions: civilization versus savagery, white versus red, male versus female, religious versus secular, and so on. But these binaries are not fixed; rather they are, as Jim Kitses notes in *Horizons West*, in fact antinomies—that is, recognizable states that are in flux.[21] As the narrative unfolds, the binaries cross and combine producing an impure and unstable state of things (Pippin's "messiness"). Through this process all the characters become tainted in one way or another. The more a character is decreed as an ideal of whiteness, or femininity, or whatever, the more certain it is that he or she will be crossed with his or her opposite. The self becomes the other. This has long

been noted of Ethan and Scar, but it is true too of the other characters.[22] The racial crossing is explicitly stated in the narratives of miscegenation that account for Marty's (Jeffrey Hunter) mixed blood or Debbie's (Natalie Wood) lying with Scar—or through less direct markers. Like Ward Bond's soldier-minister, all in *The Searchers* are made to cross with that which might threaten a secure identity, so that their characters are founded on plurality and ambivalence—and as such are as American as Levi's and moccasins or cowboys and Indians.

Virginal, blond Laurie, of Scandinavian heritage, is contrasted with dark-haired, sexually active Debbie, who after becoming Scar's squaw has her whiteness impugned and her blood heritage denied. When not wearing simple dresses and aprons, or a white satin wedding dress, Laurie is costumed to look like any 1950s teen with braids, check shirt, pointed bra, a pinched and belted waist, Levi's 501s, and suede moccasins. Her costume has such contemporary resonance that it produces a tension between the past and the present; more fundamentally, it links her to Debbie (and Debbie to her). Though Debbie is in Indian costume, and in contradistinction to Laurie looks historically authentic, she too braids her hair and wears moccasins on her feet.

Like Debbie and Laurie, Marty and Ethan also on occasion wear moccasins and Levi's. This repetition of costuming helps close the circle between the warring factions—white and red, male and female, young and old—but also complicates things still further. In the same way that costume links and crosses Laurie with Debbie, it also connects Ethan to Debbie. When evidence reaches him that Debbie is still alive, it comes in the form of a piece of cloth cut from the gingham dress she was wearing when abducted. With this new information in hand, Ethan travels to Mexico to meet and trade with Scar. In the south-of-the-border scenes Ethan, Marty, and Mose wear check shirts. Ethan's is a red check that matches the remnant of Debbie's dress. He will wear this shirt only in this sequence, which culminates with his momentarily being reunited with Debbie and intent on acting out his homicidal rage. These correspondences in costuming provide visual support to the film's corruption of absolutes around characterization, with its distinct accent on moral ambiguity and mixed motivation.

Similarly, the film sets into play temporal modalities, which order and resolve a tension between past and present. One might say this is true of all westerns, but how these modalities are formed and operate changes as conventions shift and mutate: modal points are not fixed; they are permanently turning. As the modal points revolve, a level of redundancy occurs

that demands a counterweight, which is generally provided by introducing a novel element. The introduction of novelty, most readily provided by a film's use of the topical or contemporary, will eventually alter generic convention. In the case of *The Searchers*, the temporal modalities are often best effected through the female characters. The establishment of a film's authenticity, which is to say the image of stasis, is invariably conditional on gender. Ethan's authenticity is formed through the continuities of Wayne's costuming, which seemingly remains unchanged from film to film and within any given film. The costume does alter, of course, but it changes so slowly and so unceremoniously that it is hardly noticeable. Any overly visible disruption to the order of things as it relates to Wayne's costume would call into question issues of fidelity with regard to the history of his persona and thereby to the film's representation of history per se. Laurie's rapid and many changes of costume produce no such disruptive effect.

To maintain their persona from film to film, other stars exploited a similar continuity in costuming. A particularly extreme, but by no means unique, example of this is seen in *The Law and Jake Wade* and *Warlock*, produced by MGM and Twentieth Century–Fox and released in 1958 and 1959 respectively. Richard Widmark stars, and in both films his costume is for all intents and purposes identical: same hat, same pants, same red neckerchief, same washed-out denim jacket, same boots, and the same gun, belt, and holster. Both films are set in the 1880s, yet Widmark is wearing a Lee 101J jacket, introduced by the company in 1946. This anachronistic costuming, not just in these films but also across the genre as a whole, passed without comment by contemporary critics and has not been questioned by film historians. Admittedly few critics then or since take much interest, if any, in identifying brands of denim jackets and jeans, but the fact that these anachronisms cause not the slightest disruption to the way westerns are received and understood as portraying a history of the American frontier suggests that convention—the fermenting of an idea about how cowboys dress—rather than historical fact is what is paramount in making a film credible with any given audience.

As the genre theorist Steve Neale has shown, the concept of verisimilitude is crucial in understanding the contract that is made here between the work of fiction and its audience: "There is in any individual genre always a balance between generic and socio-cultural verisimilitude."[23] The compact between the film and its audience involves collusion over what constitutes the authentic. Whether or not there is any truth to the claim of

FIGURES 28 AND 29 Frame grabs from *The Law and Jake Wade* and *Warlock*. Widmark is dressed exactly the same in both films.

authenticity, as with denim and cowboy costume, is not the issue; rather, what is at stake is the tacit contract between parties that they agree on a representation's truthfulness, or, in Neale's terms, its semblance of verisimilitude. Delmer Daves's *Cowboy* (1958) was promoted in terms that echo Neale's comments: "A Real Western! It's *really* the best because it's *really* the West! The Epic of the Real American Cowboy."[24] Yet the image of Glenn Ford on the poster owes much more to convention than to any notion of historical reality.

Like Wayne and Widmark, their contemporary Glenn Ford wears essentially the same costume across the westerns he appears in. This is

FIGURE 30 Publicity poster for *Cowboy*. Inauthentic costuming does not blunt the film's claim to being the "real."

suggestive not only of a star's limited and circumscribed roles that must conform to type but also of a standardization of presentation. Repetition reinforces and confirms previously identified attributes about both the actor and generic indicators. In *3:10 to Yuma* (1957) Ford wears a two-pocket imitation of the boxy Levi's blouse: pleated in the front and with cinch and hasp placed in the small of the back to pull the jacket more tightly around the waist. Where it differs from Levi's is in the fabric, which is corduroy, not denim. The jacket is seen in color in *The Sheepman* (1958) and *Cowboy*. It has a creamy or off-white hue, which in the former is matched with tan pants and an off-white, high-crowned hat with the brim rolled at the sides—the same hat, incidentally, that he wears in *3:10* and had worn previously in *Jubal* (1956) and *The Violent Men* (1955). He also wore this hat in *The Man from the Alamo* (1953); it is incongruous among all the military headgear and coonskin caps, but a concession is at least made to the film's 1836 setting by dressing him in buckskin rather than denim. In fact, he would wear this hat in all but a few of his westerns up through *The Rounders* in 1965.

Beginning with Anthony Mann's *Winchester '73* (1950), Jimmy Stewart also wore the same hat in the vast majority of his westerns. Like Ford's, it has a rolled brim at the sides. The high crown is creased and pinched and circled by a large sweat stain, suggesting a life spent outside working in the sun. The hat matches the stubble on Stewart's chin and the careworn jeans and jacket, which is a copy of a Levi's 506. This costume, along with plaid shirts and a colorful but not too flamboyant neckerchief, would be worn by Stewart with minor modifications in all of the westerns he made with Anthony Mann and others in this period. The second of the Mann-Stewart collaborations was *Bend of the River* (1952), the first in color. Stewart wears the same jacket as in *Winchester '73*, but now we can see that it is tinted green rather than blue, as one might have presumed. In *The Man from Laramie* (1955) he wears a tan-colored corduroy Wrangler Blue Bell 11MJ. Like the Glenn Ford combination, the hat and jacket are color matched. The film was made in New Mexico, around Santa Fe, and the jacket blends with the sandy tones of the desert locations. Similarly, the red placket shirt that Wayne wears in *The Searchers* visually echoes the hues of Monument Valley and also symbolizes his blood lust.

Bend of the River was filmed in Oregon, and there is rarely a shot in the opening and early scenes of the film that does not feature Mount Hood as a dramatic backdrop. The forest that encircles the mountain corresponds

with the green tinge of Stewart's jacket. *Winchester '73* was filmed around Tucson and Mescal, Arizona, the *Naked Spur* (1953) in Colorado's Rocky Mountains, and *The Far Country* (1954) in Alberta, Canada. In effect, the five westerns Mann made with Stewart work their way up and down the Rocky Mountains, reinscribing the tourist route promoted by dude ranchers and railroad companies. Technicolor and CinemaScope proved

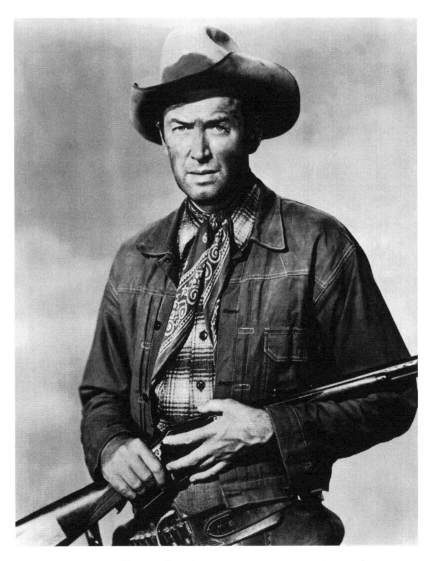

FIGURE 31 Publicity still for *Winchester '73*. James Stewart wears a Levi's 506 jacket.

a particularly adroit technical and aesthetic means of capturing and show-casing these landscapes, to the extent that films are often composed and edited to maximize a location's spectacular attractions. In *Jubal* a sig-nificant proportion of the action is filmed out of doors in long shot, with increased time between edits in order to fully exploit the sublime setting of Jackson Hole, Wyoming. *The Big Sky* (1952) and *Shane* (1953) were also filmed at this location, and Warner Bros. shot a ten-minute documentary there called *Dude Rancheroos* (1949).[25]

The Violent Men (Rudloph Maté, 1955) had three principal locations, and all would have been familiar to fans of the western: the Warner Bros. ranch in Burbank, the Alabama Hills in Lone Pine, and the high country around Tucson, Arizona. The film is set a few years after the end of the Civil War, but when strawberry blonde Dianne Foster is framed against the moun-tains she could just as well be posing for a 1950s photographic spread in *Arizona Highways* magazine. In an account of his fascination with Ameri-can deserts, the Independent Group member Reyner Banham writes that practically everybody's favorite view of them "seems to have a mountain in it. There is a kind of scenographic rightness in the standard relationship between a flat foreground, containing gold prospectors, cacti, the U.S. Cav-alry, the lights of Las Vegas, or other picturesque impedimenta, and some massive upstanding outcrop or mountain range behind. . . . The mountain and the plain, the vertical and the horizontal are the baseline iconography of America Deserta as surely as they are of the painting of Piet Mondrian."[26] This view of desert landscapes has been fostered and promoted through repeated cinematic representation across countless westerns.

The view does not depend on any direct knowledge of ranching or of the Southwest but rather, as Banham's colleague Lawrence Alloway has claimed, on the fact that we recognize it from comparative representa-tions familiar from other movies and other media: "The West of the 1880s is enacted in the unchanged present landscape, known to us from post cards, photographs in the *National Geographic* magazine, and state tourist-office literature, or from the bubble on a Vista-Dome train and through an automobile windshield. . . . They are part of the correspon-dence among media which give a film the authority of being real at more than one level as it complies with information derived from other sources. This kind of allusion, characteristic of postwar movies, has an elaborate emblematic quality."[27]

Vista-Domes, as the railway historian Christian Wolmar records, "were added to the streamliners, special coaches with a glass-roofed upper deck that gave passengers an unparalleled panoramic view of the passing scenery. The ultimate development came in the early 1950s with 'super-domes,' with bigger and better viewing points, used by several railways principally on the long scenic trips through the Rockies and Western deserts. In order to attract leisure passengers, timetables were adjusted so that the train went through the most picturesque areas in daylight."[28] There is here an ongoing association between the railroads, dude ranching, and tourism that is intimately linked to fiction factories that churned out western dramas for film and publishing industries.

Discussing his first forays into writing for a living in the late 1940s, the novelist Elmore Leonard notes, "I looked for a genre where I could learn how to write and be selling at the same time. . . . I chose Westerns because I liked Western movies. . . . There was a surge of interest in Western stories in the early fifties . . . from *Saturday Evening Post* and *Collier's* down through *Argosy, Adventure, Blue Book*, and probably at least a dozen pulp magazines. . . . I decided I'd better do some research. I read *On the Border with Crook, The Truth about Geronimo, The Look of the West*, and *Western Words*, and I subscribed to *Arizona Highways*. It had stories about guns—I insisted on authentic guns in my stories—stagecoach lines, specific looks at different facets of the West, plus all the four-color shots that I could use for descriptions, things I could put in and sound like I knew what I was talking about."[29] Whether on the page or on film, then, how authentic a piece of fiction appears to audiences and readers depends less on an appreciation of actual locations, historical events, and material culture, and rather more on how the West was being portrayed through tour guides, magazine articles, advertising, and other movies.

Jeans are at once authentic cowboy wear and a fabricated idea of that costume produced by advertisers and the movies; as such they correspond to the western's shifting notions of historical verisimilitude and an often incompatible appeal to contemporary taste. Filmmakers will talk about how much they respect and attend to the history of the West in making creative decisions, but in fact it is the history of the western that they are most mindful of. Regard is paid to how the West has been delineated by previous interpreters and not to whether certain elements such as costumes, settings, props, and music are anachronistic or not.[30] Convention effectively signals a film's historical authenticity or verisimilitude.

But when a convention turns into a cliché it starts to undermine whatever claims to veracity the film has; convention is revealed as artifice and becomes discernible as such. What once represented the authentic now appears as fabrication. The shifts and changes in styles of costuming in the western are an index of this complex play between authenticity and convention, between the contemporary and the historical, and between the chronologically appropriate and the anachronistic.

Conclusion

• •

> The end of the passage was a black cur-
> tain, vaguely repellent to the touch, as
> though made of snake bellies. Caution
> was replaced in Caliato with disgust, the
> need to get away from here, out of the
> rotten place. He pushed through into
> another room, and suddenly saw himself
> a dozen times. He saw the long-barreled
> .44 in his right hand, the unlit flashlight
> in his left. Over and over, a dozen times.
> —Richard Stark, *Slayground* (1969)

This study has pushed back against the prevalent insistence on isolated titles as the gold standard of film study. The focus has been on what a film shares with other films, with each chapter, like an evolving cycle, adding an element of novelty to the mix. Repetition has gained our attention but, as in the movies, the elements of distinctiveness insure against monotony; the peculiarities of each cycle make it compelling enough in its own right to avoid that pitfall, I think. Throughout the seven chapters the theme of a cycle's uniqueness has been counterbalanced by the notion of shared and commonly held attributes from across the field of film production and beyond.

Each of the case studies can readily and easily give up generalized accounts of social currents, so that it is possible to move from a discussion of a cycle's formal elements to make a claim about how it corresponds to a wider set of concerns. This might be to suggest how gender and class issues are addressed in order to make the argument that masculinity in this period was in crisis and that the cycle shores up a masculine identity that was threatened by the blandishments of a feminized consumer culture (as in the boxing movie or the western); a symptomatic reading might also show how work and the domestic sphere are defined and valued in the home-front movies in the Korean War cycle, with its deviant mirror image in the period's gangster films helping to reinforce a dominant ideology. Perhaps too some of the cycles say something about how the moral panic detailed in various JD pictures expresses a generalized fear that economic and social improvement is uncertain and insecure. However, I set out to avoid such an all-encompassing set of interpretative schema that might level the peculiarities of any given cycle, and instead chose to draw attention to how the films work with and within the public sphere, so that the industry's agency in aligning itself with the topical and making use of the everyday is better and more fully understood.

In staying faithful to the historical record I have documented film's acts of infidelity toward the society it purports to depict. Though the films play fast and loose with actuality, they balance this by being overly respectful toward their inherited conventions, producing the compact that creates verisimilitude. Within each cycle the instrumental attributes of conventions have evolved in unique and highly specific ways. The activation of verisimilitude, the marshaling of authenticating elements, is at times discrete and compensates for this cleaving to convention, but as distinct elements get appropriated and repeated, they in turn become formulaic and the cycle collapses: It becomes outmoded.

If the play with verisimilitude operates in similar ways across cycles, so does the way film works with the topical in its use of material culture. What might be said of television's intervention into everyday life as documented in the boxing cycle can also be said of that medium in juvenile delinquent movies. In the former, boxers watch boxing on television, and in the latter, teenagers watch teenagers on television—an audience is encouraged to watch itself like an actor standing between mirrors. The audience sees its acts of consumption validated and confirmed.

The hot rod cycle similarly mirrored its own site of consumption in the drive-in culture it documents, producing a pitch-perfect image of

what art historians call a *mise-en-abyme*—an image and its copy placed in an endlessly recurring sequence. The hot rod cycle and the drive-in were of the moment, and despite its nostalgic bent, so was the boxing movie, which documents the decline of a local entertainment culture as television became the sport's primary vessel. And that story echoes the decline in the neighborhood cinemas where films like *The Set-Up* would have found a likely home. In such ways film documents itself.

The attributes of popular cinema are self-defining, even solipsistic: hot rods are topical because they appear in the movies—the movies are topical because they depict hot rods. Film reflects on this and its own recursive, repetitive status, and like all formulaic industrial story forms, it does this most visibly at the point when its conventions are playing out, becoming exhausted. When it is predicated on repetition, novelty will inevitably expire. The end point can be measured when it shows consciousness of its own fatigue, and in doing so it is apt to reveal, to bring into the light, the thin fabrication on which it is based, presenting the convention as convention. When the concept of the regular novelty is recognized by an audience as a contradiction in terms, it has served its purpose, at least for that moment in time, but it will return, resuscitated, repurposed, and retooled so it can reenact its part in a new cycle.

Notes

Introduction

1 René Crevel, "Battlegrounds and Commonplaces," in *The Shadow and Its Shadow: Surrealist Writings on the Cinema*, ed. Paul Hammond (San Francisco: City Lights, 2000), 57.

2 Michael Denning, *Mechanic Accents: Dime Novels and Working-Class Culture in America* (London: Verso, 1997), 200.

3 David Bordwell, *Making Meaning: Inference and Rhetoric in the Interpretation of Cinema* (Cambridge, MA: Harvard University Press, 1991); Jeff Smith, *Film Criticism, the Cold War, and the Blacklist: Reading the Hollywood Reds* (Berkeley and Los Angeles: University of California Press, 2014).

4 Richard Maltby, "New Cinema Histories," in *Explorations in New Cinema History: Approaches and Case Studies*, ed. Daniel Biltereyst, Richard Maltby, and Philippe Meers (Malden, MA: Blackwell, 2010), 8.

5 Ibid., 11.

6 See Lawrence Alloway, "Critics in the Dark," *Encounter*, February 1964, 50–55; also Peter Stanfield, "Regular Novelties: Lawrence Alloway's Film Criticism," *Tate Papers*, no. 16 (2011): 1–9; and Peter Stanfield, "Maximum Movies: Lawrence Alloway's Pop Art Film Criticism," *Screen* 49, no. 2 (2008): 179–193.

7 Lawrence Alloway, "The Arts and Mass Media," *Architectural Design* 28, no. 2 (1958): 84–85.

8 Barbara Deming, *Running away from Myself: A Dream Portrait of America Drawn from the Films of the Forties* (New York: Grossman, 1969), 6.

9 Lawrence Alloway, *Violent America: The Movies, 1946–1964* (New York: MoMA, 1971), 19.

10 Franco Moretti, *Graphs, Maps, Trees: Abstract Models for Literary History* (London: Verso, 2005), 49.

11 John H. Lenihan, *Showdown: Confronting Modern America in the Western Film* (Urbana: University of Illinois Press, 1985), 5.

12 Richard Nowell, *Blood Money: A History of the First Teen Slasher Film Cycle* (New York: Continuum, 2011), 13–56.

13 Jim Kitses, *Horizons West* (London: Thames & Hudson, 1969), 7–28.

14 Nowell, *Blood Money*, 3–4; Peter Stanfield, *Hollywood, Westerns and the 1930s* (Exeter: University of Exeter Press, 2001).

15 Rick Altman, *Film/Genre* (London: British Film Institute, 1999), 60, 64.

16 Tino Balio, *The Grand Design: Hollywood as a Modern Business Enterprise, 1930–1939* (Berkeley and Los Angeles: University of California Press, 1993), 179–313.

17 Steve Neale, *Genre and Hollywood* (London: Routledge, 2000), 255, 253, 254.

18 Ibid., 217, 219.

19 "B.O. Being Killed by Film Cycles Avers Pix Buyer," *Variety*, August 16, 1950, 3.

20 Gael Sullivan, "Sales Execs Emphasize Need for Revitalized Showmanship," *Variety*, January 3, 1951, 34.

21 For more on the breakup of Hollywood's universal audience, see John Sedgwick, "Product Differentiation at the Movies: Hollywood, 1946 to 1965," in *An Economic History of Film*, ed. John Sedgwick and Michael Pokorny (London: Routledge, 2005), 186–217.

22 "We May Go in Cycles but We're in There Pedaling," *Motion Picture Herald*, September 15, 1956, 28–29.

23 Moretti, *Graphs, Maps, Trees*, 14.

24 Fernand Braudel, *On History* (London: Weidenfeld & Nicolson, 1980), 27, 30–31.

25 Stanley Bober, *The Economics of Cycles and Growth* (New York: John Wiley & Sons, 1968), 44.

26 Ibid., 21, 25, 27.

27 Ibid., 44–45.

28 Quoted in ibid., 45.

29 Quoted in Barry Curtis, "From Ivory Tower to Control Tower," in *The Independent Group: Postwar Britain and the Aesthetics of Plenty*, ed. David Robbins and Jacquelynn Baas (Cambridge, MA: MIT Press, 1990), 224.

30 Bober, *The Economics of Cycles and Growth*, 44–45.

31 Braudel, *On History*, 31.

32 Alloway, *Violent America*, 33–34.

33 Ibid., 281.

34 Richard Maltby, *Hollywood Cinema* (Oxford: Blackwell, 2003), 161.

35 Ibid., 293.

36 John Cawelti, *The Six-Gun Mystique* (Bowling Green, OH: Bowling Green State University Popular Press, 1975); Thomas Schatz, *Hollywood Genres: Formulas, Filmmaking, and The Studio System* (New York: McGraw-Hill, 1981); Will Wright, *Sixguns and Society: A Structural Study of the Western* (Berkeley and Los Angeles: University of California Press, 1977).

37 Gregory A. Waller, "Narrating the New Japan: Biograph's *The Hero of Liao-Yang* (1904)," *Screen* 47, no. 1 (2006): 65.

38 Franco Moretti, *Signs Taken for Wonders: On the Sociology of Literary Forms* (London: Verso, 2005), 25.

39 Alloway, *Violent America*, 41 (citing Panofsky), 43.

40 Christine Gledhill, "Rethinking Genre," in *Reinventing Film Studies*, ed. Christine Gledhill and Linda Williams (London: Arnold, 2000), 240, 239.

Chapter 1 Monarchs for the Masses

1 Richard Keenan, "*The Set-Up/Champion* Controversy: Fight Films Go to Court," *American Classic Screen* 2, no. 6 (July 1978): 40–42.

2 See Leger Grindon, "Body and Soul: The Structure of Meaning in the Boxing Film Genre," *Cinema Journal* 35, no. 4 (Summer 1996): 54–69.

3 Coincidentally, Garfield and Roberts had originally optioned the screen rights for Nelson Algren's novel.

4 Meyer Levin, "The East Side Gangsters of the Paper-Backs: The 'Jewish' Novels That Millions Buy," *Commentary*, October 1953, http://www.commentarymagazine .com/article/the-east-side-gangsters-of-the-paper-backsthe-%E2%80%9Cjewish %E2%80%9D-novels-that-millions-buy/.

5 Allen Bodner, *When Boxing Was a Jewish Sport* (Westport, CT: Praeger, 1997), 117. Baer's biography on the International Boxing Hall of Fame website records that he had a Jewish grandfather: http://www.ibhof.com/baer.htm.

6 Jeffrey T. Sammons, *Beyond the Ring: The Role of Boxing in American Society* (Urbana: University of Illinois Press, 1988), 92.

7 Bodner, *When Boxing Was a Jewish Sport*, 57.

8 Odets appeared before HUAC in executive session in April 1952 and gave public testimony in May 1952.

9 Eric Mottram, introduction to Clifford Odets, *Golden Boy; Awake and Sing!; The Big Knife* (Harmondsworth: Penguin, 1963), 19.

10 Other critics have also made the link between the two plays; see, for instance, Gerald Weales, *Odets: The Playwright* (London: Methuen, 1985), 162, and Gabriel Miller, *Clifford Odets* (New York: Continuum, 1989), 62–93.

11 John Willett, *The Theatre of Bertolt Brecht* (London: Methuen, 1977), 71, 146–148.

12 Robert Nott, *He Ran All The Way: The Life of John Garfield* (New York: Limelight Editions, 2003), 119.

13 Cited in Robert Sklar, *City Boys: Cagney, Bogart, Garfield* (Princeton, NJ: Princeton University Press, 1992), 90.

14 Miller, *Clifford Odets*, 65–66.

15 John Lahr, "Waiting for Odets," *Lincoln Center Theater Review* 42 (Spring 2006): 18.

16 Irving Shulman, *The Square Trap* (New York: Popular Library, 1953), 74.

17 Ibid., 165.

18 Ibid., 76.

19 *Hollywood Reporter*, August 20, 1952, 3.

20 For a contemporary analysis of this "slippage" see Henry Popkin, "The Vanishing Jew of Our Popular Culture: The Little Man Who Is No Longer There," *Commentary* 14, no. 1 (1952): 46–55.

21 Her sculptures are described as "surrealist" in the published screenplay, Abraham Polonsky, *Body and Soul: The Critical Edition* (Northridge: California State University, Northridge, 2002), 38.

22 Joyce Carol Oates, *On Boxing* (London: Bloomsbury, 1987), 26.

23 Liebling, *The Sweet Science* (London: Sportsman's Book Club, 1958), 9, 241–243.

24 W. C. Heinz, *The Professional* (1958; New York: Da Capo, 2001), 87.

25 W. C. Heinz, *Once They Heard the Cheers* (New York: Doubleday, 1979), 257–258.

26 Rich Cohen, *Tough Jews* (New York: Simon and Schuster, 1998), 156.
27 Quoted in Gordon Burn, "The Games Writers Play," *Guardian Review*, October 9, 2004, 5.
28 Susan J. Douglas, *Listening In: Radio and the American Imagination* (Minneapolis: University of Minnesota Press, 1999), 63, 199–200, 208.
29 Review collected in the *Body and Soul* clipping file, Margaret Herrick Library, AMPAS.
30 Nott, *He Ran All The Way*, 198.
31 Polonsky, *Body and Soul*, 18.
32 Paul Buhle and Dave Wagner, *A Very Dangerous Citizen: Abraham Polonsky and the Hollywood Left* (Berkeley and Los Angeles: University of California Press, 2001), 113, 109.
33 *Hollywood Reporter*, August 13, 1947; *Variety*, August 13, 1947; *Daily Variety*, August 13, 1947.
34 Sammons, *Beyond the Ring*, xv.
35 Oates, *On Boxing*, 13.
36 Marcus Klein, *Foreigners: The Making of American Literature, 1900–1940* (Chicago: University of Chicago Press, 1981), 201, 215, 184, 226.
37 Stanley Ellin, *Dreadful Summit* (New York: Lion Books, 1950).
38 Liebling, *Sweet Science*, 8–9.
39 Heinz, *Once They Heard the Cheers*, 248.
40 Sammons, *Beyond the Ring*, 131, 149.
41 Ibid., 133–134.
42 Cited in Russell Sullivan, *Rocky Marciano: The Rock of His Times* (Urbana: University of Illinois Press, 2002), 208.
43 Ibid., 203–204.
44 Ibid., 210.

Chapter 2 War Fever: Korea

1 "Korean Situation Cues Circuit War-Pix Buys in Sharp About-Face," *Variety*, July 26, 1950, 3.
2 "H'wood's Head in the Clouds," *Variety*, July 26, 1950, 11.
3 "War on the Upbeat on Film Titles, Too," *Variety*, August 16, 1950, 3. The war would also have an effect on how the Japanese were being represented, because Japan was going to play a part in the war effort, and it was thought that pictures showing the war atrocities they perpetuated would have a negative effect. "Japs 'Important' to U.S. in Korean War," *Variety*, August 9, 1950, 1. New markets were also expected to open up as a result of hostilities. "U.S. Pix Gaining Another Market," *Variety*, July 12, 1950, 4.
4 *Variety*, July 12, 1950, 4; January 3, 1951, 59.
5 *Variety*, December 6, 1950, 25.
6 Film reviews, *Variety*, January 3, 1951, 67.
7 "The Corporal Reports What He Saw," *Life*, September 4, 1950, 35–36. Lisa Dombrowski valuably documents the ideas and images Fuller drew upon from his war experiences in *The Films of Samuel Fuller: If You Die, I'll Kill You!* (Middletown, CT: Wesleyan University Press, 2008), 41–42.
8 *Variety*, January 3, 1951, 4; January 10, 1951, 6; January 17, 1951, 8.

9 *Variety*, February 14, 1951, 8, 16.

10 *Variety*, January 3, 1951, 59.

11 Will Straw, "The Small Parts, Small Players Dossier: Introduction" *Screen* 52, no. 1 (Spring 2010): 1–4.

12 *Hollywood Reporter*, May 12, 1953, 3.

13 *Variety*, November 23, 1955, 6.

14 Cited in Raymond Chandler, *The Blue Dahlia: A Screenplay* (London: Elm Tree Books, 1976), xii.

15 *Variety*, January 12, 1955, 6.

16 *Variety*, May 13, 1959, 6.

17 *Variety*, October 15, 1952, 6.

18 *Target Zero* (1955) also plays with the contraction between Korea and the West when its Native American character, Private Geronimo, says, as his patrol is surrounded by hordes of North Koreans, he now knows what Custer felt like. The film was shot around Fort Carson, Colorado, and Colorado Springs, the latter another much-used location for horse operas.

19 *Variety*, August 11, 1954, 6.

20 Ibid.

21 The idea of "urgency" linked to topicality is drawn from Lawrence Alloway, *Violent America: The Movies, 1946–1964* (New York: MoMA, 1971), 10.

22 *Variety*, August 11, 1954, 6.

23 Frank Krutnik, Steve Neale, Brian Neve, and Peter Stanfield, eds., *"Un-American" Hollywood: Politics and Film in the Blacklist Era* (New Brunswick, NJ: Rutgers University Press, 2007).

24 Film reviews, *Variety*, October 31, 1951, 6.

Chapter 3 Got-to-See

1 Tino Balio, *Grand Design: Hollywood as a Modern Business Enterprise, 1930–39* (Berkeley and Los Angeles: University of California Press, 1993), 281.

2 Ibid.

3 Richard Maltby, *Hollywood Cinema*, 2nd ed. (Oxford: Blackwell, 2003), 293.

4 On the effects of the breakup of the studio system, see ibid., 159–165.

5 Stanley Kramer, "Got-to-See," *Motion Picture Herald*, September 20, 1958, 18–19

6 Bernard Eisenschitz, *Nicholas Ray* (London: Faber & Faber, 1993), 229–255.

7 Herm Scoenfield, "Disks' Peak $400,000,000 in '58," *Variety*, January 1, 1958, 1. For more information on the music industry, see Russell Sanjek and David Sanjek, *American Popular Music Business in the 20th Century* (New York: Oxford University Press, 1991).

8 Hy Hollinger, "Lost Audience: Grass vs Class—Sticks Now on 'Hick Pix' Kick," *Variety*, December 5, 1956, 1, 86.

9 Maltby, *Hollywood Cinema*, 163.

10 Hollinger, "Lost Audience," 1.

11 Ibid.

12 For a discussion of the western's role in the disputes between independent exhibitors and the studios, see Peter Stanfield, *Hollywood, Westerns and the 1930s: The Lost Trail* (Exeter: University of Exeter Press, 2001).

13 Hollinger, "Lost Audience," 86.

14 Maltby, *Hollywood Cinema*, 163.
15 Hy Hollinger, "Teenage Biz vs Repair Bills: Paradox in New 'Best Audience,'" *Variety*, December 19, 1956, 20.
16 Gavin Lambert, "From a Hollywood Notebook," *Sight & Sound* 28, no. 2 (Spring 1959): 68–73.
17 Ibid.
18 The incidents at Hollister took place over the 1947 Fourth of July holiday weekend, and *Life* published its one-page report "Cyclist's Holiday," with a picture of a boozed-up biker, on July 21. See also Frank Rooney, "Cyclists' Raid," *Harper's*, January 1951, 34–44.
19 Letter from Joseph I. Breen to George Glass (Stanley Kramer Productions), December 12, 1952, reproduced in *History of Cinema, Series 1: Hollywood and the Production Code* (Woodbridge, CT: Primary Source Microfilm/Thomson Gale, 2006).
20 Ibid.
21 Ibid.
22 Ibid.
23 Cited at http://blogs.montrealgazette.com/2011/01/20/montreal-has-a-history-of-transit-fare-fights-the-1955-montreal-riot-not-about-maurice-richard/ (last accessed May 22, 2013).
24 "Riots Halt Bus, Tram Service," *Gazette*, December 10, 1955, 1.
25 Ibid.
26 For an account of the biker cycle of films, see John Wooley and Michael H. Price, *The Big Book of Biker Flicks* (Tulsa, OK: Hawk Publishing, 2005).
27 Lawrence Alloway, *Violent America: The Movies, 1946–1964* (New York: MoMA, 1971), 11, 45.
28 Steve Neale, *Genre and Hollywood* (London: Routledge, 2000), 118.
29 *Variety*, October 16, 1957, 6.
30 Richard Maltby, "Why Boys Go Wrong: Gangsters, Hoodlums, and the Natural History of Delinquent Careers," in *Mob Culture: Hidden Histories of the American Gangster Film*, ed. Lee Grieveson, Esther Sonnet, and Peter Stanfield (New Brunswick, NJ: Rutgers University Press, 2005), 62.
31 Lawrence Alloway, "Son of Public Enemy," *Arts Magazine*, November 1966, 25–26.
32 Lawrence Alloway, "More Skin, More Everything in Movies," *Vogue*, February 1968, 168–169, 213.
33 Alloway, "Son of Public Enemy," 26.
34 Ibid.
35 John McHale, "The Expendable Icon," in *POP*, ed. Mark Francis (London: Phaidon, 2005), 201–202.
36 Alloway, *Violent America*, 71.
37 Alloway, "More Skin, More Everything in Movies," 213.
38 Alloway, *Violent America*, 25.
39 Ibid., 63, 25, 23, 63.
40 Ibid., 15, 19, 34.

Chapter 4 Teenpic Jukebox

1 Thomas Doherty, *Teenagers and Teenpics: The Juvenilization of American Movies in the 1950s* (London: Unwin Hyman, 1988), 111.

2 Marshall Crenshaw, *Hollywood Rock: A Guide to Rock 'n' Roll in the Movies* (London: Plexus, 1994), 118.

3 For example, see Greil Marcus, "Rock Films," in *The Rolling Stone Illustrated History of Rock & Roll*, ed. Jim Miller (New York: Random House, 1976).

4 Mark Kermode, "Twisting the Knife," in *Celluloid Jukebox: Popular Music and the Movies since the 50s*, ed. Jonathan Romney and Adrian Wootton (London: British Film Institute, 1995), 9.

5 For a useful and entertaining guide to the diversity of teenpix, see Alan Betrock, *The I Was a Teenage Juvenile Delinquent Rock 'n' Roll Horror Beach Party Movie Book: A Complete Guide to Teen Exploitation Film, 1954–1969* (New York: St. Martin's Press, 1986).

6 For a cultural history of hi-fi, see K. Keightley, " 'Turn It Down!' She Shrieked: Gender, Domestic Space, and High Fidelity, 1948–59," *Popular Music* 15, no. 2 (May 1996): 149–177.

7 Advertisement, *Variety*, December 19, 1956, 17.

8 David Meeker, *Jazz in the Movies: A Guide to Jazz Musicians, 1917–1977* (London: Talisman Books, 1977), unpaginated.

9 *Hollywood Reporter*, April 25, 1957, 3.

10 Robert Pruter, *Doowop: The Chicago Scene* (Urbana: University of Illinois Press, 1996), 218.

11 Crenshaw, *Hollywood Rock*, 118.

12 John Mundy, "Television, the Pop Industry and the Hollywood Musical," in *Film's Musical Moments*, ed. Ian Conrich and Estella Tincknell (Edinburgh: Edinburgh University Press, 2006), 43.

13 Evidence for this can be found in Roger Corman's almost complete lack of regard for copyrighting his 1950s productions, a miscalculation that cost him dearly when *Little Shop of Horrors* was turned into a musical. See Beverly Gray, *Roger Corman: An Unauthorized Biography of the Godfather of Indie Filmmaking* (Los Angeles: Renaissance Books, 2000), 62–67.

14 Russell Sanjek and David Sanjek, *American Popular Music Business in the 20th Century* (New York: Oxford University Press, 1991), 137.

15 In 1954 the Robins, later renamed the Coasters, recorded an ersatz mambo–"Loop de Loop Mambo," a wonderful confection composed by Jerry Leiber and Mike Stoller. Link Wray recorded "Rumble Mambo" in 1963.

16 Rolf Meyersohn and Elihu Katz, "Notes on a Natural History of Fads," *American Journal of Sociology* 62, no. 6 (May 1957): 594, 601.

17 Herm Schoenfeld, "Hot Trend: Trinidado Tunes—Calypso-Caribe Takeover Kick," *Variety*, December 26, 1956, 1.

18 Review of *Dragstrip Girl*, *Hollywood Reporter*, April 1957, 3.

19 The folk revival and its links to calypso are touched upon in Robert Cantwell's superb history of the former, *When We Were Good: The Folk Revival* (Cambridge, MA: Harvard University Press, 1996), 6.

20 Ned Sublette, "The Kingsmen and the Cha-Cha-Chá," in *Listen Again: A Momentary History of Pop Music*, ed. Eric Weisbard (Durham, NC: Duke University Press, 2007), 79, 81; Schoenfeld, "Hot Trend."

21 Sublette, "The Kingsmen and the Cha-Cha-Chá," 81.

22 Philip H. Ennis, *The Seventh Stream: The Emergence of Rocknroll in American Popular Music* (Hanover, NH: Wesleyan University Press, 1992), 227.

23 Meyersohn and Katz, "Notes on a Natural History of Fads."
24 Baxter also provided most of the music for *Untamed Youth*, a May 1957 release by Warner Bros. that featured a mix of rock 'n' roll and calypso.
25 John Mundy, *Popular Music on Screen: From Hollywood to Music Video* (Manchester: Manchester University Press, 1999), 110.
26 Michael S. Eldridge, "Bop Girl Goes Calypso: Containing Race and Youth in Cold War America," *Anthurium* 3:2 (2005), http://scholarlyrepository.miami.edu/anthurium/vol3/iss2/2/.
27 The best account of rock 'n' roll's penetration of the suburbs is found in W. T. Lhamon Jr., *Deliberate Speed: The Origins of a Cultural Style in the American 1950s* (Cambridge, MA.: Harvard University Press, 2002), 67–97.
28 Reprinted in *Rock 'n' Roll, 1939–59* (Paris: Foundation Cartier, 2007), 152–153.
29 Roger Garcia, ed., *Frank Tashlin* (London: British Film Institute, 1994), 168.
30 See, for example, Krin Gabbard, *Jamming at the Margins: Jazz and the American Cinema* (Chicago: University of Chicago Press, 1996), and Peter Stanfield, *Body and Soul: Jazz and Blues in American Film, 1927–1963* (Urbana: University of Illinois Press, 2006).
31 Marcus, "Rock Films," 350.
32 The magazine's cover and images from the photo spread are reproduced in A. Kahan, D. Nason, A. Quattrocchi, and J. Smith, eds., *The Art of Von Dutch* (Los Angeles: Tornado Design, 2006), 84–85.
33 See the excellent popular history of the song and the movie spin-offs by Jim Dawson, *Rock around the Clock: The Record That Started the Rock Revolution* (London: Backbeat Books, 2006).
34 Marcus, "Rock Films," 350. For another iteration of Marcus's position, see R. Staehling, "From 'Rock around the Clock' to 'The Trip': The Truth about Teen Movies," *Rolling Stone*, December 27, 1969, reprinted in *Kings of the Bs*, ed. T. McCarthy and C. Flynn (New York: E. P. Dutton, 1975), 220–251.
35 Review of *Blackboard Jungle*, *Variety*, February 2, 1955, 6.
36 Gabbard, *Jamming at the Margins*, 9.
37 Norman Mailer, "The White Negro: Superficial Reflections on the Hipster," in *The Penguin Book of the Beats*, ed. Ann Charters (London: Penguin, 1993), 582–605.
38 On an earlier attempt by Hollywood to represent the hip, see Stanfield, *Body and Soul*, 142–151.
39 R. Silverman, "Coast's Beat Generation Whips Up B.O. Medley of Coffee, Culture, Comics," *Variety*, October 22, 1958, 2, 26.
40 "Poetry with Jazz in Cafes Makes Bad Rhyme out of Bohemians & Minimums," *Variety*, April 23, 1958, 1, 6.
41 See, for example, David Sterritt, *Screening the Beats: Media Culture and the Beat Sensibility* (Carbondale: Southern Illinois University Press, 2004).
42 *Hollywood Reporter*, March 29, 1957, 4.
43 In *Bell, Book and Candle* Jack Lemmon plays the bongos in the jazz band at the Club Zodiac, and he performs with the same gusto and talent that he brought to playing the bull fiddle two years later in *Some Like It Hot* (1959).
44 Costanzo is heavily featured in the episode "Nature of the Night," part of the jazz detective series starring John Cassavetes, *Johnny Staccato* (1959).

45 For more information on beatniks and bongos, see Martin McIntosh, *Beatsville* (Victoria, Australia: Outré Gallery Press, 2003), and on the instrument's Cuban roots, see Sublette, "The Kingsmen and the Cha-Cha-Chá."

46 Jeff Smith, *The Sounds of Commerce: Marketing Popular Film Music* (New York: Columbia University Press, 1998), 177.

47 Jeff Smith, *The Sounds of Commerce: Marketing Popular Film Music* (New York: Columbia University Press, 1998), 177, 264n50. Smith's source for the footnote is J. Morthland, "The Rise of Top 40 AM," in *The Rolling Stone Illustrated History of Rock & Roll*, ed. Jim Miller (New York: Random House, 1976), 92–95.

48 Louis Cantor, *Dewey and Elvis: The Life and Times of a Rock 'n' Roll Deejay* (Urbana: University of Illinois Press, 2005), 140. For more on the role of the disk jockey in the promotion of rock 'n' roll, see Ennis, *The Seventh Stream*, 131–160.

49 Review of *Jamboree*, *Hollywood Reporter*, July 16, 1957, n.p.

Chapter 5 Intent to Speed

1 Gene Balsley, "The Hot-Rod Culture," *American Quarterly* 2, no. 4 (1950): 353–358.

2 Hy Hollinger, "Teenage Biz vs. Repair Bills: Paradox in New Best Audience," *Variety*, December 19, 1956, 20.

3 See, for example, "Autos: Hot Rods," *Time*, July 18, 1949, and "Education: Last Date," *Time*, June 12, 1950, http://www.time.com/time/archive.

4 Frank Richardson Pierce, "I've Got a Thunderbolt in My Back Yard," *Saturday Evening Post*, November 18, 1950, 28–29, 108, 110–111, 114.

5 Leslie T. White, "Action in the Prowl Car," *Saturday Evening Post*, September 14, 1946, 14–15, 103.

6 "The 'Hot-Rod' Problem," *Life*, November 7, 1949, 122–124.

7 Alex Gaby, "52 Miles to Terror," *Saturday Evening Post*, January 14, 1956, 17–21, 80–82. The film rights to the story were bought by MGM, which was looking for another juvenile delinquency feature to follow up on its success with *Blackboard Jungle*, as reported in the *Saturday Evening Post*, January 14, 1956, 140.

8 "Texas: I Hope He Dies," *Time*, August 25, 1958, http://www.time.com/time /archive. For earlier examples of the journal's attempts to explain the phenomenon, see "Autos: Hot Rods," and "Education: Last Date."

9 An earlier film depiction of hot rods can be seen in *Wings* (William Wellman, 1927), which links youthful enthusiasm for car customization with flying.

10 H. R. Moorhouse, *Driving Ambitions: A Social Analysis of the American Hot Rod Enthusiasm* (Manchester: University of Manchester Press, 1991), 17, 36–37, 48, 73, 85–86. In 1951 Charlton publishers issued the comic book *Hot Rods and Racing Cars*, a bimonthly that ran for at least twelve issues. On hot-rod-themed pinball machines, see Frank Krutnik, "Theatre of Thrills: The Culture of Suspense," *New Review of Film and Television* 11, no. 1 (March 2013): 6–33.

11 "Music: Real Hogbear," *Time*, April 7, 1952, http://www.time.com/time/archive.

12 This musical exploitation of hot rods was part of a wider fascination with speed and automotive thrills—e.g., Jackie Brenston and Ike Turner's "Rocket 88" (1951); the Medallions' "Buick 59" (1954), "Speedin' " (1955), and "59 Volvo" (1959); the Cadillacs' "Speedo" (1955); Bo Diddley's "Cadillac" (1959); and, of course, Chuck Berry's "Maybelline," "No Money Down," and "You Can't Catch Me" (all 1955).

13 Brian Chidester and Daniel Priore, *Pop Surf Culture: Music, Design, Film, and Fashion from the Bohemian Surf Boom* (Santa Monica, CA: Santa Monica Press, 2008).

14 Balsley, "The Hot-Rod Culture"; Moorhouse, *Driving Ambitions*, 122–413.

15 Tom Wolfe, *The Kandy-Kolored Tangerine-Flake Streamline Baby* (London: Picador, 1981), 67–90.

16 *Daily Variety*, January 22, 1947, 3.

17 Blair Davis, *The Battle for the Bs: 1950s Hollywood and the Rebirth of Low-Budget Cinema* (New Brunswick, N.J.: Rutgers University Press, 2012), 108.

18 Hot rods also feature in similar ways in the period's literature, for example, in Jack Kerouac's *On the Road* (1957; London: Penguin, 2000):

> Two rides took me to Bakersfield, four hundred miles south. The first was the mad one, with a burly blond kid in a souped-up rod. "See that toe?" he said as he gunned the heap to eighty and passed everybody on the road. "Look at it." It was swathed in bandages. "I just had it amputated this morning" (72).
>
> We were already almost out of America and yet definitely in it and in the middle of where it's maddest. Hot rods blew by. San Antonio, ah-haa! (247).

19 Thomas Doherty, *Teenagers and Teenpics: The Juvenilization of American Movies in the 1950s* (London: Unwin Hyman, 1988), 110.

20 Moorhouse, *Driving Ambitions*, 57.

21 Ibid., 85.

22 Ibid., 108.

23 See Davis, *The Battle for the Bs*.

24 Kevin Heffernan, *Ghouls, Gimmicks, and Gold: Horror Films and the American Movie Business, 1953–1968* (Durham, NC: Duke University Press, 2004), 65.

25 John Sedgwick, "'Product Differentiation at the Movies: Hollywood 1946 to 1965," in *An Economic History of Film*, ed. John Sedgwick and Michael Pokorny (London: Routledge, 2005), 192.

26 Heffernan, *Ghouls, Gimmicks, and Gold*, 67, 82, 70.

27 Advertisement reproduced in Mark Thomas McGee and R. J. Robertson, *The J.D. Films* (Jefferson, NC: McFarland, 1982), 56.

28 Peter Wollen, "Speed and the Cinema," in *Paris Hollywood: Writings on Film* (London: Verso, 2002), 265, Hitchcock quoted 266.

29 Richard Maltby, *Hollywood Cinema* (Cambridge: Blackwell, 2003), 164.

30 "See $35,000,000 in 1950 Rentals from Drive-Ins," *Variety*, June 14, 1950, 1.

31 *Hollywood Reporter*, February 19, 1957, 3.

32 Mary Morley Cohen, "Forgotten Audiences in the Passion Pits: Drive-in Theatres and the Changing Spectator Practices in Post-war America," *Film History* 6, no. 4 (1994): 475, trade reporter quoted 478.

33 "See $35,000,000 in 1950 Rentals from Drive-Ins." See also "Drive-Ins Seen Highway Menace by State Groups," *Variety*, July 12, 1950, 1.

34 Maltby, *Hollywood Cinema*, 22.

35 Davis, *The Battle for the Bs*, 109.

36 See Peter Stanfield, "Maximum Movies: Lawrence Alloway's Pop Art Film Criticism," *Screen* 49, no. 2 (2008): 179–193.

37 John McHale, "The Expendable Ikon 1," in *John McHale—The Expendable Reader: Articles on Art, Architecture, Design, and Media (1951–79)*, ed. Alex Kitnick (New York: GSAPP Sourcebooks, 2011), 51.

38 Murray Schumach, "Violence in Films Seen on Decrease: Juvenile Delinquency Scripts Drop as a Result of Drive," *New York Times*, July 17, 1961, 25.
39 James Gilbert, *A Cycle of Outrage: America's Reaction to the Juvenile Delinquent in the 1950s* (New York: Oxford University Press, 1986), 14.

Chapter 6 Punks! JD Gangsters

1 *Motion Picture Herald*, Product Digest Section, May 6, 1961, 276.
2 *Variety* quotation used in advertising copy and pressbook for *Baby Face Nelson*, November 6, 1957, 6.
3 For a history of the television series and an episode guide, see Tise Vahimagi, *The Untouchables* (London: British Film Institute, 1998).
4 See, for example, *Stag Magazine* 9, no. 5 (May 1958), which includes "The FBI's Death Duel with Baby Face Nelson," or *Amazing Detective Cases* for December 1958, featuring "Vince 'Mad Dog' Coll: The Killer Who Killed for Kicks," "Free Love Ladies of Murder Inc.," "The Amazing Saga of a Renegade G Man," and "The Spider Spins a Noose." For an illustrated, anecdotal history of men's magazines, see Adam Parfrey, ed., *It's a Man's World: Men's Adventure Magazines, the Postwar Pulps* (Los Angeles: Feral House, 2003).
5 David Hajdu, *The Ten-Cent Plague: The Great Comic Book Scare and How It Changed America* (New York: Farrar, Straus and Giroux, 2008).
6 Mike Benton, *The Illustrated History of Crime Comics* (Dallas, TX: Taylor Publishing, 1993).
7 On the PCA's attempt to distinguish between representations of legendary, historical, and contemporary criminals, see Peter Stanfield, *Hollywood, Westerns and the 1930s: The Lost Trail* (Exeter: University of Exeter Press, 2001), 183–185.
8 *Hollywood Reporter*, July 3, 1958, 3. In preproduction the film had been called *Lady with a Gun* and *Tommy Gun Connie*. *Hollywood Reporter*, March 6, 1958, 4.
9 *Hollywood Reporter*, January 21, 1958, 3.
10 For a guided tour of movie gangland's most memorable mug shots, see Ian Cameron and Elisabeth Cameron, *The Heavies* (London: Studio Vista, 1967).
11 Carlos Clarens, *Crime Movies: An Illustrated History* (New York: Norton, 1980), 189.
12 Even the notes on the back sleeve of the tie-in soundtrack album promoted the sensational: "A word about the picture. Mickey Rooney is 'Baby Face Nelson.' He is. But only for the film. Carolyn Jones is the 'chick.' Mmmmmmmmmmmm. Sir Cedric Hardwicke is the 'Doc.' Wow! The original story was written by Irving Shulman. He collaborated with Daniel Mainwaring on the screen treatment. Al Zimbalist was the producer. The picture was directed by Don Siegel. It's gutsy."
13 Will Straw, "Urban Confidential: The Lurid City of the 1950s," in *The Cinematic City*, ed. David B. Clarke (London: Routledge, 1997), 113.
14 *Motion Picture Herald*, Product Digest Section, October 3, 1959, 437.
15 *Hollywood Reporter*, November 6, 1957, 3.
16 *New York Times*, December 12, 1957, 35.
17 *Motion Picture Herald*, Product Digest Section, June 25, 1960, 749.
18 Jack Moffitt, *Hollywood Reporter*, July 3, 1958, 3.
19 Esther Sonnet and Peter Stanfield, " 'Good Evening Gentlemen; Can I Check Your Hats Please?': Masculinity, Dress, and the Retro Gangster Cycles of the 1990s," in

Mob Culture: Hidden Histories of American the Gangster Film, ed. Lee Grieveson, Esther Sonnet, and Peter Stanfield (New Brunswick, NJ: Rutgers University Press, 2005), 163–184, esp. 182.

20 Geoffrey O'Brien, "In Cold Blood," *Film Comment*, May–June 2006, 22.

21 *Harrison's Reports*, January 9, 1960, 6.

22 *Motion Picture Herald*, Product Digest Section, January 16, 1960, 557.

23 Richard Maltby, "Why Boys Go Wrong: Gangsters, Hoodlums, and the Natural History of Delinquent Careers," in *Mob Culture: Hidden Histories of American the Gangster Film*, ed. Lee Grieveson, Esther Sonnet, and Peter Stanfield (New Brunswick, NJ: Rutgers University Press, 2005), 41–66.

24 *Motion Picture Herald*, Product Digest Section, January 23, 1960, 565.

25 "The Last Mile," *Motion Picture Herald*, January 31, 1959, 433.

26 *Motion Picture Herald*, Product Digest Section, November 9, 1957, 593.

27 *Motion Picture Herald*, July 12, 1958, 905.

28 *Hollywood Reporter*, November 6, 1957, 3.

29 Straw, "Urban Confidential," 119.

30 Jean-Luc Godard, "La Photo du Mois," *Cahiers du Cinéma* 92 (February 1959), reprinted in translation in Jim Hillier, ed., *Cahiers du Cinéma: The 1950s—Neo-Realism, Hollywood, New Wave* (Cambridge, MA: Harvard University Press, 1985), 51.

31 O'Brien, "In Cold Blood," 22.

32 *New York Times*, December 12, 1957, 35.

33 *Harrison's Reports*, January 30, 1960, 18.

34 *Terry and the Pirates*, by Milton Caniff, ran from 1934 to 1946. The complete strips have been reprinted in six volumes by the Library of American Comics, published by IDW (San Diego). The same company is also reprinting the complete Dick Tracy strips.

35 The same dictionary defines a "gangster" as a "member of a gang of roughs, gunmen or the like."

36 The strips are reproduced in Alex Raymond, *Rip Kirby, 1946–1948* (San Diego, CA: Library of American Comics, IDW Publishing, 2009), 71, 72, 77, 100, 115, 141, 142.

37 In a November 1, 1939, memorandum on profanity and vulgarity in films, produced by the PCA following discussions engendered by the use of "damn" in *Gone with the Wind*, a list of proscribed words is produced with an indication of the territory in which the word is particularly problematic. I am grateful to Richard Maltby for sharing this document with me. For a wider discussion of the British censors' influence on the PCA, see Ruth Vasey, *The World According to Hollywood, 1918–1939* (Exeter: University of Exeter Press, 1997).

38 See the *Oxford English Dictionary* for the word's etymology. The *OED* lists "punkateroo," a vulgar compound of "punk" with the Spanish "muleteer," as a procurer of prostitutes.

39 For a revealing discussion of the confusion over the use of "gunsel," see Gaylyn Studlar, "A Gunsel Is Being Beaten: Gangster Masculinity and the Homoerotics of the Crime Film, 1941–1942," in *Mob Culture: Hidden Histories of American the Gangster Film*, ed. Lee Grieveson, Esther Sonnet, and Peter Stanfield (New Brunswick, NJ: Rutgers University Press, 2005), 120–145.

40 Raymond, *Rip Kirby, 1946–1948*, 110.

41 William R. Cox, *Hell to Pay* (New York: Signet, 1958), 119–121.

42 Leo Margulies, *The Young Punks* (New York: Pyramid, 1957).

43 Ibid., unpaginated introduction.

44 Ibid., 51.

45 Ibid., 91.

Chapter 7 Dude Ranch Duds

1 Dave Hickey, "Mitchum Gets Out of Jail," in *O.K. You Mugs: Writers on Movie Actors*, ed. Luc Sante and Melissa Holbrook Pierson (New York: Pantheon Books, 1999), 16.

2 On the matter of changing approaches to censorable material, see Lea Jacobs, *The Wages of Sin: Censorship and the Fallen Woman Film, 1928–1942* (Berkeley and Los Angeles: University of California Press, 1997) and Ruth Vasey, *The World According to Hollywood, 1918–1939* (Exeter: University of Exeter Press, 1997).

3 Marc Vernet, "Film Noir on the Edge of Doom," in *Shades of Noir*, ed. Joan Copjec (London: Verso, 1993), 20.

4 See, for example, Alain Silver and Elizabeth Ward, eds., *Film Noir* (London: Secker and Warburg, 1979), 325–326.

5 Vernet, "Film Noir on the Edge of Doom," 21, 23, 24.

6 Lynn Downey, *Levi Strauss & Co.* (Charleston, SC: Arcadia, 2007), 15.

7 Niall Ferguson, *Civilization: The Rest and the West* (London: Allen Lane, 2011), 241.

8 Downey, *Levi Strauss & Co.*, 27; see 79–85 for reproductions of Levi's advertisements that track the shift from overalls and workwear to jeans and leisurewear.

9 Christian Wolmar, *The Great Railway Revolution: The Epic Story of the American Railroad* (London: Atlantic Books, 2012), 1, 324, 60.

10 Ibid., 61.

11 Lawrence R. Borne, *Dude Ranching: A Complete History* (Albuquerque: University of New Mexico Press, 1983), 40.

12 Ibid., 40, 49.

13 "In the decades after World War I, many young women went west to learn a new set of skills: to swear and spit and seduce, to spin a rope and crack a bullwhip, to loaf and to flirt. . . . For many, the dude ranch itself was a romance—of history, of the Wild West, of nostalgia for the way it used to be but never actually was." Adrienne Rose Johnson, "Romancing the Dude Ranch, 1926–1947," *Western Historical Journal* 43, no. 4 (Winter 2012): 437–462.

14 All three quotations are from Borne, *Dude Ranching*, 94. The *Vogue* article (May) is entitled "Dressing the Dude."

15 Peter Stanfield, *Horse Opera: The Strange History of the 1930s Singing Cowboy* (Urbana and Chicago: University of Illinois Press, 2002).

16 Bernard Eisenschitz, *Nicholas Ray: An American Journey* (London: Faber & Faber, 1993), 175. The *Life* magazine article was by Claude Stanush featuring rodeo champ "Wild Horse Bob" Crosby (May 13, 1946), 59–64. *Life* ran a number of articles on rodeo in this period, e.g., "Champ Rider: Casey Tibbs Has a Rip-Roaring Time on Broncs and Off" (October 22, 1951), 123–126.

17 Eisenschitz, *Nicholas Ray*, 185.

18 From a reproduction of Wrangler Blue Bell marketing materials in the author's own collection. See also Wrangler Blue Bell advertisements that ran regularly in *Life* magazine, e.g., March 28, 1949, 138.

19 Jeans are worn by many of the significant characters in *The Searchers*, usually Levi's with the notable exception of Harry Carey Jr.'s character. He wears Wranglers; the slimmer fit of these pants offers a youthful contrast with Wayne's loose-cut Levi's.

20 Robert B. Pippin, *Hollywood Westerns and American Myth: The Importance of Howard Hawks and John Ford for Political Philosophy* (New Haven: Yale University Press, 2010), 134.

21 Jim Kitses, *Horizons West* (London: Thames and Hudson, 1969), 10–12.

22 See Edward Buscombe, *The Searchers* (London: BFI, 2000).

23 Steve Neale, *Genre and Hollywood* (London: Routledge, 2000), 34.

24 The quote is from the film's poster.

25 See also *Colorful Colorado*, an MGM short about the attractions of Colorado Springs.

26 Peter Reyner Banham, *Scenes in America Deserta* (Salt Lake City: Peregrine Smith, 1982), 133.

27 Lawrence Alloway, *Violent America: The Movies, 1946–1964* (New York: MoMA, 1971), 27. See also Peter Stanfield, "Maximum Movies: Lawrence Alloway's Pop Art Film Criticism," *Screen* 49, no. 2 (Summer 2008): 179–193.

28 Wolmar, *The Great Railway Revolution*, 343–344.

29 Greg Sutter, "A Conversation with Elmore Leonard," in *The Complete Western Stories of Elmore Leonard* (New York: William Morrow, 2004), xi–xii.

30 On the anachronistic use of music in the western, see Peter Stanfield, "From the Barroom: American Song, Saloon Culture, Stack O'Lee, and *Wild Bill*, or 'Did you touch my hat?' " in *Music in the Western: Notes from the Frontier*, ed. Kathryn Kalinak (New York: Routledge, 2011), 183–202.

Index

About the Author

PETER STANFIELD is a professor of film at the University of Kent. He has written two monographs on the western, published extensively on gangster movies, and coedited a book on the blacklist era in American cinema. He has produced a substantial body of research on popular music and film, on topics ranging from Hollywood's fascination with America's gutter songs in the early sound period to 1930s singing cowboys to the figure of Stagger Lee in westerns. His previous book was *Maximum Movies—Pulp Fictions: Film Culture and the Worlds of Samuel Fuller, Mickey Spillane, and Jim Thompson,* which takes a long look at our fascination with a pulp aesthetic.